THE GOLDEN AGE OF CHINESE ART

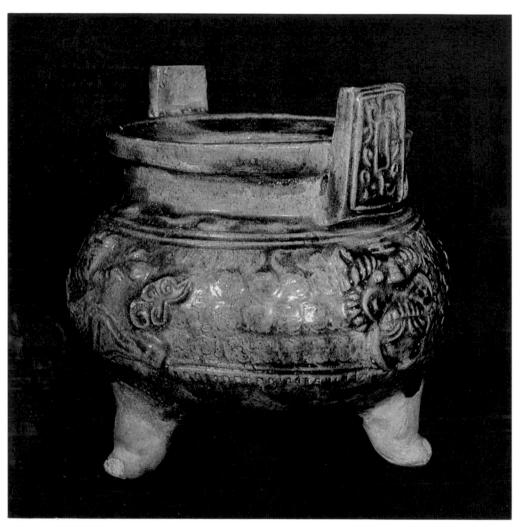

FRONTISPIECE:
RARE BLUE-GLAZED POTTERY TRIPOD
Greatest diameter: 5 1/4 *inches*
Overall height: 4 1/2 *inches*

THE GOLDEN AGE
OF CHINESE ART

The Lively T'ang Dynasty

HUGH SCOTT

Rutland, Vermont • Charles E. Tuttle Company • *Tokyo, Japan*

Representatives

For Continental Europe:
BOXERBOOKS, INC., Zurich

For the British Isles:
PRENTICE-HALL INTERNATIONAL, INC., London

For Australasia:
PAUL FLESCH & CO., PTY. LTD., Melbourne

For Canada:
M. G. HURTIG LTD., Edmonton

Published by the Charles E. Tuttle Company, Inc.
of Rutland, Vermont and Tokyo, Japan
with editorial offices at
Suido 1-chome, 2-6, Bunkyo-ku, Tokyo, Japan

Copyright in Japan, 1966
by Charles E. Tuttle Co., Inc.

Library of Congress Catalog Card No. 66-16264

International Standard Book No. 8048-0212-2

First printing, 1967
Second printing, 1970

Book design and typography by John Paull
Layout of plates by H. Doki
PRINTED IN JAPAN

To
Anne, Mary, Thomas Scott, Sean, Susan,
Carol, and Brian

May you
Love Beauty
Revere the Past
and
Serve the Future

Table of Contents

List of Illustrations

Asterisk () indicate color plates*

Unless captioned otherwise, all objects illustrated are from the T'ang Dynasty.

Introduction

by Henry Trubner
Curator, Far Eastern Department
Royal Ontario Museum,
University of Toronto, Canada

THE T'ANG DYNASTY IS OFTEN REGARDED AS ONE OF THE PROUDEST AND MOST glorious epochs in China's long and turbulent history. The first half of the almost three hundred year reign was an age of undisputed military and political power, which saw China emerge as the world's largest and most powerful empire, feared and respected throughout Asia. The period also witnessed an unrivalled florescence of the arts, notably the major arts of sculpture and painting as well as ceramics, the decorative arts, poetry and music.

Despite the reunification of the country into a single empire under the Sui Dynasty, revolt and disunity, fostered by a weak and corrupt court, were once again in evidence during the late sixth and early seventh centuries. China was on the verge of another extended period of civil strife, like that which followed the fall of the Han empire, but was saved from such a fate by Li Shih-min, the hero of the hour and a youth of only eighteen, who seized the reins of power and put his aged father on the throne as the first emperor of the T'ang Dynasty. Li Shih-min, one of the outstanding personalities in the history of China, then consolidated the empire he had founded, defeating all opponents of his plans during years of bitter civil war and ultimately, in 627, succeeded to the throne his father had occupied.

With the founding of the T'ang Dynasty in 618, there began one of the most glorious and vital epochs in the history of China, which was to leave a permanent and indelible mark on the country's future. When Li Shih-min died in 649, the

centralized government he had established was secure and the prestige abroad and strength and prosperity at home which marked his reign were to endure for at least another hundred years.

Two other remarkable personalities were responsible for continuing the achievements of Li Shih-min. One was his former concubine Wu Tse-t'ien, who ruled as Empress Wu from 683-705, but was also the guiding power behind the throne during the reign of Kao-tsung (649-683), her predecessor. Unscrupulous and cruel, she ruled China with an iron hand until forced to abdicate at the age of eighty-two. She was also a fervent and devout Buddhist, and the carving of the colossal group of Vairocana, attendant Bodhisattvas and other figures at the Feng-hsien temple, Lung-mên, was largely due to her influence. The central figure of Vairo-cana, which was undoubtedly carved to rival the colossal Buddha at Yun-kang, of the second half of the fifth century, was commissioned in 672, in the reign of Kao-tsung and was completed in 675.

The third major personality of the T'ang Dynasty was the emperor Hsuan-tsung (Ming Huang), who succeeded to the throne in 713. His long reign, which lasted until 756, was one of the most brilliant and most enlightened eras in the history of China, comparable to the Gupta reign of King Harsha or the Sung court of Hui-tsung during the early twelfth century. The court of Ming Huang was a gathering place for poets, painters and scholars. The wealth and energies of the country, when not required for the construction or decoration of Buddhist temples, were concentrated on the arts, on learning, music, drama and ultimately on Yang Kuei-fei, the emperor's beautiful mistress. In 754 Ming Huang founded the Han-lin Academy, which was to serve as a nucleus for scholarship and the literary activities of the court. Some of the T'ang painters were also attached to the Academy.

While the reign of Ming Huang was distinguished by a great sense of refinement and luxury, the seeds of decay were also present, and slowly gathered force as this era approached its end. Through Yang Kuei-fei and her influence at court, An Lu-shan, a general of Mongol or Tungusic origin, had achieved a position of in-creasing power, unsuspected by the emperor who took him into his confidence. Finally, in 755, he revolted and Ming Huang was forced to flee from Ch'ang-an, together with Yang Kuei-fei. The latter was put to death by An Lu-shan's soldiers, and the emperor himself was forced to abdicate. A few years later the empire was restored, but its former power was broken and the glory which marked the reign of Ming Huang was gone. Despite a steady deterioration in the T'ang fortunes, the ultimate collapse of the T'ang empire, which ended in chaos, was delayed until the beginning of the tenth century, when the Five Dynasties, centered around local courts, each administered by its own royal house, replaced the T'ang rule.

[2]

INTRODUCTION

The collection of Chinese art gathered over the years by the Hon. and Mrs. Hugh Scott is remarkable in that it is largely devoted to the arts of the T'ang Dynasty. The author of the book is therefore particularly well qualified to write on the subject of T'ang art, as illustrated by the many fine objects in his distinguished collection. Some of these important T'ang pieces have been exhibited at various museums, but the greater part of this collection is herein illustrated for the first time. It is especially rich in T'ang gold and silver, bronze mirrors, ceramics in whiteware and san t'sai glaze, but the great range of the collection, which includes many aspects of T'ang art, also reflects the wide interest and discriminating taste of the collector.

Acknowledgment

I express here my thanks to Miss Barbara Sweeney for her knowledgable help with the transcription and her preparation and arrangement of the descriptions accompanying the illustrations. The index and glossary are largely her work. My thanks are also extended to Miss Margaret Lynch, and to Miss Grace Hussie, for their invaluable help with numerous revisions.

My appreciation is here expressed also to Mr. John Pope of the Freer Gallery for his valuable suggestions regarding the attribution and description of certain of the art objects and to Miss Jean Lee, Curator of Oriental Art, Philadelphia Museum of Art, for her encouragement. My thanks go also to Mr. Arthur Scott for his patient and careful photographic work.

I am especially grateful to my wife Marian for her patience and encouragement of my efforts. No author can fail to appreciate the trials of his wife as she endures his preoccupation with the agonies of book creation. This is especially so when the author is also a public official, whose everyday activities often deprive both of them of the pleasures of normal, leisurely companionship.

I am most grateful to my publishers, Charles E. Tuttle Company, and especially to Mr. Charles V. S. Borst, for their amiable acceptance of the delays incident to textual correction.

May I dare hope that this book will bring to my readers some moment of shared pleasure in the glory that was China.

HUGH SCOTT

Preface

THIS BOOK IS INTENDED AS A MODEST CONTRIBUTION TO THE STORY OF THE T'ANG told largely through objects in my collection.

As with most collectors, my interest began mildly at first and continued to increase through random purchases, leading gradually to specialization. This process described by some as "knowing more and more about less and less" began with the furnishing of a new house in 1935.

My first Oriental art object was a "kakemono," one of the well-known ancestor portraits. To escape from the strictures of legal research, I had been attempting a "Japanese Self-Taught" course while riding the commuter train to the city. This, in turn, inspired an interest in the arts of Japan.

Most of my early purchases were predictably Japanese and not very good. A trip to pre-Communist China in 1947 aroused a love for the art of China, never to be quieted.

My collection included (and in part still does) Shang and Chou bronzes, Han inlaid bronzes and ceramics and objects in gold or silver of this remarkable period of the T'ang. They are quite hard to come by these days and other collectors tell me that my collection in this field, rather small as it is, nevertheless is one of the most representative in private hands in this country. Of course, it does not compare with the Kempe Collection in Sweden nor those splendid objects in the Minneapolis Museum.

I have just had the extraordinary good fortune to acquire some fragments of T'ang (or immediately pre-T'ang) textiles, one of which is identifiable as having once been a part of the Japanese Imperial Collection.

The most frustrating search for this collector has been for pieces of T'ang glass. (Perhaps some reader will steer me in that direction!) I have never been able to acquire authentic T'ang lacquer, and the pursuit of elusive and prohibitively costly T'ang paintings is out of reach.

The soaring auction prices for all good works of art tend to leave less and less available for the modest collector who cannot compete with his wealthier colleagues or that new breed, the investor collector. The latter buys art as he buys securities, to hold and to sell at a profit, but not to love, honor and cherish.

Someday, too, the hidden or withheld treasures still in Communist China may return with the Chinese people to the free world, but that time is not presently foreseeable.

The field of Chinese art is spiked with controversy. To begin with, archeology has yet to fill in the many still barren areas in the landscape of China's early history: whence came the first "people of the Han" as the Chinese came later to call themselves? Were there Seven Legendary Emperors? The civilization of the Shang abounded with artistry in bronze, marble and jade, its craftsmanship full blown in lusty, even brutal vigor, its works of art among the most beautiful and powerful ever created on this earth. What earlier, cruder efforts preceded it? What did these remote artifacts look like? A little is known, but scholars will argue these matters for a long time to come.

So it is with another controversy. The very title of this book continues it. What was truly the Golden Age of Chinese Art?

Some will opt for the skillful variety of the Ming times. Many suggest that the eighteenth century, under the reign of the cultivated Chien Lung (equating it with the eighteenth century in Europe), was the period of the ultimate development of beauty in art. The opulence of this period is undeniable.

Among writers and students in recent years, there is a considerable school of thought that the gifted excellence of Sung work entitles it to be hailed as the pinnacle of Chinese art. But this excellence seems to me to have been uneven at best, and, at worst, a sense of *"déjà vu,"* a wistful longing for glories past.

If this were a book on painting alone, I would readily concede the point and leave the field to far better informed men such as the eminent Csvald Sirén of Sweden, whose recent demise all collectors mourn.

Painting aside, one must concede also that many Sung ceramics, such as the "out of this world" monochromes and some Tzu Chou paintings on overglaze, are incomparable.

Yet much of the ceramic work is but a carrying forward of T'ang inspirations, a perfecting of techniques, a growing mastery of glaze and form.

The art of the lusty T'ang gives way to the smooth sophistication and inward-lookingness of a nation no longer expanding its boundaries and contacts, no longer victorious in war and secure at home.

Sung inlaid bronzes are beautiful but unfaithfully rendered copies of master artists. They shine but they hardly glow. The same may be said of much of their work in gold and silver.

Sung jades are usually artistic improvements upon or re-enactments of the small decorative pieces or large bowls or vases of the archaic periods they recall. True they are not vulgar copies but rather memorials to earlier conceptions. Some of the smaller pieces are exquisite.

This book, as described and as illustrated, presents my reasons for awarding the laurels of eminence to the Dynasty of T'ang.

Under T'ang emperors, China became an international power in the East, greater than the western sweep of the contemporary Charlemagne. Here was a golden era which saw China, victorious in military actions, expand a huge empire increasingly hospitable to foreigners. Here was a period which honored learning and welcomed the entry of new thinking in art, culture, economics and religion within its borders and welcomed innovations from without. Its artistry in metal crafts has never been improved upon; its bold glazing and its ceramic forms, original or sinicized from other civilizations, have come down to us as prototypes, and as inspiration for almost all later artistic development.

In short, with all that came later, let it be noted that it began with the optimistic dynamism of the T'ang.

I

HISTORY OF THE
T'ANG DYNASTY

SAID THE ARAB, ABŪ ZAYD: "OF ALL THE CREATURES OF ALLAH, THE CHINESE HAVE hands most gifted in designing and fashioning things; ... there is no people on earth who can do so well as they."[1] The Chinese themselves have always eulogized the T'ang period as their "Golden Age" which has also been called "the greatest period of creative art in China" and "the most virile period of Chinese art."[2]

Who were these Chinese people of the T'ang? What occurred before and during their glittering three centuries upon the world's stage? Considering their immense power in the most populous country on earth, why has the non-Asian world known so little of them until the discovery by Occidentals of their works and way of life, mostly within the last half-century?

The dynasty of the T'ang rulers dates from the years A.D. 618 to 906. The Liao Dynasty, A.D. 907 to 960, is the bridge between T'ang and Sung and often linked with T'ang for cultural and artistic reasons.

Before the golden dawn of the T'ang was the turbulence of the period of the Sui. Following the decline of the Han Dynasty (206 B.C. to A.D. 220), China was fragmented under a number of rulers including the Three Kingdoms (220–280),

[1] *Jane Mahler,* Westerners Among the Figurines of the T'ang Dynasty of China *(Roma: Istituto italiano per il Medio ed Estremo Oriente, 1959), p. 72*

[2] *William Willetts,* Chinese Art *(Harmondsworth, Middlesex: Penguin Books, 1958), II, 423*

the Wei Tartars (386–557), and the Six Dynasties (222–589). It was during this period that Buddhism began to move north from India into China.

The entire country was reunited under the first emperor of the Sui Dynasty (589-618), whose capital was at Ch'ang-an in Shensi.[3] The emperor, Yang Chien, reigned not only over the Turco-Mongolians of the North as the former Wei sovereigns whom he succeeded but over all of China. In 589, he subjugated the provinces of the Nanking Empire of the South and thus ended a separation that had lasted two hundred and seventy years. His son, Yang-ti (605-18), lost popularity through the oppressive use of force in huge public works projects which, coupled with military disasters in Korea, led to his assassination and the end of the brief dynasty of the Sui.[4]

As China expanded into Central Asia under the Sui, foreigners who came in increasing numbers to the Eastern Capital were dazzled by the imperial splendor. The cities of far off Syria became linked through the caravan routes that crossed Afghanistan and joined the old silk roads to the East.[5] A great part of the Turkish Empire came under hegemony.

The T'ang Dynasty—the "Golden T'ang"—rich, powerful, cosmopolitan, the inheritor of over two thousand years of the Great Central Kingdom's culture, was perhaps the greatest period in the long history of China. Some may point out that nothing in its craft equalled the sublime power of the Shang bronzes, and others may cite the perfect proportion and unique sophistication of the Sung ceramics. To me, at least, the era of the T'ang, begun in valor, nourished by the leisure and resplendence of the ruling class and refreshed by the infusions of foreign cultures, must be ceded the place of honor as the most exciting period culturally and the highest apex of art in China's long history.[6]

One can scarcely overrate the invigorating effect of the influx of foreigners on the Chinese creative spirit and intellectual grasp. They came from every quarter of the known world. Greeks, Syrians, Persians (largely refugees from Islamic conquests), Arabs and Indians, as well as peoples from outlandish regions like Siberia and the jungles of Southeast Asia, found homes and livelihood in China. Koreans and Japanese helped to complete this varied assemblage. In cities like Ch'ang-an and Hangchow, entire districts were set aside for their living quarters. The foreign

[3] *Judith Burling and Arthur Hart Burling,* Chinese Art *(New York: Studio Publications, 1953), p. 134*

[4] *Rene Grousset,* Chinese Art & Culture, *trans. Haakon Chevalier (New York: Orion Press, 1959), pp. 170–1*

[5] *Mahler, op. cit., p. 9*

[6] *Ernest Francisco Fenollosa,* Epochs of Chinese & Japanese Art, An Outline History of East Asiatic Design *(London: W. Heinemann and New York: Frederick A. Stokes Co., 1921), I; Edwin O. Reischauer and John K. Fairbank,* East Asia: The Great Tradition, A History of East Asian Civilization, *V. 1 (Boston: Houghton Mifflin, 1960), p. 155*

population of Canton alone must have been well over 120,000, for we learn from an Arab source that that number lost their lives when the City was fired by Huang Ch'ao in A.D. 879.

In pottery, the shapes and motifs of Iranian, Mesopotamian and Syrian vessels were becoming as well known in China as they were in Byzantium, Alexandria and Lombard Italy.

Meanwhile China prospered. The great rift between North and South was mended. Officials traveled freely over the entire country and life in the big centres on the Yangtze and southward was no different in quality from life in Ch'ang-an and Lo-yang. The population, composed chiefly of peasants, landed gentry, State officials, soldiers and the monks and nuns of Buddhism and other religions, stood at forty million—over two million of them in the metropolitan district of Ch'ang-an.

"...Lo-yang was the second in rank, and it was the second city of the empire in population, having more than a million inhabitants. It had its holy traditions of a thousand years, was not second in pride even to Ch'ang-an, and was endowed with a spiritual atmosphere somewhat milder and more elegant than its western rival. It was the 'Godly Metropolis' of the Empress Wu, well on its way to becoming what it became in the eleventh century, the proudest and most beautiful city of China. It had palaces and parks and throngs of officials. It was noted for its fine fruits and flowers, its patterned damasks and fine silk crepes, and its ceramic wares of all kinds. It had a great market place, the Southern Market, occupying two blocks (*fang*), with a hundred and twenty bazaars, or streets given over to the sale of a single type of ware, and thousands of individual shops and warehouses. For the aliens there on business, there were the usual temples to alien gods, among them three shrines to the Sacred Fire, attesting to the presence of a Persian colony.

"...of all the cities of the south, and of all the towns where foreign merchants congregated, none was more prosperous than the great port of Canton, the Khanfu of the Arabs, the 'China' of the Indians. Canton was then a frontier town, on the edge of a tropical wilderness populated by savages and wild beasts, and plagued with unpleasant diseases, but handsomely set among lichees, oranges, bananas, and banyans. During the reigns of the T'ang emperors it became a truly Chinese city, even though a large part of its population of 200,000 was 'barbarian.' It was a wealthy city, but a flimsy one: its triple wall surrounded a crowded mass of thatch-roofed wooden houses, which were repeatedly swept by disastrous fires, until, in 806, an intelligent governor ordered the people to make themselves roofs of tile. In the estuary before this colorful and insubstan-

[13]

tial town were '...the argosies of the Brahmans, the Persians, and the Malays, their number beyond reckoning, all laden with aromatics, drugs, and rare and precious things, their cargoes heaped like hills.' In exchange for their fragrant tropical woods and their almost legendary medicines, these dark outlanders sought bales of silk, boxes of chinaware, and slaves. They enriched the Chinese businessmen who were willing to give up the comforts of the north for the profits of the south,...."[7]

Among all of the competitors for the vacant throne of the Sui, a strong man emerged in the person of young Li Shih-min, who established his father, the able General Li Yüan, as the first T'ang Emperor. Nine years later, Li Shih-min became the Emperor T'ai-tsung ("T'ai-tsung the Great"). He completed the conquest of the Mongolian Turks and of the Indo-Europeans of Central Asia. Following the conquest of Korea by his son, other rulers repelled recurrent attacks. In 712, the greatest of the T'ang chieftains, the Emperor Hsüan-tsung (also known as Ming-huan), ascended the throne and reigned for forty-two brilliant years. His armies ranged to the borders of Afghanistan and Pakistan. Great poets and painters flocked to his courts. Emissaries and traders came from all the Eastern world and as far away as Rome and Araby. All the varied arts and crafts flourished; new concepts and customs were born and the influence of what was created in those days has come down through nations and centuries to leave its inescapable mark upon the art and culture of our times.[8]

During the Hsüan-tsung Dynasty, culture and art appreciation reached it apogee with poets such as Li Po, Tu Fu, Meng Hao-jan and Wang Wei and illustrious painters as Wu Tao-tzu, Li Ssu-hsun, Wang Wei (again) and Chang Hsüan, who was chiefly celebrated for his paintings of young nobles, and women of rank.[9]

In Ch'ang-an, the Academy of Literature (Han-lin Yüan) was founded. Advanced studies in music were held in the imperial "Pear Garden". All the talent and wealth of the country which was not given to the construction and adornment of Buddhist temples seemed concentrated on the Emperor's court, his palaces, favorite scholars, poets, painters, schools of dramas and music, orchestras, and his beloved concubine, the beautiful Yang Kuei-fei whose protégé, in turn, was the rough and daring Tungusic General An Lu-shan.

In 755, An Lu-shan led a successful revolt and the emperor fled. His soldiers

[7] *Edward Hetzel Schafer*, The Golden Peaches of Samarkand: A Study of T'ang Exotics *(Berkeley: University of California Press, 1963), pp. 14–5, 19*

[8] *Grousset, op. cit., p. 178*

[9] *Bo Gyllensvärd, "T'ang Gold and Silver,"* Bulletin, *Museum of Far Eastern Antiquities, Stockholm No. 29 (2) (1957), p. 14; Michael Sullivan,* An Introduction to Chinese Art *(Berkeley: University of California Press, 1961), p. 126*

blamed the adventurous Yang Kuei-fei and strangled her before his eyes. For good measure, they also killed his son and his Prime Minister.

A damaging defeat by the Moslems had been suffered four years earlier and it was not until 763 that the country was reconquered. In the latter part of the eighth century and throughout the ninth, the empire sustained many attacks from the Tibetans. Defeats were also sustained in Turkestan and Yunnan and later, sometimes due to eunuch influence in the capital, less competent emperors suffered internal revolts and betrayals.[10]

Foreigners enjoyed freedom to trade, travel and to achieve prosperity until, in a see-sawing religious competition, the Taoists gained power over the Buddhists and turned the Emperor against them (as had happened before, although less drastically, under Hsüan-tsung). Finally in 845, all "foreign" religions were proscribed and all Buddhist holdings in lands and temples were confiscated. The Christian religion, which had gained some headway, was also banned as "heretical". Notwithstanding the massacre of foreigners at Canton in A.D. 879 by Huang Ch'ao, Hindus, Arabs, Christians, and Jews continued to live and work in China throughout the T'ang Dynasty and indeed were still settled in Canton and Hangchow as late as the thirteenth century.

During the reign of Hsi Tsung (874–888), this same bloodthirsty Huang Ch'ao destroyed the great cities of Ch'ang-an and Lo-yang. He was defeated by a Turk, Li-K'o-yung, who was loyal to the emperor. The new Emperor Chao Tsung (889–904) was weak. After a massacre of court eunuchs in 903, Chu Wen brought him as a prisoner to Lo-yang. There he and his relatives were murdered, except for a child puppet-heir, who abdicated in 907 to Chu Wen.[11] So ended the house of Li—the dynasty of the magnificently resplendent T'ang, with its Lorenzos, "Sun King," and "gray eminences."

[10] *Gyllensvärd, op. cit., pp. 14–5; Sullivan, op. cit., p. 118; Swann,* Art of China, Korea and Japan, *(New York: Praeger, 1963) p. 121*

[11] *Gyllensvärd, op. cit., p. 17; see also, Schafer,* Golden Peaches of Samarkand, *p. 10*

II

CULTURE OF THE T'ANG DYNASTY

BEFORE CONSIDERING THE ARTS AND CRAFTS OF THE CHINESE OF THIS TIME, LET US examine briefly the manner in which they lived and how they appeared to foreigners who so freely visited their cities.

The Arab traveller, Ibn Wahhāb, who came to China in 815, describes the capital city of Chang-an:

"The city was very large, and extensively populous; that it was divided into two great parts by a very long and broad street; that the Emperor, his chief ministers, the soldiery, the supreme Judge, the eunuchs, and all belonging to the Imperial Household, lived in that part of the city which is on the right hand eastward; that the people had no manner of communication with them, and they were not admitted into the places watered by canals from different rivers, whose borders were planted with trees and adorned with magnificent dwellings. The part on the left hand westward, was inhabited by the people and the merchants, where were also great squares and, markets for all the necessaries of life. At break of day, you see the Officers of the King's Household, with the inferior servants, the purveyors, and the domestics of the grandees of the court, some on foot, others on horseback, who come into that division of the city where there are public markets, and the inhabitations of the merchants, where they buy whatever they want, and return not again to the same place till the next morning."[12]

[12] *Mahler,* op. cit., *p. 103; Marshall Broomhall,* Islam in China, A Neglected Problem *(London: Morgan and Scott, 1910), pp. 45–6*

Sulaymān, an Arab merchant, visited China between 830 and 851 and reported:

"The Chinese have gold, silver, pearls, brocades and silk, all in good quantity.... They import into China ivory, incense, copper ingots, tortoise shells and rhinoceros horn, of which they make belt ornaments. They have no Arab horses, but horses of another breed; they have asses and two-humped camels in great numbers. They have clay of an excellent quality of which they make porcelain bowls as fine as glass [as clear as glass drinking cups;] the sparkle of water can be seen through it, although it is pottery."[13]

This is the first Occidental note on porcelain, although it must have been known in Samarra at this time or shortly thereafter. Samarra was abandoned in A.D. 883 If the wares exported from China were more or less contemporary products, then the pottery found at Samarra was made at the earliest not long before A.D. 838 when Samarra was built. Sulaymān discussed the payment of duty on goods and noted that the Emperor had first choice and held the monopoly on salt and tea. Then the goods were sold in the open market.

The famous Nestorian Christian Bishop Issac (called Issu by the Chinese) was among the thousands of Westerners mobilized in 757 to help in the recapture of Chang-an from the rebel An Lu-shan. Nestorian and Manichaean churches flourished and even in court circles there were converts. Nestorian bronze crosses have been found even in modern times in Central Asia.[14] When Ibn Wahhāb had his interview with the Chinese Emperor about 815, he reported that the Emperor produced pictures of the prophets, among whom he recognized Noah, Moses, Jesus and Mohammed.[15]

The tomb figures from T'ang burials offer abundant evidence of the pervasive presence of persons from all races and lands who came to China to trade, to serve the prosperous, to share in their prosperity, and to entertain or to join the skilled craftsmen or superb artists of the period.

Since a number of T'ang burials can be dated historically, the authenticity of many tomb pieces thus can be established; sometimes the provenance, or at least the general area from which a given object comes, can likewise be determined. Other external means of dating specimens of these times are to be found in known T'ang kiln sites, or by comparison with the priceless works of art and articles of daily use, which came from the Chinese Court to the Japanese Emperor Shōmu

[13] *Mahler, op. cit., p. 102*

[14] *Ibid., pp. 100, 103, and see Plate illustrations;* Arnold Silcock, Introduction to Chinese Art and History *(New York: Oxford University Press, 1948), p. 153*

[15] *Mahler, op. cit., p. 103*

and which were catalogued by the Dowager Empress Kōmyō in A.D. 756. These items and others received up to 950 are still to be found among the treasures of the Shōsō-in at Nara, Japan.[16]

The economic and cultural progress mainly in the earlier part of the T'ang established a climate in which both arts and crafts flourished. The distinction between art and craftsmanship was strictly drawn. The arts, as accepted by the scholars of those days, embraced only painting and calligraphy. All else was considered to be the work of artisans and craftsmen. To us, in the light of T'ang sculpture, metalwork and ceramics, this seems incomprehensible. It is, of course, true that much, if not most, of the surviving ceramics, for example, were indeed the work of men who were not artists but artisans. The burial figures were often turned out in quantity from molds, and there is much duplication to meet the exigent demands of the times. As a matter of fact, a number of the tomb figures came to be standardized by law as to height.[17] This appears to have been done to curb wasteful and ostentatious display. It also appears to have been widely disregarded!

"... It became the mode to use the age-old custom of tomb-furnishing for purposes of social competition. The mechanics of this practice are revealed to us by a chronicler of the times, who tells us that the dead were accompanied to their grave by great throngs and that along the procession's route, in pavilions and tents, the mourners were entertained with food, wine, actors, acrobats, circuses and women. In these temporary structures the furniture which was to adorn the tomb was on view. Of all that panoply of pleasure the earthenware tomb furniture is all that has remained. But the quantities found are enough to reveal how widespread was the custom and how it permeated society from the highest to the lowest. They reveal, too, that a chronicle's account of the financial disasters of some families in their effort to keep up with their neighbours is more than probable. Before the first hundred years of the T'ang dynasty had run out, an imperial edict was promulgated laying down strict specifications for the practice of tomb decoration. It was decreed that a personage above the fourth rank could be accompanied by no more than 40 pieces. The rules also fixed the maximum size of the pieces, and specified that the statuettes and pots which were to accompany princes were to be drawn from the stocks of the 'Imperial Department of Model Makers'.

"This ruling cannot have been enough to curb extravagance. We are told that later a strong complaint was lodged with the Imperial Household by a bureaucrat

[16] *Willetts, op. cit., pp. 428–9*
[17] *Mahler, op. cit., pp. 130–2*

in the Ministry of Finance criticising in no uncertain terms the ostentation displayed in funeral ceremonies and the enormous expense involved. He did not scruple to include princes and grandees in his condemnation, though the *nouveaux riches* came in for most of the blame, and he enumerated the practices which caused the unprecedented squandering. First among these was the habit of displaying and then burying with the dead 'remarkably beautiful effigies of horses and men'. Apart from this bureaucrat's sedulousness and pedantry, the statement does reveal that the objects we of the present day admire so much were also considered beautiful by their contemporaries."[18]

Nevertheless, strength, kinetic force, and originality are to be found in many T'ang pottery pieces; and as stoneware was followed by porcelain, some of the exquisite whiteware, for example, has not been bettered to this day. In fact, the beauty of the best of the T'ang ceramics, with their striking colors and splash glazes, is only beginning to receive its just appreciation.

Many regard the T'ang religious figures as the zenith of all Chinese sculpture. Certainly the realism and dynamic ferocity of the stone animals is beyond compare, save those of its predecessor Six Dynasties.

Artistry in the use of gold and silver alone or with articles of bronze had been handsomely exemplified in the cleverly patterned inlay work of the Chou and Han Dynasties. As has been noted, many foreigners, skilled in the working of metals, appear to have made their way to the T'ang cities, bringing with them stylistic inspirations from the Sassanians, Romans, Greeks, Turks, Hindus, Moslems and other cultures.

[18] *Mario Prodan,* The Art of the T'ang Potter, *(New York: The Viking Press, 1961,) pp. 64–6*

III

GOLD & SILVER

SINCE DISCUSSION OF THE ARTS OF THE T'ANG WILL RELY UPON ILLUSTRATIONS primarily from the Scott collection, it is my preference to vary the usual order and to begin with the work of the goldsmith and silversmith. Normally these *objets d'art* are treated as of minor importance or under the heading "Metalwork." This appears to have been largely due to the great scarcity of these objects in comparison with ceramics, as only the small bronzes are known in any quantity. Another reason seems to have been the difficulty of attribution, not so much for lack of deductive powers among scholars as for lack of opportunity (until recently) to inspect similar objects or perhaps for lack of interest.

"When the first Chinese silver objects from the T'ang period made their appearance on the European market, the collectors and connoisseurs were generally skeptical. Several times they declared the silver to be a forgery and the strongest criticism was against the tomb figures... after the increase of the material in the market, the scholars became more positive in their opinion of the authenticity of the T'ang silverware."

After referring to a number of forgeries of T'ang gold and silverware:

"The author has, however, hitherto come across no forgeries directly corresponding to the original gold and silver objects from T'ang in shape, decor, and technical execution."[19]

[19] *Gyllensvärd, op. cit., pp. 28, 38*

Cubes of gold were used as currency from the eleventh to the third centuries B.C. Before China came into close contact with foreigners, gold and silver had the same value.[20] The discovery of gold on T'ai-shan in 95 B.C. is recorded in Pan-ku's History of the Han Dynasty as a notable and fortunate event, which further underlines the scarcity of precious metals in China at that time. In T'ang times, there were native sources of gold in Szechwan and remote gold deposits at Lingnan and Annam.

The learned pharmacologist Ch'en Ts'ang-ch'i, wrote:

"I have regularly seen men taking gold: they dig into the ground to a depth of more than a ten-foot to reach rock which is greatly disturbed. Here each lump of rock is all blackened and scorched, but beneath such rock is the gold. The larger is like a finger; the smaller resembles hemp seeds and beans; the color is like 'mulberry yellow,' and when you bite it, it is extremely soft—this then is the true gold. But when a workman stealthily swallows some, I have not seen that it is poisonous. The 'bran gold' comes from the midst of river sands, and is taken by washing it out on felt....

"Before the advent of T'ang, both gold and silver were hardly ever worked as the basic materials of dishes, vases, or even of jewelry. Gold was made into some personal ornaments, in costly imitations of styles of ancient bronze prototypes, and for splendid inlays in large bronze vessels....

"Gold leaf, gold foil, and 'cut gold,' the last-named being a style of gold-leaf appliqué, were all employed by the artists of T'ang. Leaf gold was used in paintings, as we know from examples found at Tun-huang, while the Shōsō-in contains many objects beautifully decorated with it—for example, a 'Silla zither' adorned with birds and plants in cut gold. At least one of the towns where gold-beaters produced the materials for these gorgeous objects is known; it was Huan-chou in Annam."[21]

Most of the silver objects were found in tombs—this is true also of some of the gold objects—but it is difficult to say how many were made expressly for burial purposes. Many show signs of wear and even of repair. This tends to support the theory that they were personal possessions in daily use and followed the owner to the grave. Ancient reports tell of how the area was sometimes actually impoverished to provide suitable objects.[22]

[20] *Burling,* op. cit., *p. 334*
[21] *Schafer,* op. cit., *pp. 251–52. (Reference to a 'silla zither' emphasizes the skill of Korean craftsmen.)*
[22] *Gyllensvärd,* Carl Kempe Collection, op. cit., *p. 26*

Many gold and silver objects survive, particularly from the Chou and Han Dynasties. These appear as sheet gold (sometimes in *repoussé*) believed to have been used to decorate coffins, boxes, and costumes. They also appear as "sleeve weights," sword guards, and most often as inlay in bronze vessels, chariot ornaments, finials, and in the most lovely and variegated forms as "dress hooks". Very few gold vessels have survived because they could be too easily converted into coin or bullion.[23]

Due to the demands of foreign trade from the Han Dynasty on, gold tended to become more expensive and its use in making Buddhist images greatly increased.[24] Gold was also used for gilding other objects and for the famous Chinese gold thread. Yet, during the T'ang period, we find no bronzes inlaid with gold and silver as in the Huai style period of the Han. During the Han Period, in addition to the gold and silver used for intarsia work on bronzes, cast silver objects were made in the same shapes and with the same decorations as the bronzes. Gold was wrought with great taste and skill. Hammered gold foil was used as were the techniques of granulation and gilding.

"...a Western houri beckons with her white hand, inviting the stranger to intoxicate himself with a golden beaker. ...an edict of 714 [forbade] the export or the sale to foreigners of tapestries, damasks, gauzes, ...or of yaktails, pearls, gold, or iron [or any metals]."[25]

From whence came the foreign prototypes of T'ang vessels and decorative motifs? On the whole, we find most of them in Persian metalwork of the Sassanian period (A.D. 226–637). But almost as influential is the more purely Hellenistic art of the Near East as expressed in domestic vessels of pottery and glass. Thus Mesopotamia of the Parthian period, Syria, Alexandria, and even Byzantium, among others, probably all sent tributary streams into the main current of T'ang ceramic art. Some reached China only by way of Iranian translations but others must have passed directly through normal trade channels. The so-called "Dark Ages" must "have witnessed a flow of commodities, both east and west, on a scale scarcely known until modern times, resulting in diffusion of Hellenistic styles to almost every corner of the Old World."[26]

During T'ang, the Chinese developed new techniques and improved upon the earlier use of *granulé* and casting. A major influence appears to have come from

[23] *Burling, op. cit., p. 335*
[24] *Ibid., p. 334*
[25] *Schafer, op. cit., pp. 21, 24*
[26] *Willetts, op. cit., pp. 458–9*

Sassanian silversmiths, although the use of granulation can be traced back to Egypt in the 18th century B.C. and to Etruscan work in the 6th century B.C. The connection with Chinese gold and silver work generally can be traced to Irano-Hellenic centers of art, including the Taxila culture of Northern India. Some Chinese and Roman silver cups as well as Greek pottery cups (one from the 4th century A.D. in the author's collection) also appear to have had the same common ancestry.[27] The new techniques and the skill and imaginative artistry employed established the time of the T'ang as the period of the finest metalcraft ever produced in China.

Space will permit only brief discussion of methods used by the silversmiths. Once again I am principally indebted to the works of my friend Mr. Bo Gyllensvärd, unquestionably the greatest authority in this area and without whose research this field of information would be bare indeed.

While casting continued to be used in both gold and silver, raising and chasing became the predominant techniques. Where casting was the method, the body of a cup or bowl was sometimes made of an alloy of silver and tin which was then covered with a good quality silver surface. Following the Sassanian practice, most of the bowls, cups and dishes, as well as spoons and ladles, were hammered out of a more or less thick silver sheet and then "raised" to the desired shape. The ordinary method was to press up the sides by hammering from the center of a circular sheet. By this method—to this day the most common one in silver work—it was very easy to adorn the sides with lobes and bosses of different shapes.[28] The Scott collection contains a large silver vase of the Corn God of the Chimu civilization (Peru, 12th century), which was also formed by raising.

Also adopted from the Sassanian is the chased pattern against a ground of matted circles ("ring matting")—quite common among T'ang vessels. Occasionally the pattern is wholly or partially gilt and in the latter case, the complete surface was probably covered with gold and then removed from the ground by matting. Gold plating may have been a T'ang invention. It is referred to in several poems of the ninth century. The circles, made by a small metal tool, were arranged in more or less even rows to facilitate the even covering of the surface with an underlying pattern. The intention was to bring out the pattern against a matte surface giving the illusion of relief. Sometimes the Chinese used *repoussé* work to achieve relief effects mainly on the gold and silver foil backing on mirrors and on some of the later silver specimens. The high relief on the "white bronze" mirrors with lion and grape and grapevine patterns has been followed with extraordinary skill.

Most of the silver specimens, such as bowls or cups, are adorned with a traced

[27] *Gyllensvärd, op. cit., pp. 28–30; Kempe, op. cit., pp. 16–7*

[28] *Gyllensvärd, op. cit., pp. 28–30; See also Gyllensvärd, Carl Kempe Collection, op. cit., pp. 21–2 and Plate 20, p. 78; See also illustrations from my collection. (Nos. 00)*

[24]

pattern often covering the exterior. Tracing results in a positive reproduction of the pattern on the inside. To be smooth or to receive decoration as well, it became necessary to use double sheets of metal, sometimes very skillfully "turned" or soldered at the rim.[29] This appearance of the tracing on the interior is very clearly shown in a gold-decorated silver lobed bowl in the Scott collection.[30]

For boxes and more complicated shapes, the Chinese usually hammered out several sheets which were soldered together. The circular box with slightly convex lid and base and straight sides, a form also found in ceramics, is one of the more familiar forms. Other boxes are rectangular, oval, lobed or clam-shaped and some bear the shape of a rosette or star flower. Globular pots with lids and globular incense burners are also found.

Among the personal effects of the T'ang aristocrat were scissors, sometimes attached by a chain to a combination tweezers and earpick. The scissors may be plain or decorated with scroll patterns, rosettes, and other designs (Plate 44, 48), but the curved spring handle is common to them all. Spoons, chopsticks and occasionally silver tomb figures occur. Beautiful long curved ladles exist, which may be plain or decorated on the inside or the outside, as well as on the upper part of the handle. The bowls are oval, lobed or shallow and the handles sometimes terminate in a duck's head[31] (Plate 13, 15).

Mirrors

In A.D. 736 all of the great men competed with each other in the magnificence of their gifts, including mirrors, which were said to have been obtained at great expense from distant places.[32]

The T'ang poet Li Po speaks feelingly of his mirror:

> *"My whitening hair would make a long, long rope,*
> *Yet could not fathom all my depth of woe,*
> *Though how it comes within a mirror's scope*
> *To sprinkle autumn frosts, I do not know."*[33]

[29] *Gyllensvärd, op. cit., pp. 29–35;*
[30] *For an interesting discussion of stem cups, pottery and silver, see Willetts, op. cit., pp. 482–5*
[31] *Gyllensvärd, Carl Kempe Collection, op. cit., pp. 25–6. See silver tomb figures, extremely rare silver dog and ladles illustrated herein from the author's collection.*
[32] *Werner Speiser,* The Art of China: Spirit and Society *(New York: Crown Publishers, 1961),* p. 143
[33] *Burling, op. cit., p. 229*

The famed General An-Lu-shan especially admired the *p'ing-t'o* technique, which was so expensive that the Emperor Su-tsung later forbade it. *P'ing-t'o* means "flat cut-out" and refers to gold and silver sheets cut out in the "à jour" technique and often engraved and then set into a lacquer background.

T'ang mirrors which abound in modern collections are nearly all circular, floral shaped or "polylobed" in the form of petals, although a few prized square shapes survive.

The T'ang mirrors show us in the floral or animal themes of their decoration the naturalistic tendency that is basic to T'ang art. In keeping with the spirit of the times, these mirrors display ornamental elegance.[34]

The use of silvery "white bronze" was quite common (Plate 5), both to give the appearance of silver and the mirror a better reflecting surface. The body of the mirror itself usually was made of a bronze alloy. No mirrors made entirely of silver—or gold for that matter—are known.

One of the earliest known border designs is the lion and grape pattern, dated at A.D. 650.[35]

A saw-toothed border design appears on some mirrors, often a simple zigzag band where the pointed teeth may be varied by a circle between each point.

Typical motifs include spirals, palmettes, plants, vines, birds, animals and zoomorphic objects.

The cloud volute appears chiefly as a border on mirrors, as in hunting and landscape scenes. These ornaments often have long tails like a plant stalk. There are mirrors featuring animals as the four cardinal points of the compass, as the twelve signs of the Zodiac (Plate 7) or as prey in hunting scenes. Dragons emerging from water or striding along the shore and the dancing phoenix of *feng-huang* were also popular. Mythological half human maritime monsters are also found.[36] Each of these examples may be seen on mirrors and a dish in the Scott collection. On one mirror one may see the phoenix of the South; the white tiger of the West; the tortoise in the coils of a snake, symbolic of the North; and the dragon of the East.

Not only phoenixes but birds of many species appear on the mirrors as well as the stem cups and boxes. These birds, like the animals, are part of the typical Chinese naturalistic mood and are usually found among plants, trees, vines, rocks, or at other times, among more formalized ornamentation.

It was also in keeping with the extravagant taste of the T'ang court that mirror-backs be gilded, silvered or covered with gold, silver foil or inlaid with a sort of

[34] *Grousset,* op. cit., *p. 205*

[35] *Gyllensvärd,* op. cit., *pp. 46, 164; Schuyler Cammann,* "The Lion and Grape Patterns on Chinese Bronze Mirrors," Artibus Asiae, XVI, 2 (1948), *p. 265ff*

[36] *Gyllensvärd,* op. cit., *pp. 93–102; Schafer,* op. cit., *pp. 79–105*

lacquer. Sometimes as a part of the pattern, the inlay design included mother-of-pearl, amber, or malachite. The old abstract and magical designs, such as the well-known TLV pattern, gave way to symbols of felicity, entwined dragons, phoenixes, birds and flowers. Two beautiful mirrors in the Shōsō-in Repository of T'ang art at its best bear landscapes of foam-washed peaks ringed with clouds and set about with immortals and mythological characters. It is claimed by some that the sea horse and grape (also known as the lion and grape) design reflects the influence of Manichaean (Christian) symbolism.[37]

The decorations on the mirror-backs vary a great deal in both subject matter and use of material. They may be gold-washed or pressed on silver, bronze and tin alloys. The decoration may be flat, inlaid or *repoussé*. Some have inlays of lacquer, mother-of-pearl or stones; some are worked into the bronze back and others applied as metal foil.

Except in the landscapes of some mirrors, the Chinese normally did not use figures as part of naturalistic outdoor scenes, although occasionally Taoist Immortals are seen. Landscapes with animal figures were somewhat more popular, but are also comparatively rare. Native or imported wild animals included elephants, rhinoceroses, lions, leopards, cheetahs, sables, gazelles, mongooses and ferrets. Among the many birds, there were hawks, falcons, peacocks, kingfishers, parrots and ostriches.

While T'ang mirrors were heavier than the Han mirrors, the designs were generally more sparsely used and more graceful. In addition to those already mentioned, one finds squirrels, interlacing vines, hunting scenes, floral medallions, mountains and trees with galloping animals (the Scythian "full gallop") and mythological figures playing musical instruments. There is one of the latter in the Scott collection (Plate 2). "T'ang landscapes" in painting are unattainable to the average collector but one of these miniature "landscapes" on a mirror-back can be a prized surrogate.

The small hand mirrors, being portable, are presumed to have been carried about by the user, probably on a silken cord or tassel. The larger, quite heavy mirrors were meant to be used on low stands, as one may still see quite frequently in the case of handsome Japanese mirrors with lacquered stands from the 17th and 18th centuries.

Perhaps the finest known mirror with an inlay design of gold, silver, amber, mother-of-pearl and lacquer is at the Shōsō-in Repository at Nara.

On a recent visit to Iran, the author added to his collection four handsome silver Sassanian bowls. These illustrate quite tangibly the influence if not the actual

[37] *Sullivan,* Chinese Art, *p. 130*

artistry of Sassanian silversmiths in the two oval Chinese bowls in the Scott collection.

The largest of these Sassanian creations ($11\frac{1}{2}$ inches long, $2\frac{1}{2}$ inches high and $5\frac{1}{2}$ inches wide) is of flowing oval shape distinguished by double horizontal lobes, the interior dramatically highlighted by gold bands covering the major facing channels. The narrow fluted base is of gold over silver. This is one of the finest works of Sassanian artistry of its type known to me.

Two of the bowls are of long oval shape, one with a central medallion of a bird within a gold-rimmed circle.

The fourth bowl is circular, on a high, slightly-flared base, of very heavy silver. The central medallion adorning the interior bears ancient Pahlevi symbols encircled by a repeated diamond in circle pattern, inlaid with what appears to be either enamel or base metal.

The children of these bowls faithfully reflect their parentage.

IV

JADE

"WHAT IS JADE?

"Many would answer: 'A green stone that comes from China.'

"They would be wrong on three counts.

"First, jade comes in every shade of the rainbow (plus a few, according to the Chinese, that mortal man cannot see). Even in the accustomed green, there are dozens of distinct hues, bearing such colorful names as kingfisher, spinach, emerald, moss and young onion green.

"Second, jade is not one stone but two; the mineral nephrite and jadeite, each with its distinctive characteristics, properties, colors, sources, and uses. Though the differences between the two are highly significant, too few writers have, for one reason or another, bothered to distinguish clearly between them.

"Nephrite is a silicate of magnesium—fibrous, hard to fracture, almost soapy in appearance. Jadeite is a silicate of aluminum, microcrystalline, much more readily broken, and, when polished, far more brilliant.

"Jadeite is a comparatively young stone, in terms of carving, having been used in China to any great extent only since 1784. Small wonder then that some dealers do not bother to make a clear distinction between the two stones inasmuch as most of the 'ancient' jadeite pieces on their shelves are considerably less than one hundred years old.

"The jade we know as nephrite is as old as China's recorded history, a part of

[29]

its first myths and legends. We may be sure that the piece of jade, which tradition tells us was carried by a unicorn to the mother of Confucius announcing his impending birth with the inscription 'the son of the essence of water shall succeed to the withering China and be a throneless king,' was nephrite, not jadeite. Confucius, who lived six hundred years before Christ and was one of the world's most eloquent spokesmen for jade, never saw the bright green stone which is today commonly associated with the word. For Confucius never knew the beautiful gem jade, which is jadeite.

"Third, though the use of jade is inseparably linked with the development of Chinese worship, court ceremonials, thought, and art, we have no evidence that jade (of either variety) was ever found in the earth of China itself. We believe it was mined there thousands of years ago and, as elsewhere in the world, the supply was in time exhausted, but we have no proof. So the stone which determined, directed, and changed the course of Chinese history is, in so far as positive evidence goes, an import."[38]

The word "jade" (yü) includes nephrite, a tough web-like amphibole, and jadeite, a pyroxene with a crystallized structure. Chloromelanite is a rarely encountered form of very dark green or black jade.

"Nearly twenty-four hundred years ago Confucius stated that if jade is highly valued it is because since ancient time, '...the wise have likened it to virtue. For them, its polish and brilliancy represent the whole of purity; its perfect compactness and extreme hardness represent the sureness of the intelligence; its angles, which do not cut, although they seem sharp, represent justice; the pure and prolonged sound which it gives forth when one strikes it represents music. Its color represents loyalty; its interior flaws, always showing themselves through the transparency, call to mind sincerity; its iridescent brightness represents heaven; its admirable substance, born of mountain and of water represents the earth. Used alone without ornamentation it represents chastity. The price which all the world attaches to it represents truth. To support these comparisons, the Book of Verse says: "When I think of a wise man, his merits appear to be like jade." And that is why the wise set so great store by jade.' "[39]

"Pure jade is white jade. Color comes from the presence of other minerals in the stone. The smooth, soft, glossy appearance that the world identifies with jade is the result of the application of the mysterious polishing abrasive, *pao yao*, to the tough surface of the stone. Jadeite, being crystalline, takes the higher polish

[38] *Richard Gump*, Jade, Stone of Heaven *(Garden City, New York: Doubleday, 1962), pp. 17–9;* See also Schafer, *op. cit., pp. 223–4*
[39] *Gump*, op. cit., *pp. 23–4*

and possesses a greater brilliance. Both nephrite and jadeite are often translucent and, in very rare instances, transparent."[40]

Renewed interest in China's past caused the craftsmen of T'ang to imitate many of the more severe ancient forms. Attribution is difficult, but it is likely that a number of the so-called Sung "re-creations" of archaic forms actually date to the T'ang Dynasty, as may be the case with a reddish brown curved jade or "half-bracelet" in the Scott collection.

Jade was still associated with cult usage. It was during the T'ang Dynasty that the edict forbidding inferior jades for funerary purposes was issued. Such an edict would have had no meaning unless jade was in fairly large supply.

Known as the "Jade Beauty" was the lovely Yang Kuei-fei, concubine of the Emperor Hsuang Tsung. She slept on a "jade bed," wore only jade ornaments, and surrounded herself with only objects of jade.

"From her robes hung a large variety of tasseled jades in the shape of baskets, flowers, fruit, birds, and animals. From her waist hung a small jade cylinder which exuded the fragrance of crushed blossoms. In her long black hair, knotted in the back, were two long jade hairpins and two pierced white ornaments of jade. When wearing her festive headdress, there were dozens of additional jades: small pendants in myriad forms and colors, elaborate earrings, and a pair of festoons over a foot in length which hung from the headdress.

"On her arms were solid jade bracelets; on her gently heaving chest, brooches of jade.

"*Yü* was no less evident in her Imperial suite. Her furniture was ornamented with jade. On her dressing table were small jade bottles of perfume and feminine spices, a jade box for her jewelry, a jade tray, jade combs. She played upon a jade flute."[41]

"In T'ang, jade was also used for every sort of small object of utility and pleasure by those persons who could afford to buy them. These included little vases and boxes, sometimes cut in the archaic rectangular manner of late Chou, often in the yellow or brownish jade favored in antiquity . . . [or] in the more . . . conventional green or white material. . . .

"Body ornaments of jade were in the old tradition, even if they might have a new form. We have, surviving from T'ang, ladies' hair ornaments such as jade bird forms embellished with gold and silver, and comb backs of jade decorated with human and animal figures in relief. Jade girdle ornaments in the form of fish were newly popular as symbols of rank and prestige. . . .

[40] Ibid., *p. 25*
[41] Ibid., *pp. 148–9*

"A new vogue among the nobility was to wear girdles made of jade plaques, in place of the older leather belts or those composed of metal rings, worn formerly under Sui. ...during the first half of the ninth century, the Tibetans several times sent jade girdles to the rulers of T'ang. ...

"Much small sculpture was done in jade during T'ang: camels, lions, tortoises, rabbits, and various birds, as well as mythological and symbolic creatures like the Chinese 'phoenix.'"[42]

Three small flat animals, sculptured on one side only, are in the Scott collection. They include a horse, a ram and a prowling tiger. There are also several small slender dogs carved in the full round.

Some additional data from the work of scholars and from recent excavations now permits more attributions of jade carvings to the T'ang era than formerly. Yet the comments of the well-known expert, Dr. Cheng Te'-k'un, in a paper read before the Oriental Ceramic Society of London on April 7, 1954, are of considerable interest. He states:

"...In making a selection for the Exhibition [of Chinese Jades, 1948, Oriental Ceramic Society] we found it rather difficult to establish criteria for the identification of jades of the T'ang, Sung, and Ming periods. For these three dynasties lasting from A.D. 613 to 1643 over a thousand years, we had only one set of jade objects with archeological data. These were excavated by us in Chengtu, Szechwan, in 1942 from the tomb of Wang Chien which dated from A.D. 918 This group of jade objects, especially the belt plaques, has a style of its own and no analogy can be drawn between it and the collection we had assembled for the occasion. ...

"We took into consideration the distinctive spirit expressed in the art of each period and related the style of the carvings to one or other of these periods."[43]

In all periods the tendency of the Chinese to copy the work of earlier periods and especially to copy, re-create or "improve" upon objects of archaic origin presents problems in dating jade works based solely upon style. Yet many jade works may be determined to be later than T'ang by their similarity to work in other media. At times, as in the case of the belt plaques, the deft touch of the T'ang is a clue toward identification.

The jade carvers of each dynasty, however, did not spend all their time looking back over their shoulders to "safe" forms. The true artist never hesitated to ex-

[42] *Schafer, op. cit., pp. 225–6*

[43] Transactions of the Oriental Ceramic Society, *London, 28 (1953–4), pp. 23–35; Cheng Te-k'un,* "The Royal Tomb of Wang Chien," *Sinologica, 2 (1949–50), pp. 1–11; Cheng Te-k'un, "The Royal Tomb of Wang Chien,"* Harvard Journal of Asiatic Studies, *8 (1944–45), pp. 234–40; Michael Sullivan,* Excavation of the Royal Tomb of Wang Chien, *Transactions, Oriental Ceramic Society, 23 (1948), pp. 17–26*

press himself in new forms. An example of this, I believe, is to be found in the forceful jade reptile or animal, twisted artistically head between coils, in the Scott collection (Plate 30).

Some years ago Dr. Cheng Te'-k'un acquired from the famous collector, Mr. Ch'en Jen-t'ao, formerly of Shanghai, a set of seven decorated mutton fat jade plaques together with a silver buckle, all of which originally belonged on a leather belt.

At the four corners of each of the plaques is a tunnelled perforation which was made by drilling two slanting holes close to each other to meet under the surface. Silver cords were passed through these perforations to fasten the plaques to the belt. All are the same size, 6 cm. by 5.5 cm. by 8 mm. thick and correspond unmistakably in size and style to the jade plaque herein illustrated in my collection. The decoration on the front surface of the plaques was carved in low relief. These particular plaques represent musicians and are illustrated in Dr. Cheng's article on plates 5 and 6. Illustration lb on Plate 6 shows the rear perforations. These plaques were reportedly unearthed from a T'ang tomb in Sian, Shensi and are now in the Museum of Fine Arts, Boston.[44]

The single jade plaque in the Scott collection (Plate 32) shows precisely the same perforations and is of similar dimensions. This plaque has a raised border within which is an outlined circle. The raised decoration within the circle is most likely a seated figure in T'ang costume wearing a peaked hat and holding a staff atop which may be a bird or branch. At the left hand appears a rock form. On the rear appears the incised symbol "III". The features and dress are more distinctively T'ang than those in Dr. Cheng's collection. The jade is mutton fat with light brownish tints.

Since the Shang period the aesthetic refinement of jade made it pre-eminently suitable for headdress ornamentation. In the Yunkang caves, centrally placed ornaments in the form of flower vases and animal masks adorn the heads of Bodhisattvas, while in the T'ang period the use of a bird as a headdress ornament was already established, jade coiffure ornaments of human and bird form with perforations for attachment are known.[45] My collection includes two exquisite examples of the use of jade in T'ang jewelry.

One of these is a silver hairpin, divided into two silver spring stems, from each of which depend tiny white jade birds bearing a small silver rosette on their backs,

[44] Archives, *Chinese Art Society of America, XIII (1959), p. 89*

[45] *Desmond Gure, "Some Unusual Early Jades and Their Dating,"* Transactions of the Oriental Ceramic Society, *33 (1960–2), p. 51;* Catalogue of an Exhibition of the Arts of the T'ang Dynasty, *Oriental Ceramic Society, London, 1955, Plates 2(b) and 17(b);* Los Angeles County Museum, The Art of the T'ang Dynasty, *Exhibition Catalogue, No. 292 (1957);* Venice, International Exhibition of Chinese Art, *Catalogue, No. 222, 1954*

which may have been enamelled. From the beak of each bird hangs a small silver chain to which silver bird-shaped pendants and an enamelled silver oval pendant at the end are attached. Some of the blue enamel remains, but the insets of original kingfisher feathers, traces of which remained at the time of purchase, have since been lost. (See "Jewelry.")

The other object (Plate 39) is a white jade earring, carved in the form of a fish, with incised lines to indicate fins and gills. The fish is partly covered by silver gilt decoration suggesting a head and eye and wavy lines, probably suggesting water.

Flat plaques used as handles for jade combs are known with incised decorations such as apsaras. One of mother-of-pearl and another of a much decomposed whitish jade attributed to the T'ang Dynasty appeared at Sotheby's (London auction) in 1950.[46] Such a mother-of-pearl comb head, with carved animal decoration is illustrated from the author's collection (Plate 49).

While the usual *caveat* must be repeated—that the exact attribution of carved jades is most difficult and, generally speaking, still tentative—the author concludes that certain objects in his collection can be cautiously attributed to the T'ang period. It is possible, nevertheless, that these articles may be of Sung derivation although there is reasonable evidence to support T'ang or Sung, and one or two pieces may be later. These include a yellow jade sheep with two lambs, a pair of jade sword ornaments (one of which could be earlier), a yellow jade girdle hook and a beige brown jade disk. There is also a yellow and brown jade circle with an open center, the surface bearing the cowrie shell decoration.

To the interested collector, there is much curiosity about the continuing and controlled excavation of ancient tombs, including those of the T'ang, by scientists working for the Chinese Communist Government. Some of these excavations are at T'ang sites such as Ch'ang-an, and reports are eagerly awaited in the art world. Recently the tomb of a slain young T'ang princess was excavated. Magnificent murals, a stunning stone lion head, a gilded sword hilt, as well as burial figures were found. So far as reported, no jades were discovered.[47]

That the future will reveal datable T'ang jades can hardly be doubted. The eager collector and specialist hopes these revelations will occur in his time!

Let me emphasize once more that all attributions of jades must be tentative— and highly argumentative!

[46] *Gure,* op. cit., *p. 55*
[47] *Chu Chang-Chao,* "China Unearths Its Greatest Wall Paintings," Art News, *62 (September 1963), p. 31 et. seq.* See also Art News *(May 1962), p. 25 et. seq.*

V

GLASS

A FEW INTERESTING PIECES OF GLASS, ASSUMED TO BE OF THE T'ANG DYNASTY, HAVE
been found, and in the "T'ao Shou" we read: "During the T'ang dynasty, cups
were made of ruddy gold, white jade, engraved silver, rock crystal and glass, beau-
tifully carved and designed for drinking wine."

Glass objects were probably first imported from abroad, and thereafter, in all
probability, made by foreign craftsmen. Carved rock crystal objects have been
found in Persia, of much earlier times.

T'ang glass was known as *Po-li* (transparent, colorless) or *Liu-li* (colored, opaque
or dully translucent).

"Though *liu-li* was primarily an ornamental glass, often molded or sculp-
tured, and applied (as the T'ang poets tell) to every sort of rich object, *po-li* was
most commonly the material of blown vessels—cups, pots, dishes, and the like.
Many of the latter, possibly Chinese, possibly Western, are displayed in the
Shōsō-in, and kept in private and public collections in all parts of the world. To
list only a few, there are dark green fish-pendants with eyes, mouth, and gills in
gold, possibly imitations of the tallies of T'ang officials; a shallow green cup,
with wavy edge;a shallow brownish dish with a foot; pieces for the 'double six'
game, yellow, indigo, green, and pale green; a four-lobed red-brown pedestal
cup with 'raised floral design and scrolls . . . derived from Sāssānian silver work';

a greenish white bracelet in the form of two confronting dragon heads holding a pearl, and another, amber-colored with red-brown stripes, also shaped as two facing dragons. Possibly the pendants and bracelets would have been described in T'ang as made of *liu-li;* that is, perhaps *liu-li* meant simply glass worked like stone. (Could it also refer to carved rock crystal — Author.)

"T'ang and Sung specimens of glass are still quite rare and difficult to date except by their general shape and type of decoration, as well as by the tomb, or other place where they were found."[48] Some glass objects, including small figurines (some of which are Buddhistic), are engraved rather than moulded. These show some affinity to Persian motifs and suggest a T'ang date. One such figurine is illustrated in this collection. Once attributed to Han, the shape of the figure and garment strongly suggest T'ang workmanship. Illustrated in this collection is a T'ang sword guard which is quite similar in shape and style to two T'ang jade sword guards (Plate 33). A Syro-Roman glass beaker (c. A.D. 100) in the Scott collection is of the same shape and style as the silver cup illustrated as exhibiting Roman influence. It likewise resembles closely the ceramic cup of whiteware. (Illus. 64)

Several lovely glass bracelets of the period are known. One was exhibited in Venice in the T'ang Exhibition of 1954 and another of similar quality is in the Scott collection.

Their wooden artifacts, musical instruments and furniture included: purple sandalwood, pawlonia, bamboo, yellow sandalwood, rosewood and ebony, some native and some imported from southern lands.

All the arts of the T'ang bear the imprimatur of one of the most spirited and cultured ages ever enjoyed by man, a plateau of human experience which continues to influence our times, as it will leave its mark in the future. Even today islanders in the South Pacific still refer to China as "The People of T'ang."[49]

[48] *Burling,* op. cit., *p. 172; See also* Exhibition of East Asiatic Glass, *Toledo Museum of Art, October 1948 Introduction*

[49] *Silcock,* op. cit., *p. 165*

VI

JEWELRY

SILVER AND GOLD JEWELRY DESIGNS WERE OFTEN BORROWED FROM PERSIAN AND Indian work, which the Chinese nevertheless fashioned with an unmistakably Chinese touch. These designs, therefore, often represented a combination of foreign influence and traditional Chinese shapes. During T'ang there were also a large number of innovations, which in turn were to influence the work of the Sung and later artists.

Most of the jewelry of the period was in the form of headdress, hair ornaments and earrings. We find some of these adornments worn by ladies in the T'ang paintings. A lady of the court, wearing a handsome hairdressing, is in a painting dated A.D. 897.[50]

Haircombs, often of bone or wood, were worn in China at least two thousand years before the T'ang. The T'ang combs used these materials as well as gold and silver (usually segmental sheets) in which wooden or bone teeth were often set. Such combs were also made of other materials, such as jade and agate. This collection exhibits a comb head of skillfully carved mother-of-pearl (Plate 40).

During the Han period hairpins of ancient heritage were made in a simple U-

[50] *Gyllensvärd, op. cit., pp. 48, 90; Paul Pelliot*, Les Grottes de Touen-houana; peintures et sculptures buddhiques des époques des Wei, des T'ang et des Sung *(Paris: Libraire P. Geuthner, 1914–24), pp. 1–6; Osvald Sirén*, Chinese Paintings: Leading Masters and Principles *(New York: Ronald Press, 1956–8), p. 71*

shape. The plain T'ang hairpins had a straight or slightly rounded top accentuated by its triangular sectional shape, a top divided into two concave parts, or U-shaped *(tsan)* with the top or upper third covered by a complicated filigree work, often combined with granulation of turquoise inset.

Carried over from earlier styles is a form of hair ornament with slender stems of silver or gold at the top of which or depending from it are ornaments of precious metals or precious stones. This type of hairpin *(pu yao)* must have given a pleasing aspect as it moved gracefully whenever the wearer was in motion. In the Scott collection is a small hairpin once inlaid with real kingfisher feathers on a forked silver stem from which hang two silver chains bearing tiny jade birds with silver rosettes and silver leaves on their backs (Plate 46).

A more common type is a bird standing as a small tiara with outspread tail, surrounded by palmette scrolls. Many of these bird ornaments were decorated with turquoise insets. Another *pu yao* type is a palmette scroll from which eleven pendants hang.[51]

While the hairpins described above reached their peak of popularity in Middle T'ang, another type came to light in excavations in Hsi-an and are more typical of Late T'ang taste. These are long-tongued, with broad flat tops, and richly adorned in open-work with floral scrolls of various kinds and birds. Sometimes the birds can be identified as the phoenix or the mandarin duck. The chrysanthemum appears to be the flower most favored. The transition between the gold-decorated head and the parallel silver pins is marked by spathe leaves, a repetition of an Indian motif, or, as in a pair in the Scott collection, by dragon heads (Plate 48). The scrolls are complicated in design with several small spiral hooks.

There is some evidence of a decline in technical ability in metalworking in Late T'ang. These big hairpins, for example, while quite dramatic, demonstrate how ornamentation sometimes tends to be so dominant as to get out of hand.[52] It seems odd that the gorgeously wrought and artistically decorated dresshooks of earlier dynasties (especially Huai and Han) do not appear during T'ang. There had been marked changes in clothing styles and leather girdles had become common to retain the inner robe—often worn partly covered by an outer cloak. These leather girdles were often decorated with ornamental plaques of silver, gilt bronze, glass (!), jade or other stones. Bronze or silver buckles dating back to the Han period survive and some in precisely the same form as modern buckles.

These plaques were most often square or rectangular and the patterns, particularly the jade ones, indicate a dating in Early T'ang, or perhaps even Suei. In the

[51] *Gyllensvärd,* op. cit., *pp. 48–49; Gyllensvärd,* Carl Kempe Collection, op. cit., *pp. 26, 35 & 36*
[52] *Gyllensvärd,* op. cit., *pp. 193–195; See also note 00*

author's collection is a square jade belt plaque (Plate 32) decorated with a female figure. The dimensions and the spacing of the four groups of double holes on the back correspond exactly with certain finds dating to T'ang burials.[53]

Possibly due to their fragility the number of earrings which have survived are not numerous. Generally they appear to have been soldered on to a gold, silver or gilded pin. Some have gold or silver petals or design, upon which pearls or precious stones were affixed. It is possible that glass ornaments were also used. In the Scott collection is an exquisite little earring: a golden bat of thin gold conveying the concept of happiness (the word "fu" means both "bat" and "happiness") on which is set a single pearl. The attached pin is gold, bent to fit around and behind the ear (Plate 45). Earrings in the Kempe Collection include two in differing designs, one in beaten gold and one in flat, scalloped beaten silver.[54]

Bracelets are often noted on Buddhist divinities but do not appear to have been affected generally by the T'ang people, although a few bracelets survive in silver, gold and glass. Some of the twisted white jade bracelets usually attributed to Sung may also be early enough for inclusion within the time of the T'ang. The same is true of finger rings.

Bracelets of plain or twisted open circles of silver, as well as a few open silver bracelets with tapering open ends wrapped with narrow bands or thongs, have been found. They are also known in Sassanian silver work.

A bracelet in the Kempe collection is of beaten silver—a partial circle, hammered wires form loops around each open end. Another bracelet in the Kempe collection in nearly the same form is of beaten gold and decorated in two confronting panels. In one panel is a walking Ch'i-lin and a bird in flight and in the other a lotus scroll. The pattern is chased on a ground with regular ring matting.[55]

Long pendants were sometimes worn suspended from the belt in front or at the sides (a style which became popular in much later revivals of ancient styles). They were worn by both men and women and some of them may have been similar to the belt plaques.

As has been noted, jewelry was sometimes based on earlier forms but was usually more purely Chinese in derivation and development than the gold and silver bowls and boxes.

In addition to jewelry, the busy goldsmiths and silversmiths, Persians, and other foreign craftsmen or native Chinese, supplied varied accessories for ladies to use—and gentlemen to buy.

[53] Transactions of Oriental Ceramic Society, *London (1953–4), pp. 23–35, plates 1a, & 1b;* Catalogue, *Exhibition of Chinese Art, Venice (1954), figure 250 (glass)*

[54] *Gyllensvärd,* op. cit., *p. 8; Gyllensvärd,* Carl Kempe Collection, op. cit., *p. 104, plates 49, 119, 58, 245 & 166*

[55] *Gyllensvärd,* op. cit., *p. 81; Gyllensvärd,* Carl Kempe Collection, op. cit., *p. 198, plates 44a & 100*

These included beautifully wrought and decorated small boxes for cosmetics, or to hold knicknacks. Some were round, others square, lobed, or shaped in such forms as hinged clam shells.

There were also silver scissors, sometimes with long earpicks, thoughtfully attached by a chain. There were also larger boxes, perhaps to hold jewelry, possibly to contain sweetmeats.

In many ways, at least among the well-favored, the world of the T'ang was a woman's world.

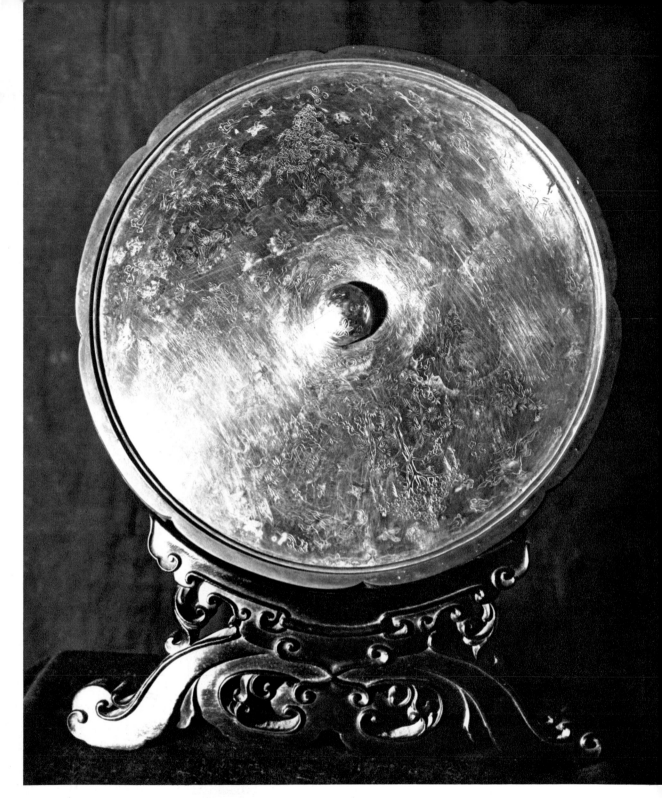

1. LARGE GOLD AND SILVER MIRROR
Diameter: 10 inches, Height with stand: 13 inches

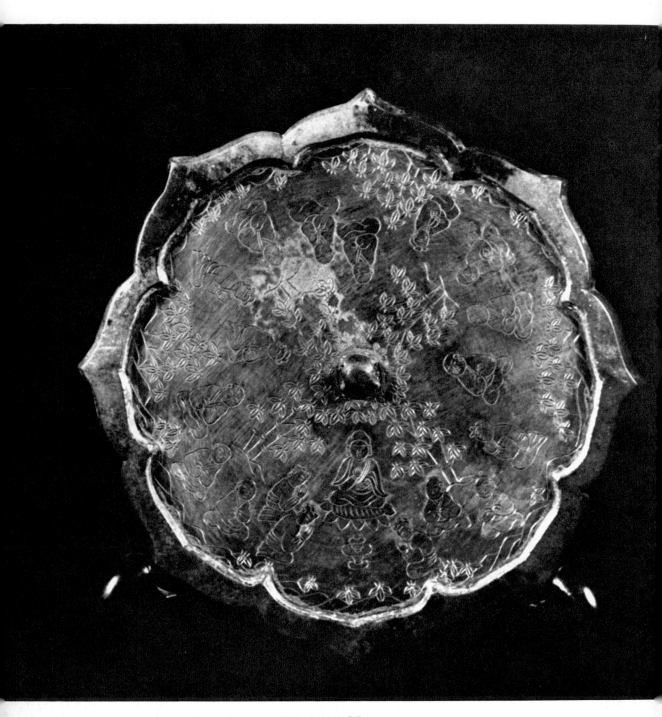

2. SILVER AND GOLD MIRROR
Diameter 9 3/4 inches ;

3. SILVER STEM CUP
Height: 2 inches
Diameter: 3-1/4 inches

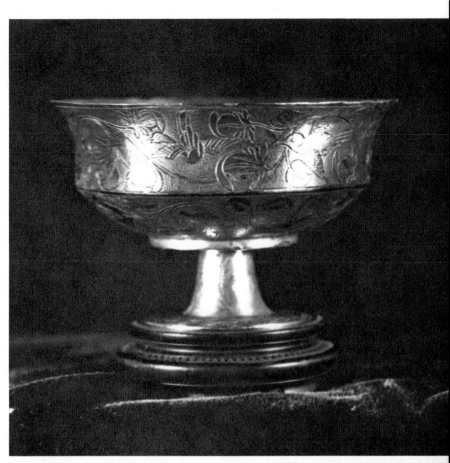

4. PAIR OF SILVER BOWLS
Height: 2 1/4 inches
Diameter: 5-1/4 inches

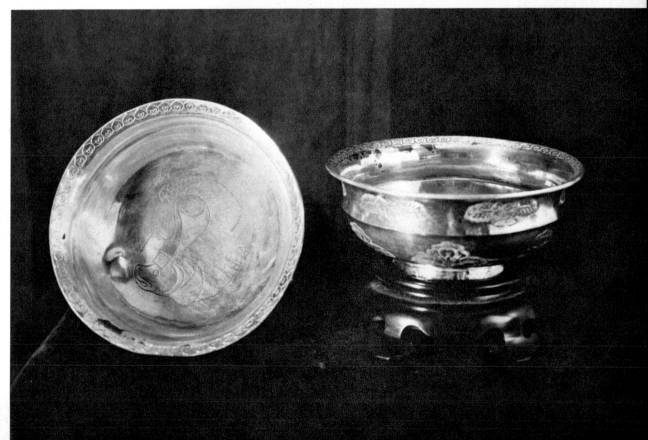

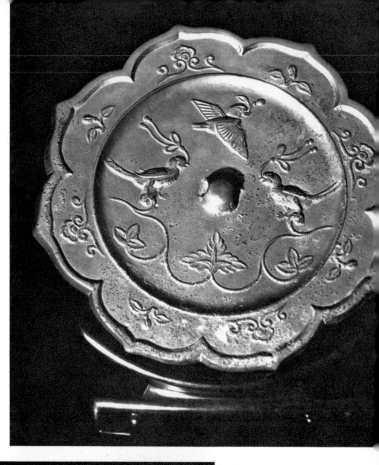

5. "WHITE BRONZE"
MIRROR
Diameter: 7 1/2 inches

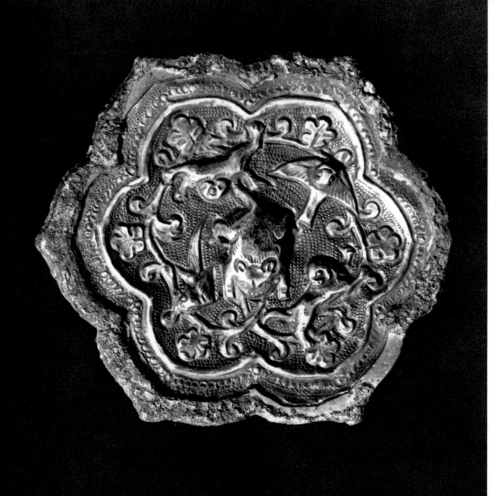

6. SILVER MIRROR
Diameter: 6 5/8 inches

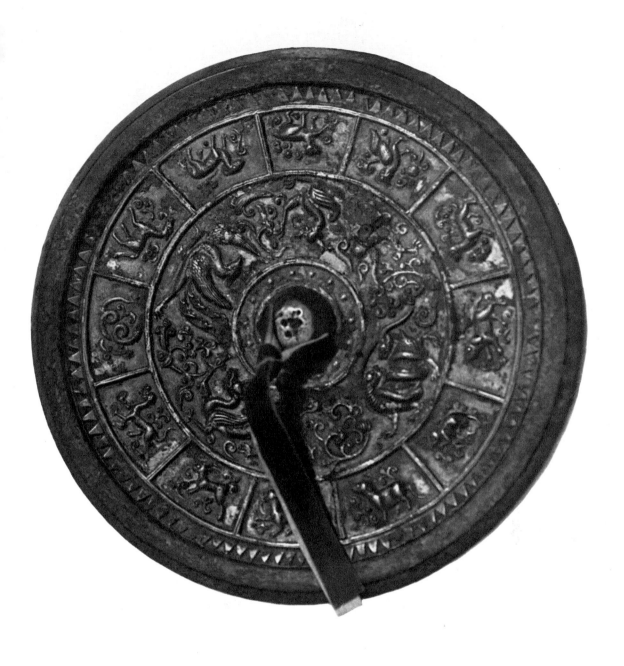

7. GOLD AND SILVER MIRROR
Diameter: 7 inches

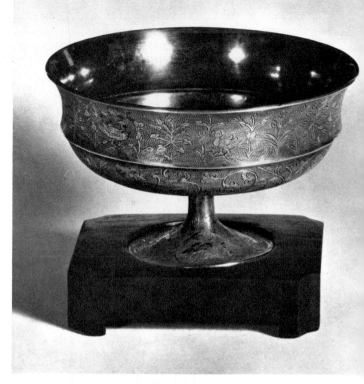

8. SILVER STEM CUP
Height: 2 inches
Diameter: 3 inches

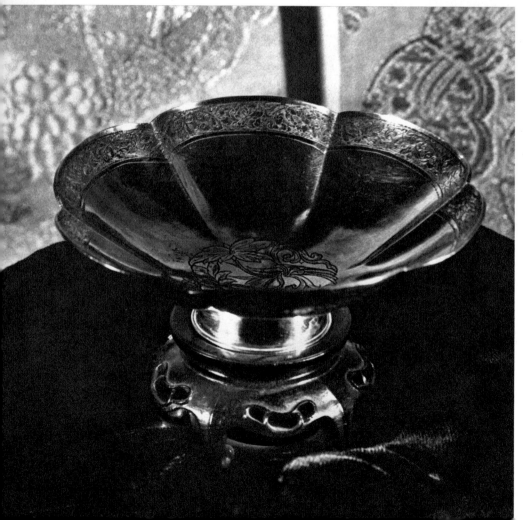

9. SILVER BOWL
Height: 1 1/2 inches
Length: 4 5/8 inches

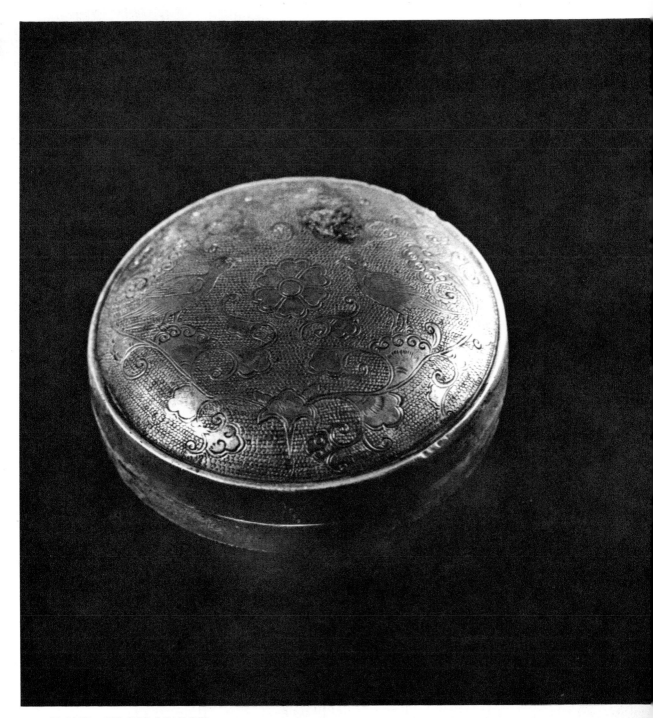

10. SMALL CIRCULAR BOX
Diameter: 2-3/16 inches

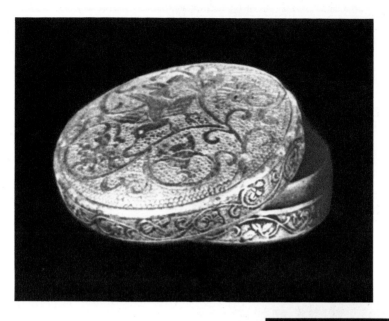

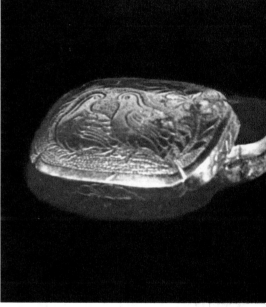

11. SILVER COSMETIC BOXES
Widths: above 1-1/4 inches.
centre: 1 3/8 inches
below: 1 1/4 inches

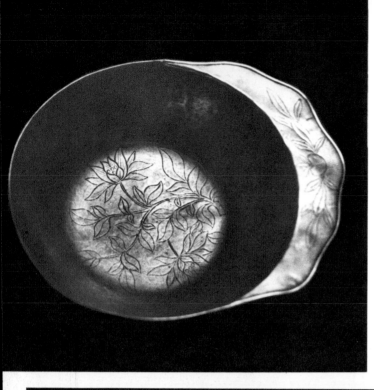

12. GOLD CUP AND PLATE
Diameter of cup: 4 1/2 inches
Diameter of plate: 6 inches
T'ANG DYNASTY (Possibly early Sung)

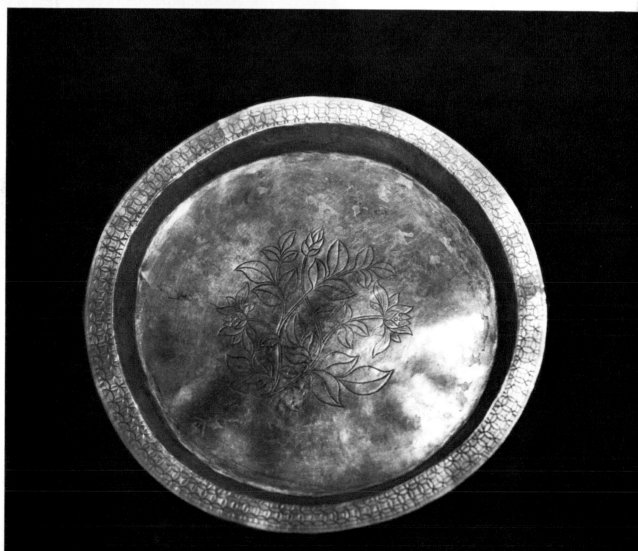

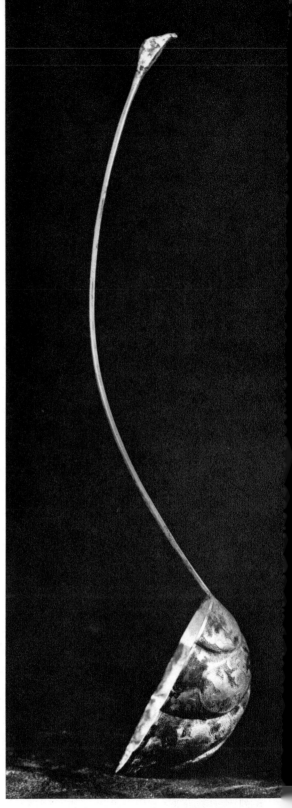

13. SILVER LADLE
DECORATED WITH GOLD
Length of ladle: 10 inches
Length of bowl: 2 7/8 inches
Width of bowl: 2 1/2 inches

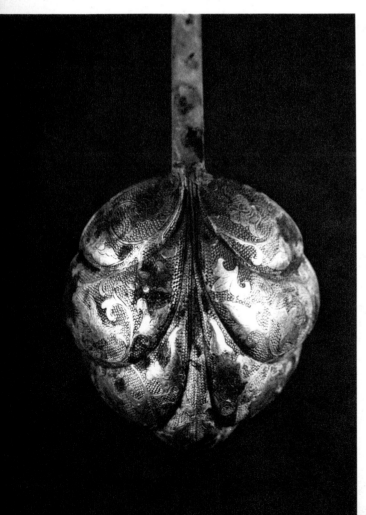

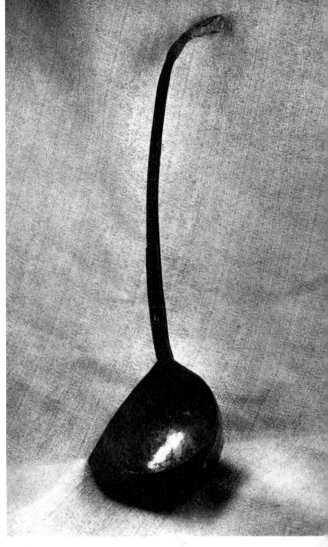

14. SILVER LADLE
Length of ladle: 13 inches
Width of bowl: 3 1/2 inches

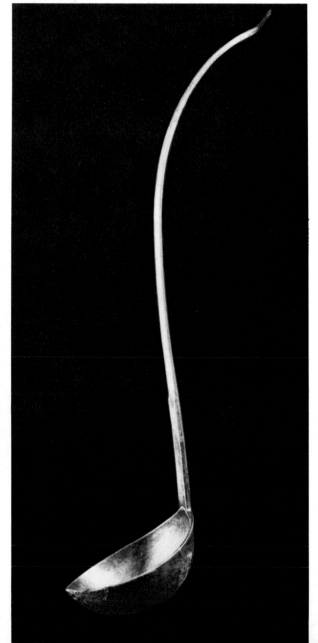

15. SILVER LADLE
Length of ladle: 11 inche
Length of bowl: 2-3/4 inches
Width of bowl: 2-3/8 inches

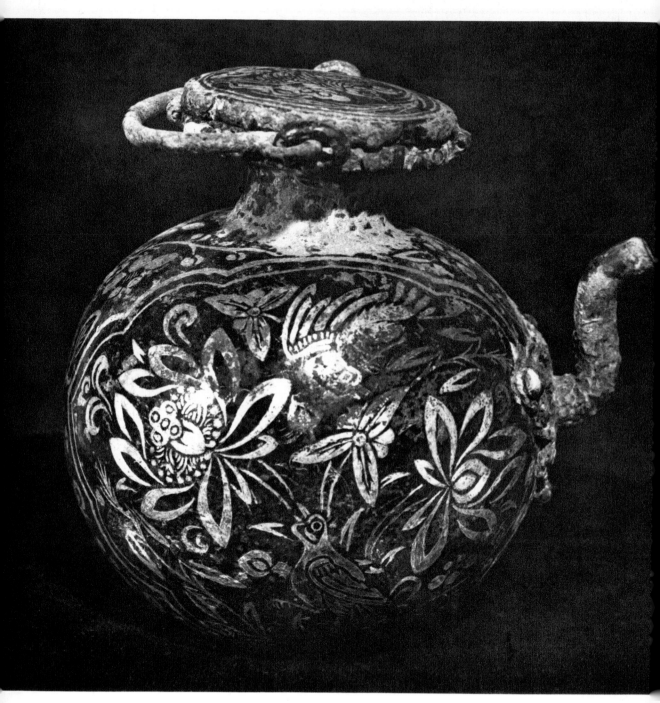

16. GOLD AND LACQUER TEAPOT
Height: 6 5/8 inches. Width: 6 inches

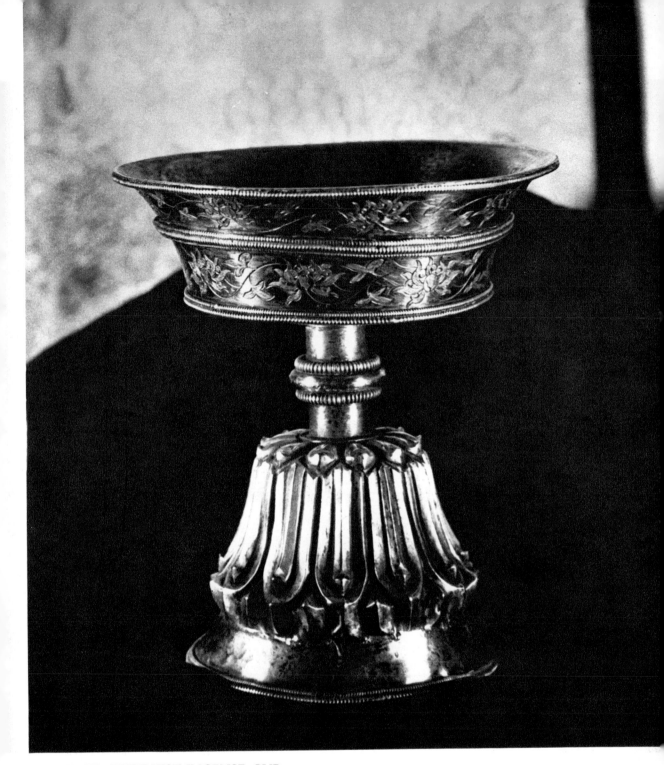

17. SILVER BUDDHIST-INCENSE CUP

Height: 4 inches
Diameter: 3 5/8 inches at rim

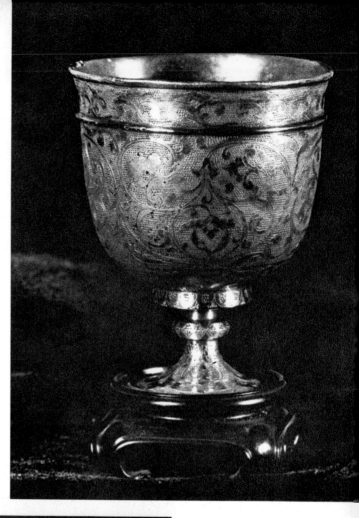

18. SILVER CUP
Height: 2 5/8 inches

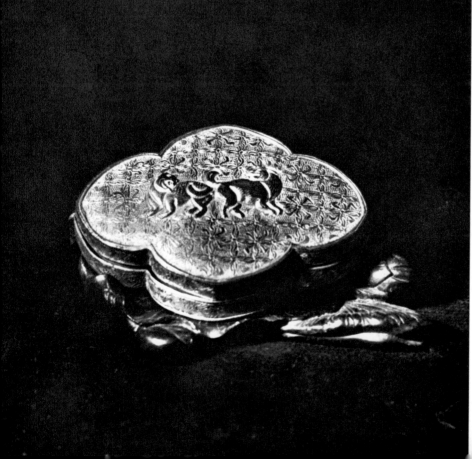

19. SILVER GILT
OVAL BOX
Height: 9/16 inch
Length: 3 inches
Width: 2 inches

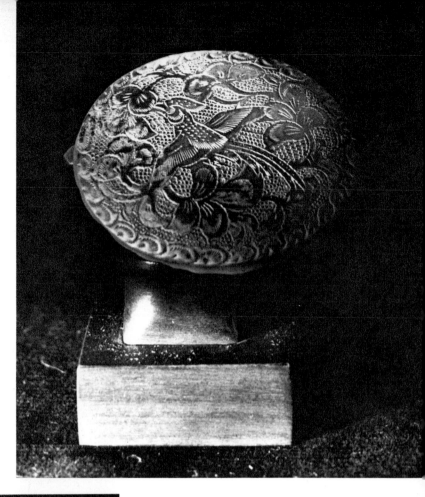

20. SILVER
"TURKS HEAD"
COVER
Width: 2 inches

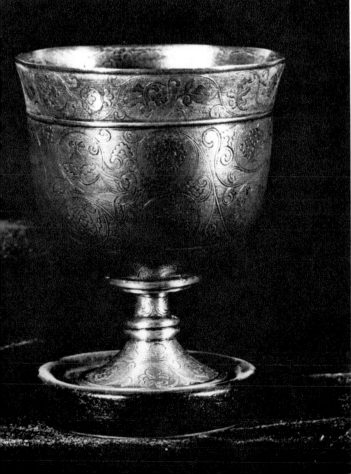

21. SILVER STEM CUP
Height: 2 5/8 inches Diameter: 2 3/16 inches

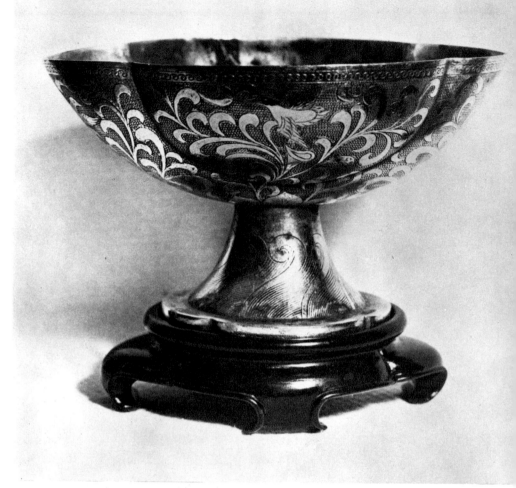

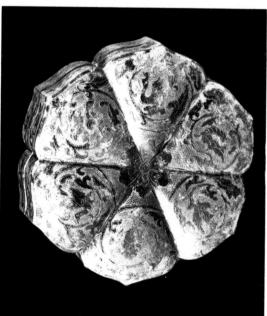

22. SASSANIAN TYPE
OVAL SHAPED TAZZA CUP
Greatest width: 5 inches
Narrowest width: 3 1/4 inches
Height: 3 1/4 inches

23. HEXAFOIL BOX
AND COVER
(Beginning of the 8th century)

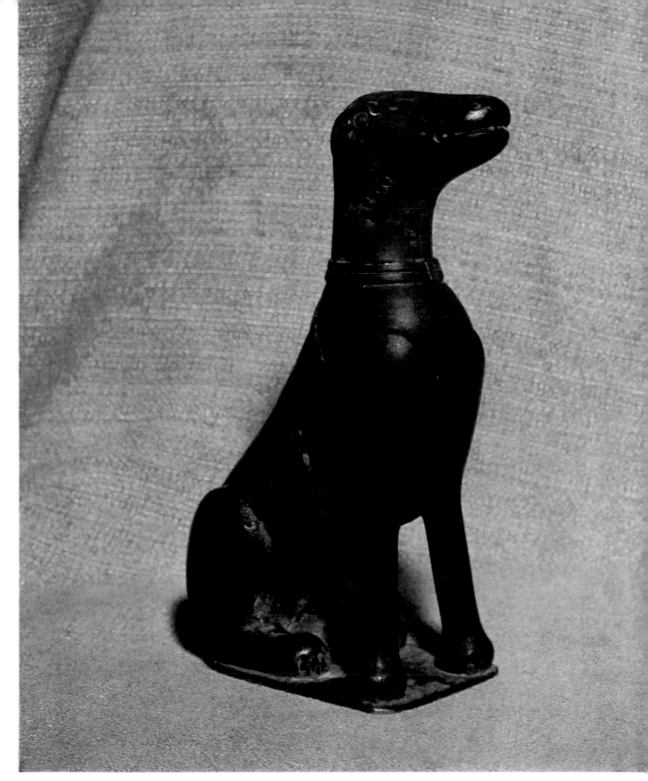

24. SILVER STATUETTE OF A DOG
Height: 5 1/4 inches

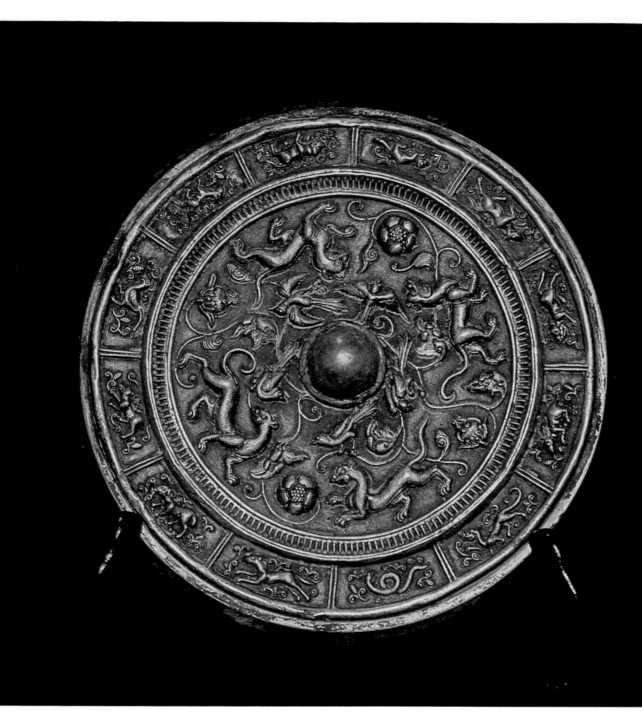

25. SILVER MIRROR
Diameter: 7 1/2 inches

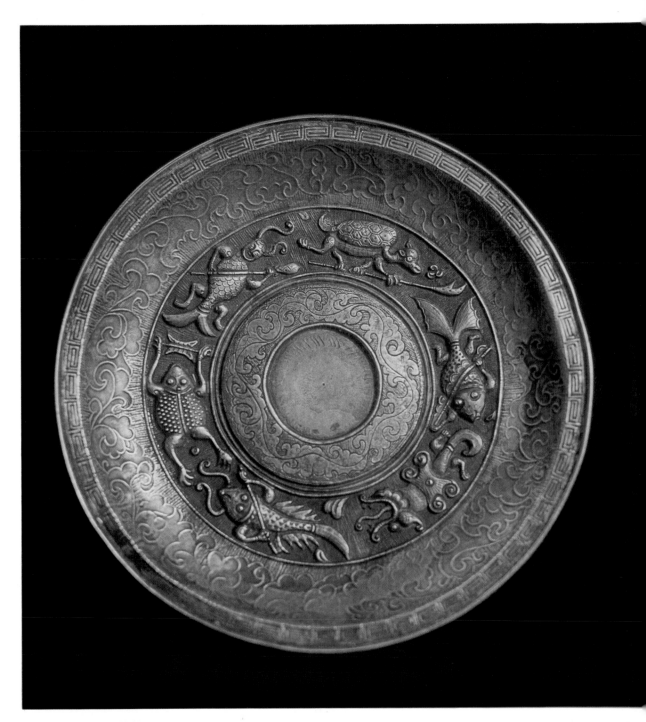

26. SILVER PLATE
Diameter: 5 1/4 inches

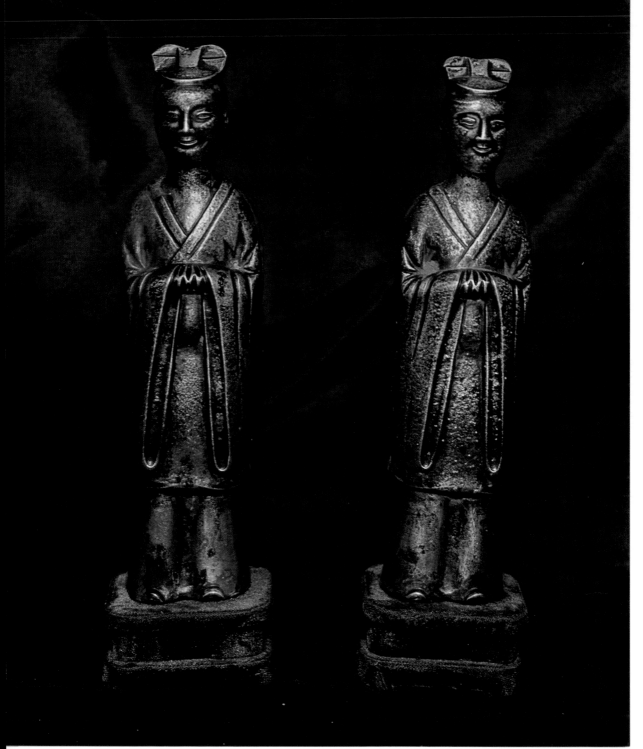

27. PAIR SILVER STATUETTES OF OFFICIALS
Height: 7 1/2 inches. SUI-T'ANG DYNASTY

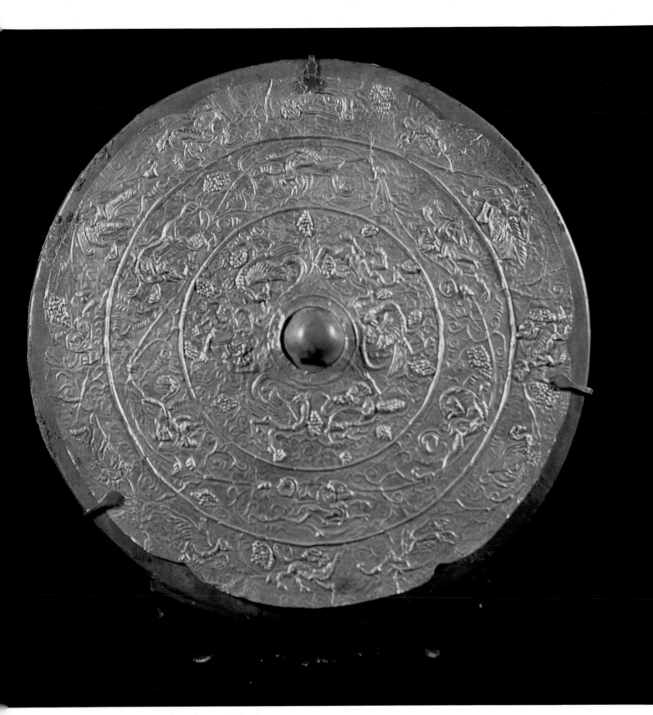

28. GOLD MIRROR (On bronze disc)
Diameter: 7 1/2 inches

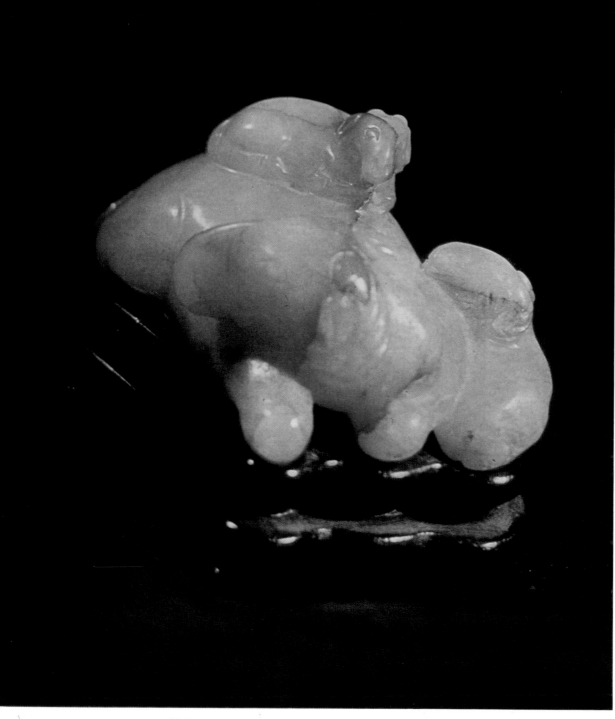

29. JADE ANIMALS

Height: 2 7/8 inches. Length: 4 1/2 inches

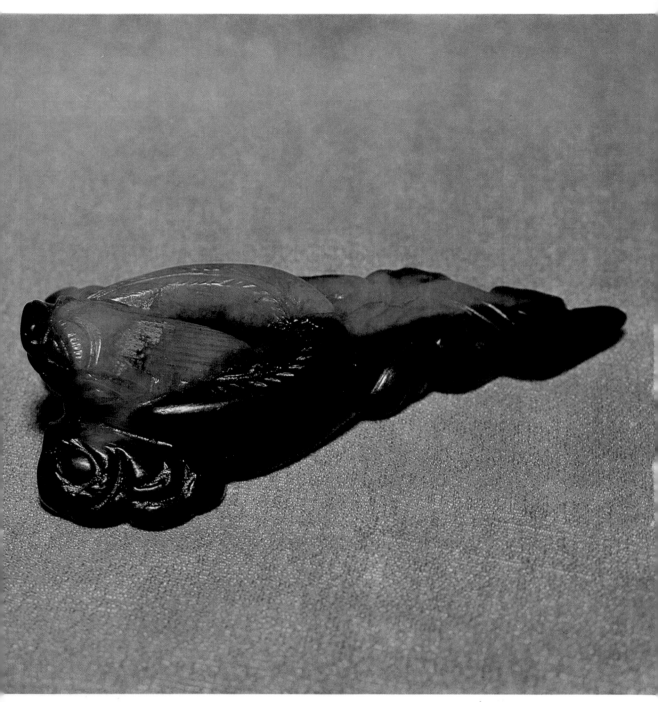

30. ANIMALISTIC JADE FIGURE
Length: 4 1/2 inches. Width: 2 inches

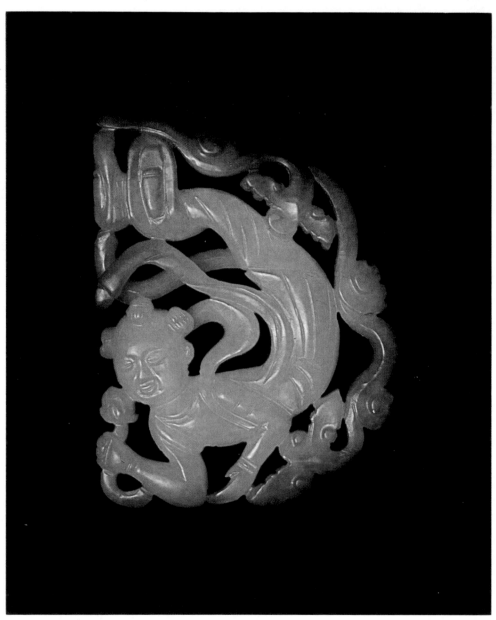

31. SUNG JADE
Length: 2 5/8 inches. Height: 2 inches. SUNG DYNASTY

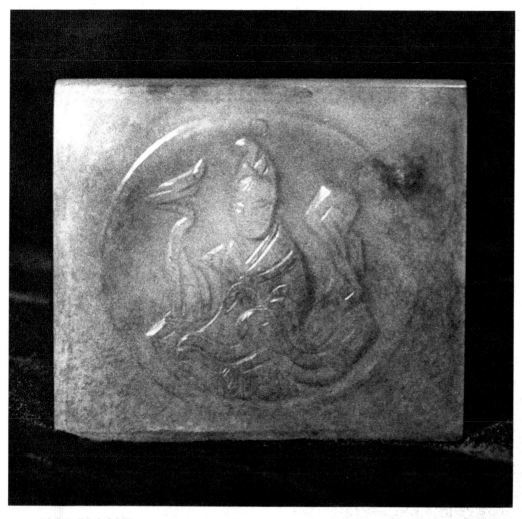

32. JADE PLAQUE

Height: 2 1/8 inches. Length: 2 1/4 inches. T'ANG or SUNG DYNASTY

33. JADE SWORD
ORNAMENTS
A. *Height: 1 1/8 inches*
Width: 2 inches
B. *Height: 1 1/4 inches*
Width 1 7/8 inches

34. JADE ORNAMENTS
A. *Length: 3 5/8 inches*
B. *Diameter: 2 inches*

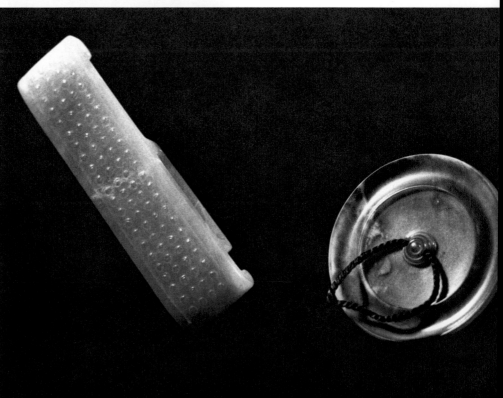

35. YELLOW JADE CIRCULAR DISK
Diameter of disk: 6-1/2 inches

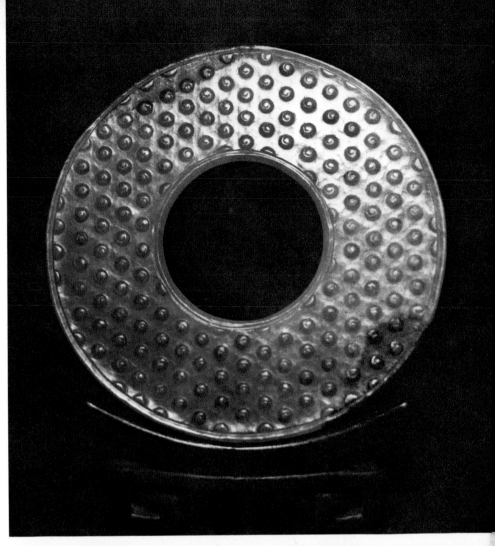

36. SMALL JADE ANIMALS
Length; 1 1/4 to 1 1/2 inches

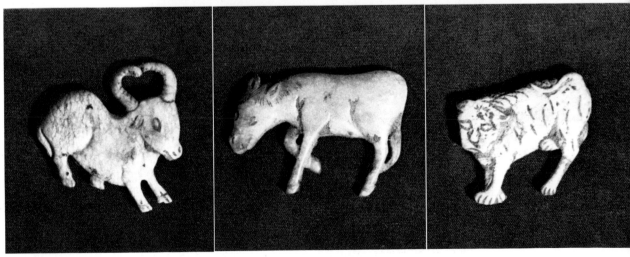

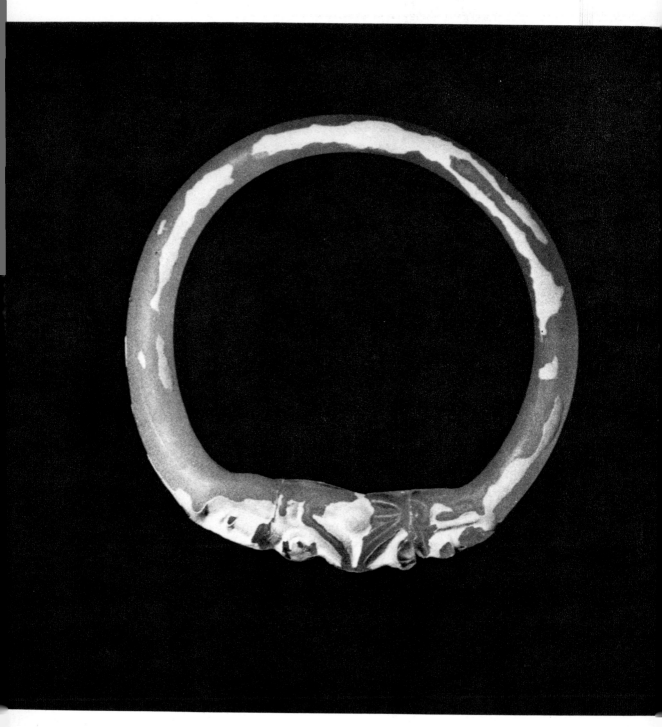

37. GLASS BRACELET
Diameter: 3 1/8 inches

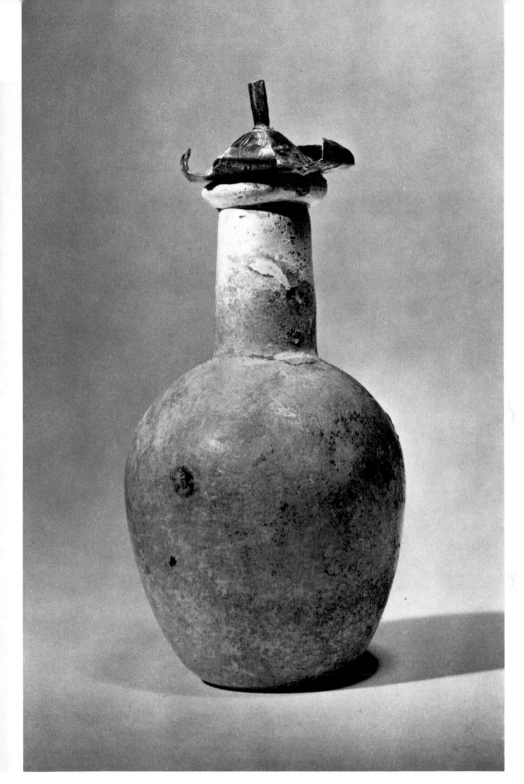

38. GLASS BOTTLE
Height: 3 1/2 inches. (Courtesy Yale University Art Gallery)

**39. SILVER GILT
AND
JADE EARRING**
Length: 2 1/4 inches

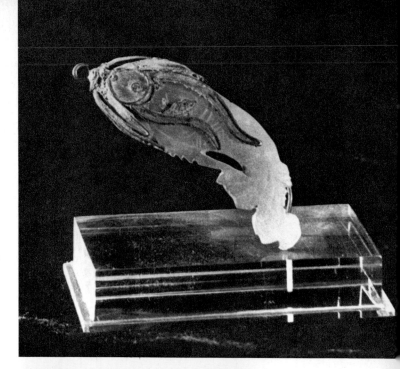

**40. GOLD AND
SILVER HAIRPIN**
A. Length: 4 3/8 inches
B. Length: 3 7/8 inches

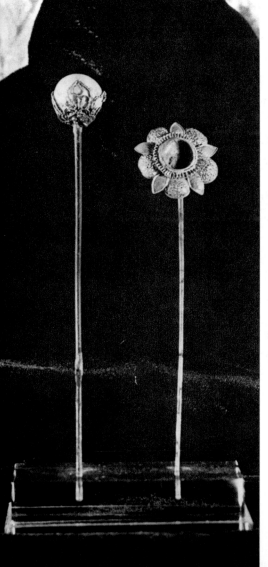

**41.
SILVER
HAIRPINS**
Length: 11 inches
Weight of both:
34.5 grams
LATE T'ANG DYNASTY
(Probably from
Si-an, Shensi)

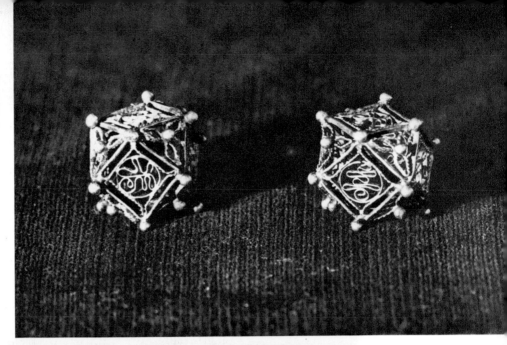

42. GOLD FILIGREE BEADS
Diameter: 1/2 inch
ᴀᴛᴇ ᴛ'ᴀɴɢ ᴏʀ ꜱᴜɴɢ ᴅʏɴᴀꜱᴛʏ

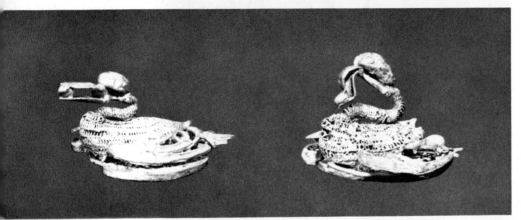

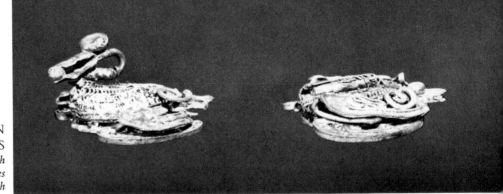

43. SMALL CROWN ORNAMENTS
Length: 1 inch
Width: 1 1/8 inches
Height: 1/2 inch

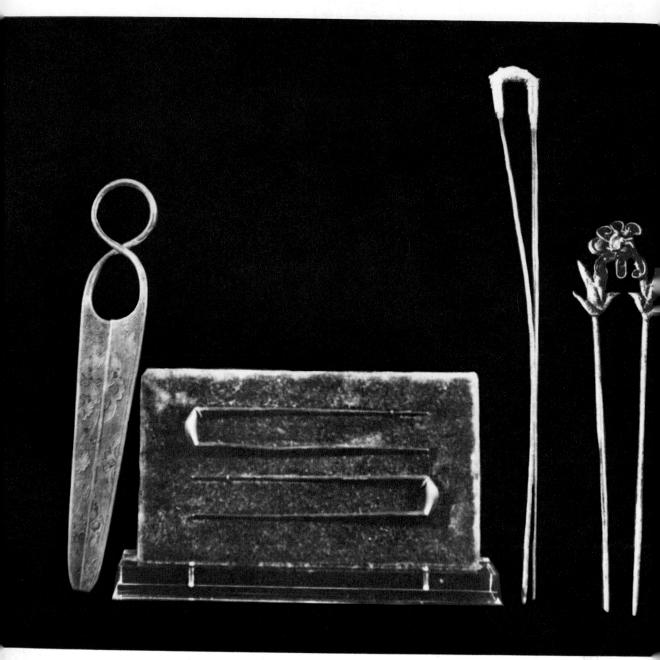

44. SILVER SCISSORS
Length: 6 inches
SILVER HAIRPINS
Length: 3 1/4 inches

SILVER AND GOLD HAIRPIN
Length: 8 1/4 inches
SILVER HAIRPIN
Length: 5 3/4 inches

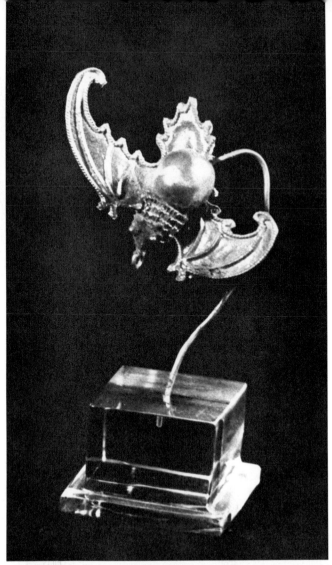

45. GOLD EARRING
Width: 1 1/4 inches
T'ANG DYNASTY
(Possibly early SUNG)

46. SILVER HAIRPIN
*Length: 6 1/4 inches (from point
of silver pin to end of pendant)*

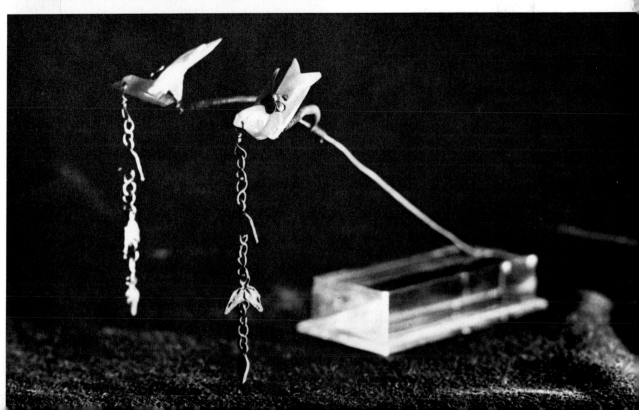

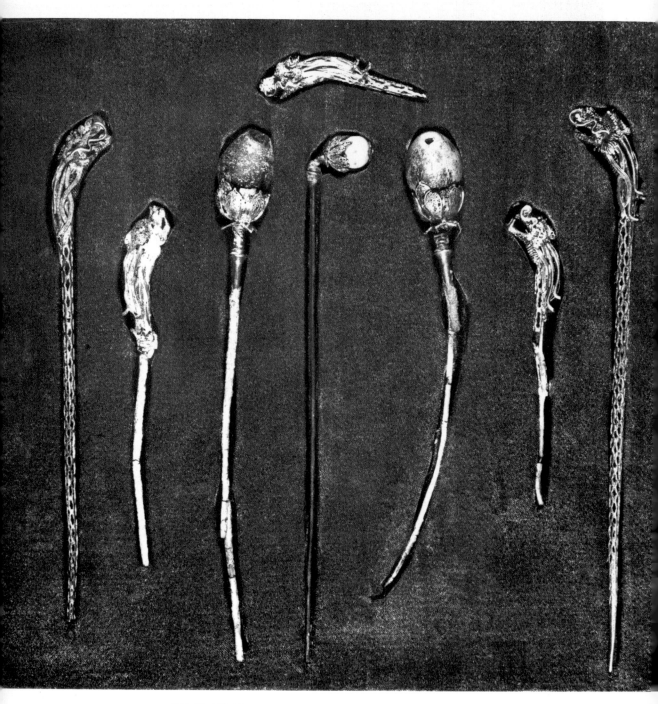

47. HAIR PINS
Length: various; longest 5 3/4 inches
SUNG DYNASTY A. D. 960-1279 (Possibly late T'ang)

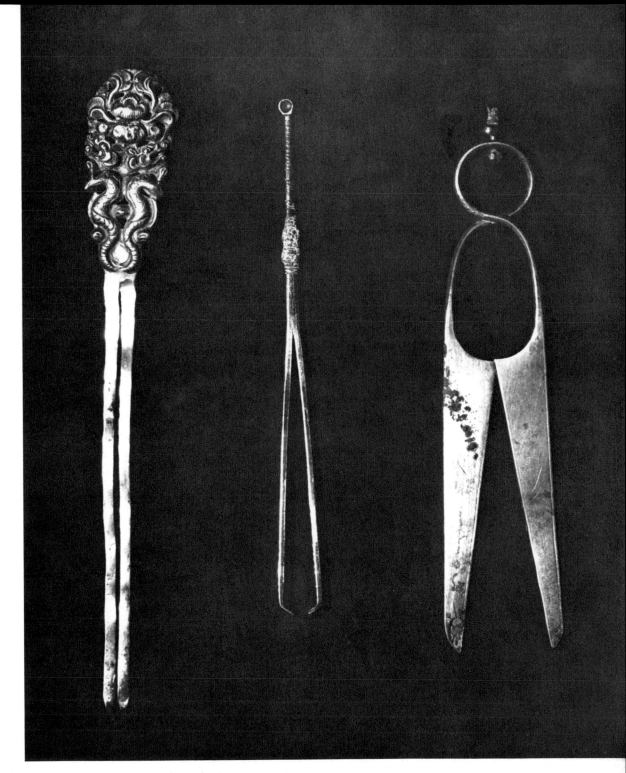

48. SILVER HAIRPIN SILVER TWEEZERS SILVER SCISSORS
Length: 7 inches *Length: 5 5/8 inches* *Length: 5 7/8 inches*

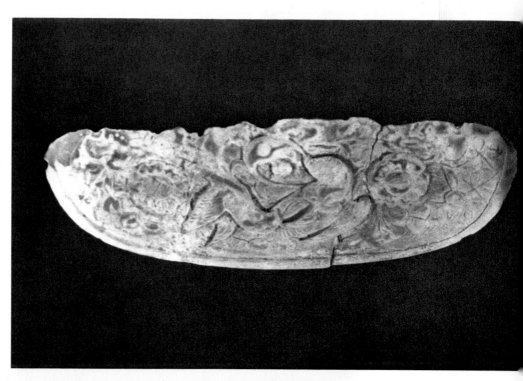

49. MOTHER-OF-
PEARL COMB
Length: 4 3/4 inches

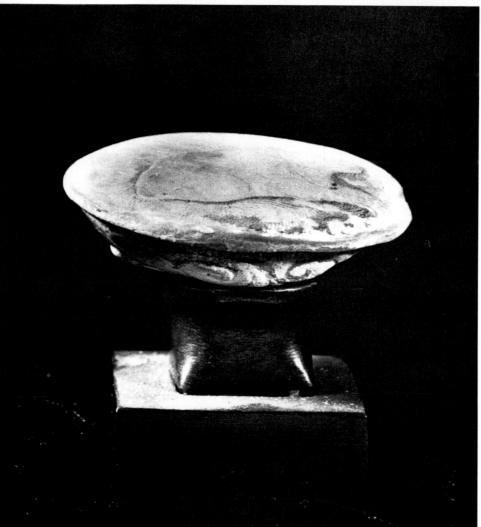

50. MOTHER-OF-
PEARL BOX
Width: 2 inches

VII

POTTERY &
PORCELAIN

EXTENDING BACK EVEN INTO PRE-HISTORY, THE CHINESE CRAFTSMAN MADE EVERY utensil he possibly could out of clay. Almost from the beginning, he also decorated each pot or vase.

The desire of the potter to imitate nature appeared early. Into the storehouse of man's culture poured the countless contributions from the Chinese to the imitation of life. Only a Chinese poet could have written: "Let neither man nor animal wandering through the forest recognize the potter's work therein arranged."

The T'ang potter was inspired but not restrained by the creations of earlier periods; he borrowed and was influenced by, but did not copy, the foreign forms which poured in by three main gateways—the merchants on the Silk Road, the warriors on the Steppes and the holy men across the sea.[56] This increasing commerce by land and sea brought in waves of Hellenistic, Persian and other influences.

The character of T'ang culture, the most brilliant in Chinese history, was thus influenced by the free intercourse of the Chinese peoples with those of other lands, and marked by a concentration of intellectual forces.

The elements of native culture included the spread of block printing, the perfecting of the examination system for the appointment of officials, increased atten-

[56] *Prodan*, The Art of the T'ang Potter op. cit., *p. 57. Willetts*, Chinese Art, *p. 479*

[77]

tion to calligraphy and the impact of Confucianism, Taoism and Buddhism upon each other. The T'ang was the golden age of poetry (this was the time of Li Po—A.D. 699–762) and the development of prose literature.[57]

It was, all in all, an exciting time in which to live, if one were poet, scholar, military leader, ruler or member of the court circles. Certainly since the middle dynasties on the Nile, history had never known such glories. It would be a long time before such an intermingling of cultures produced again these happy cultural results.

Turning to pottery, the Chinese established their supremacy in this field during the T'ang. Pottery is capable of an almost infinite variety of treatment in form and decoration. A plastic art, like sculpture, the beauty of form and the splendor of color were mastered, as nowhere else, by the Chinese potter of the T'ang.[58] More sophisticated than the heavy-necked, small-headed, red clay horses of the Wei and more naturalistic than the winged lions of the Six Dynasties, the T'ang potters had become skilled masters of their craft.[59]

> "In very broad terms, T'ang pottery is lively and robust, its shapes full and 'exploding,' its decoration bold and assertive; whereas Sung wares are ...'quieter and more contemplative' (*The Ceramic Art of China* [London, 1945])... The T'ang profile tends to divide up into distinct horizontal zones. Changes in direction are sudden. The line made by the foot-rim contrasts sharply with the curve of the body above it, shoulder and neck are no less distinctly articulated, and so are neck and mouth-rim. By comparison the Sung profile is a continuous one.... The essential practicality and strength of T'ang shape ... T'ang ware ... discloses a feeling for order—carrying with it the idea of contrast—that is missing from Sung decorative design, in which the decoration is conceived as an overall unit, its shape curvilinear and asymmetrical, and its execution calligraphic and free."[60]

Now the technique of potting had improved and the T'ang wares are usually whiter in body and varying from soft to porcelanous, though some are also buff, light gray and pinkish or reddish.

The most usual glaze is transparent, straw-colored and thinly applied. The familiar lead glaze evolved into a transparent, colorless one, and applied over a white

[57] *Freer Gallery of Art, Washington, D.C.,* Annotated Outlines of the History of Chinese Arts, *Outline for the Study of Far Eastern Arts, I (1962), pp. 38–40*
[58] Bernard Rackham, "Ceramics," in Fry et al., Chinese Art (London: Batsford, 1935), p. 29
[59] *Prodan,* Chinese Art, *p. 95*
[60] *Willetts,* op. cit., *pp. 425–8*

kaolin slip, it became a white glaze. Faint yellow glaze, containing a small amount of iron, also appeared at this time.[61]

William Burton in his authoritative work on the art and manufacture of porcelain, a book long out of print, says:

"The Chinese from a very early period had learned to fire their potteries at a much higher temperature than their contemporaries in the West. It is difficult for anyone but a potter of wide practical experience to realize how varied are the colors that may be obtained from one mineral oxide or compound, like oxide of iron and oxide of copper, the two prevalent minerals used in early Chinese ceramics, according to the nature of the flux or glaze, the condition of firing, and the other compounds that are used in conjunction with the pure oxide. Oxide of iron, for instance, in different states of oxidation, with different fluxes or by addition of some oxide which itself yields no color, may run through the most protean changes. It is possible to have yellow, buff, brown, drab, red, and enamel colors of many shades—all from oxide of iron. Dissolved in porcelain glazes, it may give yellows, browns, and even certain blueish, purple shades, while under certain conditions of firing it gave the famous grayish green porcelain known as celadon. In the same way oxide of copper, with a flux of glaze rich in lead, gives various shades of green, but when it is dissolved in a glaze consisting of alkaline or earthy silicates, particularly in compounds rich in soda and lime, it produces all those wonderful blue-green tints which the potter calls turquoise. On the other hand, if the green or blue glazes obtained from copper oxide are fired in a reducing atmosphere, the color changes to a marvelous red.

"The potter's art, even in those early days, was fundamentally a scientific process involving principles of chemistry, the laws of which the potters themselves could not have realized. But, being the pragmatic people they are, the Chinese soon made use of the magic results that came from their kilns; from the simple early cucumber-green glazes of the Han period they gradually developed the world's most magnificently glazed potteries and porcelains."[62]

The low-fired glaze, when blended with copper, iron and (much more rarely) cobalt as coloring agents, takes on a pleasing, colorful effect of green, brown and yellow *(san-t'sai)*, with or without the rare blue imported from the West. Sometimes the colors overlap. Some objects were colored in monochrome or in two-color glaze.[63]

[61] *Warren Earle Cox*, The Book of Pottery and Porcelain *(New York: L. Lee and Shepard Co., 1944)*, I, 106. Sekai Toji Zenshu, Catalogue of the World's Ceramics *(Tokyo: Kawade Shobo, 1956), IX, 1–2*

[62] *Dagny Carter (Olsen)*, Four Thousand Years of China's Art *(New York: Ronald Press Co., 1948)*, pp. 198–200

[63] *Sekai Toji Zenshu, op. cit., IX, 2; Swann, op. cit., pp. 112–3*

I have had a special affinity for ceramics decorated in the rich rare blue color, appearing alone as on two miniature horses, or in combination with the more usual *san-t'sai* (three color) glazes, as on some plates, vases, and on a pair of camels. The Scott collection contains twenty-two objects showing the blue glaze, a substantial number for a private collection.

Many splashed, dripped and running effects were used, perhaps unintentionally in the earlier instances. The glazes were kept under control by the use of incised outlines, as shown on a lovely green and yellow "bird picture" ceramic pillow, probably of the Liao Dynasty, in the Scott collection. But, generally speaking, on the bowls and vases, the glazes stop short of the base of the vessel.

It is typical of the T'ang foot that it was flat-bottomed and bevelled before firing, but some T'ang wares have simple foot-rims.[64]

The patterns for the plates, bowls, jugs, etc. were often cut out in the clay. They included, besides flowers and garlands of lotus and leaves, rosettes, cloud shapes, flying birds, dragons and even mice. Sometimes there are designs similar to those on the silverwork.

In the T'ang graves literally thousands of funerary figures of humans, animals, birds and countless dishes and bowls have been found. Some of the figures are small, but others are three or more feet high. There are also plain unglazed tomb figures, often colorfully pigmented. These figures included horses, camels, barnyard animals, earth spirits and tomb guardians *(Lokapala),* court officials, ladies of the court, acrobats, boxers, lady polo players, grooms and other attendants. Many of the figures were of Turkic, Persian or Mongolian origin and included Christian missionaries and Jewish merchants.

People often went to a great deal of expense to make these tomb offerings. There was a regular protocol for the number and height of the figures that might accompany a prince, minister or official into the next world. This resulted from an Imperial Edict. Most of the figures were made from moulds and there are references to statuettes and pots, evidently in large numbers, in the stocks of the "Imperial Department of Model Makers"[65] (Plates 66, 69, 70, 73, 75, 84, 87, 88).

T'ang wares were produced at numerous kiln sites and differed widely in color, form and decoration. The brownish-yellow, grayish-green or olive green *yueh* ware continued into T'ang and later.

A high-fired white porcelain, resulting from the use of the white clay kaolin (named for the place of its discovery), developed from the vitreous, transparent glaze of greenish tint of the Sui and Early T'ang into the pure white one without a bit of green tinge. The fine crackle in the glaze, which had been unavoidable in the

[64] *Cox,* op. cit., I, 107
[65] *Speiser,* op. cit., p. 145; *Prodan,* Art of the T'ang Potter, pp. 65–6

earlier periods, now disappeared. The result was a warm, soft creamy white, which may be best described as "elegant warmth."[66] This was the famous "white as snow" Hsing Chou Yao ware. Yueh Chou was near Hangchow in Chekiang province and Hsing Chou was in the southern part of the same province. Yueh Yao was said to be valued because it made the tea look green, and Hsing Yao because it made the tea look red, being white itself.[67]

The creation of pure porcelain around the end of the ninth and the beginning of the tenth century was the crowning achievement of the T'ang potter. This was made possible only after long-continued experimentation in high firing techniques. The author has been able to acquire an unusually representative collection of "T'ang whites." Until recently the high quality of this ware and the extent of its influence upon the Sung monochromes was not fully appreciated. The best known earlier collections of T'ang ceramics rarely gave this beautiful porcelain its proper due. The first really extensive exhibit of this ware was held at the Museé Guimet in Paris only a few years ago.

Marbleized or "marble-cake" ware was made by mixing light and dark clays together. Some of these were left unglazed and others, when glazed, were extremely attractive. Later, circles or rings were used to vary the design.[68]

"Contrasting elements, displayed by T'ang shapes, are no less observable in their decoration . . . decoration played a subdued role in the Sung tradition. Whereas, T'ang pottery, and especially T'ang earthenware, presents bold designs, often rendered in vivid colors which were applied as strongly contrasted patches. As with shape, unity is brought about by combining distinct, although structurally independent, parts to form an organic whole." (See, for example, the 'butter-pat' type of applied mold, which gets its effect in much this way.)"[69]

It would be difficult to find any culture appearing in the years following this Dynasty which did not owe some of its form, its spirit or its decor to the deathless skill of the unknown T'ang potters.

[66] *Sekai Toji Zenshu, op. cit., p. 2*
[67] *Cox, op. cit., p. 120*
[68] Ibid., *p. 119; Willetts, op. cit., p. 455*
[69] *Ibid., p. 428*

VIII

GILT BRONZES

THE GILDING AND SILVERING OF BRONZES BEGAN DURING THE HAN DYNASTY. SOMEtimes the foil covered the article completely and at other times formed a pattern. In many surviving examples, the gilding has disappeared in various degrees. The amusing gilt bronze bears are probably the best known and one, of a bear busily scratching its ear, is in the author's collection.

The most common gilding process for bronzes was the ancient process of gilding by fire. The demand for gilded bronzes increased enormously with the making of post-Han Buddhist statuettes.[70]

A small gilt bronze Maitreya Buddha, seated with legs pendant from a double lotus throne, is in the Scott collection. The robes fall in parallel folds over the front of the body. It is from the late sixth or early seventh century. Small "warrior guardians" in threatening poses were also known. (There is one in the Scott collection.)

Many lively gilt bronze figures of animals show the T'ang humor, taste and delight in the collection of amusing objects. These include "lion dogs," other breeds, squirrels, deer and birds.

[70] *Gyllensvärd,* Carl Kempe Collection, op. cit., *pp. 17–8.*

[83]

The author owns a lovely pair of gilt bronze ornaments with bronze plugs in the backs, indicating their use as some form of decorative appliqués. One plaque is of a stylized, streamlined duck in flight and the other is of an abstract cloud design, strongly suggesting Persian influence. Some bluish green patina remains.

Both stylistic forms are still found in Oriental objects to this day.

There is one small gilt bronze mirror with the well-known lion and grape design in the author's collection.

IX

SCULPTURE

"There is no definite line of division between the [sculptural] art of the Sui and of the T'ang period, yet a certain modification of the sculptural style gradually becomes evident—a growing dependence on Indian models . . . The waist is quite narrow and the customary crown is replaced by a high headdress whereby the figures acquire a feminine appearance, although iconographically they represent male creatures . . . The very large statues on the open terrace rising above the river at Lung-mên express in the most monumental form the religious pathos of mature T'ang art."[71]

The large stone T'ang head in the Scott collection (Plate 115) is typical of the work of this period. The raised, waved headdress, the closed lids giving the impression that the figure is looking downward, the double curves formed by brow and noseline, the full, sensuous, almost smiling mouth, and the dark granite material correspond closely with the head exhibited on Plate XIII in the MacKenzie work.[72] Corresponding details appear in the early T'ang head illustrated in Plate I of Gustav Ecke's "Throning Sakyamuni of the Early T'ang Period."[73] Later, the mouth became stern and the neck shortened and gained unattractive folds of flesh.

[71] *Osvald Sirén, "Sculpture," in Roger Eliot Fry, et al Chinese Art (London: Batsford, 1935), pp. 25–6*
[72] *Finlay MacKenzie, Chinese Art (London; Spring Books, 1961) Plate XIII*
[73] Oriental Art Magazine *(Winter 1959), Plate 1, p. 166*

"The sculptural activity of the T'ang period was by no means confined to religious subjects. A great deal of profane sculpture was also produced. . . . The restraint and serenity of the Buddhas and Bodhisattvas give way to a striving for movement and expression, the figures begin to bend, to turn on the hips, to look sideways and upwards, even to move forward, to act and look more like beings of the human world. . . [Toward the end of the Dynasty,] sculpture loses more and more of its original importance and becomes subservient to the art of painting."[74]

While during the first century of the T'ang rule Buddhist art flourished, some of the best sculpture of the T'ang dynasty was of a non-Buddhist nature. Funerary sculpture reached its highest development in technique and powerful realism.

There was some Taoist sculpture, but this consisted of smaller figures and did not have any great self-development. The Taoist immortals have always been treated in a half-humorous manner, and the stories about them are regarded as folklore.

The T'ang non-religious figures were modelled in the round. They were virile and wordly, mature and sophisticated, with little evidence of spirituality.

During T'ang, the Buddhist God of Indian origin, Avalokiteshvara, gradually assumed feminine form and became known as Kwan Yin, the Goddess of Mercy. The cult of Kwan Yin was accepted by Chinese of all faiths. Images of her began to appear in stone, wood, pottery, jade, ivory and lacquer. She is depicted standing on a rock, seated on an open lotus flower, rising from the waves or riding on a mythological animal. Although her Madonna-like aspect, with a child in her arms, is claimed to have been a later development,[75] there is in the author's collection a small pottery figure in *san-t'sai* glaze (Plate 90) of a seated mother and child, which suggests that it may be a small votive or altar figure or perhaps the personal work of a craftsman for family or friend, but this must still be accepted as my hypothesis.

"The change from the high classic to the mature classic style took place within the years A.D. 700 to 850. The terrible civil war which tore China between 755 and 763 reduced her population from fifty-three to seventeen million and shattered the civil, social and economic order, did not [appear to] affect the normal evolution of art."[76]

"There is little doubt that in the decades around A.D. 700, Chinese sculptors were possessed by a strong determination to build up their figures with sharply

[74] *Sirén, "Sculpture,"* op. cit., *p. 26*
[75] *Burling,* op. cit., *pp. 247-8*
[76] *Ludwig Bachhofer,* A Short History of Chinese Art *(London B.T. Batsford, Ltd., 1947), p. 77*

defined parts. They preferred a little rigidness to making concessions in this respect. This was their ideal of beauty and it was binding, regardless of motive and religion. Taoist sculpture abode by the same rules.... The eighth century saw the loosening of the severe tectonic system and the softening of the definite lineament. Behind it stood the wish for a more thorough integration of the parts into a whole."[77]

"The frank realism of the T'ang artists,' says Sirén, 'their love for powerful forms and muscles brought fully into play found its fullest expression in sculpturing the horse. A passion for the form of the horse ran through the whole of Chinese society of the seventh and eighth centuries.' The bas-reliefs of six chargers beloved by Tai Tsung (which have come down to our day) can be compared to the best sculpture produced in the West, not excluding the Greeks.

"In contrast to the strength and the lust for power expressed in the horse and in the sturdy warriors, we find other figures representing the exceedingly refined, leisured, upper class that remained at home and reaped the material benefits from China's far-flung imperialism. In these we see a class of Chinese who had developed the amenities of life to a degree never before known, a development that made China the most civilized land on earth for another thousand years."[78]

Animal sculpture, produced in large quantities during T'ang, is highly realistic with an emphasis on the outstanding quality of the animal concerned. Thus the wild animals tearing their prey will be carved with a savage ferocity of expression, with an accentuation of the muscles under the skin (see the pair of marble lions in the Scott collection) (Plate 118), while the domestic ox will show the placidity and soft contours of the tame household beast. The silver and ceramic watchdogs in the author's collection, by their posture and rendering, are alert and obviously ready to protect their master's possessions. At the same time many of the monumental pieces are splendid examples of sculpture on a large scale.[79]

In general, the T'ang horse (at least in the terra cottas—and in one magnificent marble head which was recently auctioned) is more robustly muscled than the great steeds of the Han or the Wei, yet less heavy than the Ming horses.[80]

A large reddish brown stone lion in the Scott collection is a fierce, hard-muscled, menacing creature and is datable between late Wei and the beginning of T'ang.

"T'ang sculptors much preferred to work in such fluid media as dry lacquer, clay, bronze or plaster, in which far greater freedom of movement and expres-

[77] Ibid., p. 75
[78] Carter, op. cit., p. 169
[79] Sir Leigh Ashton and Basil Gray, Chinese Art (New York: Beechhurst Press, 1953), pp. 109–110
[80] Grousset, op. cit., p. 211

sion was possible than in stone. But the great bronzes have all disappeared—melted down during the persecutions or lost through subsequent neglect; . . . it is Nara which today houses the finest surviving examples in the Chinese style, while some of the miniature bronzes made to stand on small altars, and some of the small gilt bronzes of animals, preserve its essentials in reduced form."[81]

There is a very interesting dated T'ang stela in the Scott collection (Plate 119). It is a gabled tablet, 4–5/8 inches high, relief-molded with a central figure of Buddha and two acolytes in an arcaded niche. Beneath them, foxes flank a brazier and on the reverse side there are twelve characters. John A. Pope, Director of the Freer Gallery, states on this particular stela, the twelve characters translate:

> "Obtaining the truth by means of the Karma of the Great T'ang and by means of this clay votive tile is as [positive a thing as] the wonderful Body of Bliss."

'To clarify this a little: "Truth" refers to the essential and ultimate truth that is the essence of Buddhism. "Karma" refers, of course, to earthly deeds; in this case, the earthly political and military activities of the T'ang Dynasty which determine its greatness. "Body of Bliss" is the second of the so-called "Three Bodies of the Buddha." These are: (1) the Body of the Law, which is the essential teaching of the Buddha, the spiritual content of the faith; (2) The Body of Bliss, which is the body of the Buddha himself, invisible to the high-level saints of the sect; and (3) the Body of Transformation, which is the body in which the Buddha can manifest himself to mankind in any way that happens to suit his immediate purpose."

More ceramics survive than sculpture, especially when we omit the massive sculptures in situ or in museums. Some small bronzes, it is true, closely follow the larger creations of the sculptor. But sculpture provides the surest insight into the religious life of the people of these times, be they Buddhist, Taoist or growingly aware of the teachings of the recent Kung-fu Tze (Confucius).

Sculpture reflected the influence of foreign lands, particularly India, but to my knowledge, no sculpture remains which can be identified as purely foreign, albeit created in China. The touch of the T'ang is always there.

[81] *Sullivan,* Chinese Art, *p. 122*

X

TEXTILES

"THE WHOLE HISTORY OF CHINA IS INTERWOVEN WITH THREADS OF SILK, AND IT IS these delicate fibers which formed China's earliest and strongest links with the outside world.

"According to tradition it was the wife of the Yellow Emperor—in the third millenium B.C.—who inaugurated the culture of the silkworm and taught the people how to spin and weave silk so that it could be made into articles of clothing. In Peking there is still a temple dedicated to her memory where every year, as had been done in similar temples for over four thousand years, the empress offered mulberry leaves at the altar and prayed for divine protection for the industry of sericulture. The silkworm became the emblem of industry, and the silk represented delicate purity and virtue."[82]

"In manufacturing silk, the filaments of silk are reeled off from two or more cocoons at the same time in order to form one continuous, regular strand—the raw silk of commerce. The natural gum is removed by soaking before the thread is wound onto spools or bobbins about four or five inches long. The strands are then twisted and scoured before spinning.

"Silk culture was the special province of women, and there is frequent reference to silk in the early Chou Dynasty writings. The last lines of a poem describing silk culture in the Chou 'Book of Poetry' run:

[82] Burling, op. cit., p. *307*

In the eighth month, they begin their spinning—
They make dark fabrics and yellow.
Our red manufacture is very brilliant,
It is for the lower robes of our young princes.[83]

"Spinning whorls of stone and pottery, similar to those in use today, were found in the course of the neolithic excavations, and textile patterns were impressed on neolithic pottery. Silk fibers were found in Shang tombs, and in tombs only a little later there were silk worms carved in jade. In the Shang dynasty clothes, cords, and pennants were made of both silk and hemp. At that time the Chinese already wore tailored clothing with sleeves and small buttons, as well as furs.

"Silk was exported to other countries which were eager to obtain this fine fabric. To the Greeks the fiber was known as *ser,* from the Chinese word 'ssû,' and they called the Chinese people the *Seres,* and the woven silk *serikon.* Thus it was as the people of silk that China was first known to the Western world.

"All the way across Asia from China to Rome the silk was carried along the caravan routes, and it was also carried in all directions by sea. The famous Silk Route was said to have been opened up late in the second century, but silk had been carried abroad long before that time.

Aristotle mentioned silk weaving in the fourth century B.C., and silk had been carried to India even earlier. It was after the opening of the Silk Route, the export trade with the West was a source of great wealth to China, and Pliny complained of its tremendous cost in Rome where it was worth its weight in gold, a fact which appears to have done little to discourage the purchasers. . .

"Of course the Chinese took precautions to guard the secret of the silk culture which had proved so profitable, and the various attempts made to steal it from them provided the plots for many tales of adventure. One of the most famous stories is about the Chinese princess who, in the first century after Christ, carried eggs of silk worm moths, hidden in her headdress, to Khotan. From there it is said that the culture of silkworms spread to India and Persia. About the third century, Japan acquired the desired knowledge through Korea.

"During the Han Dynasty the Chinese still were the only people who could weave the precious fabric, and their trade in figured silks, quilts, tapestries, and embroideries assumed tremendous proportions. In addition to silk, the caravans carried furs and spices westward, the Chinese receiving wool and cotton textiles in exchange.

"It is to China that the world owes the development of the art of using silk in

[83] *Ibid.* pp. *307–8*

[90]

weaving and embroidery. Their patterns permeated the whole of the Near East, and textile finds in Egyptian graves of the Hellenistic and Christian periods show Chinese decorative motifs.

"From the annals of the Han Dynasty and from the contemporary historical records of Ssû-ma Ch'ien we learn that it was the necessity of assuring an open passage westward for the export of silk textiles which led the Han Emperor Wu Ti, in the last quarter of the second century B.C., to seek the expansion of Chinese political and military control into Central Asia along the great caravan route in Chinese Turkestan."[84]

The earliest silk stuffs brought to the West have all perished, and we would be in the dark as to what they were like were it not for the explorations of Aurel Stein, Pelliot, Von le Coq, Kozloff and others in the buried sites of Central Asia. Even Egypt, which has provided more material for the history of early textile art than all the rest of the world, has yielded no Chinese weavings attributable to a period earlier than the thirteenth century.

"The earliest Chinese silk weavings we know were found by Sir Aurel Stein during his third Central-Asian expedition in the year 1914. They were unearthed in a cemetery site, now part of the Lop desert, in Chinese Turkestan. They were found on the route opened out for silk trade with the West by the Chinese late in the second century B.C. and finally closed early in the fourth century A.D., after losing much of its traffic by the discovery of an easier route two centuries earlier. These silk fabrics have been described in the *Burlington Magazine* (Vol. XXXVII) by the discoverer and his assistant, Mr. F. H. Andrews, who illustrated them by drawings. From considerations suggested by the site and circumstances of their discovery, Sir Aurel is inclined to place them in the first century B.C. In any case the argument that they cannot be later than the fourth century A.D. appears conclusive".[85]

This is how Sir Aurel described the excavations:

"Here rapid but systematic clearing yielded a rich antiquarian haul in quite bewildering confusion. Mixed up with detached human bones, and fragments of wooden coffins, there emerged in abundance objects of personal use, such as decorated bronze mirrors, etc . . . Chinese records on wood and paper, and above all, a wonderful variety of fabrics which even in their ragged dirt-encrusted condition delighted my eye. Among them were beautifully woven and coloured silks; torn pieces of polychrome figured fabrics, damask, tapestry and embroi-

[84] Ibid., *pp. 307–8*
[85] *A. F. Kendrick, "Textiles," Chinese Art (London: Batsford, 1935), p. 39*

dery work, all in silk; fragments of fine pile carpets, by the side of plentiful coarse materials in wool and felt."[86]

"In 1924–1925 the Kosloff expedition unearthed, in the region of Lake Baikal, many more fragments of figured silks. Further specimens of Han silks—plain and figured and embroidered—have been found in tombs in northern Mongolia, Siberia, Palmyra, Afghanistan, and the Crimea.

The high quality and complicated techniques of all these silks—which included moiré, damask, gauze, quilting, and embroidery—show the prosperity and refinement of the age and obviously are the result of a long history of development in the weaving of textiles.

"Most of these fragments date from about the first century B.C. In some cases there is a small-scale intricate design, while on others there are simply diaper patterns.[87]

"China first conceived the idea of weaving figured silk, and, about the end of the third century, the Roman monk, Dionysius Periegetes, wrote: 'The Seres make precious figured garments, resembling in color the flowers of the field, and rivalling in fineness the work of spiders.' This figured silk was called 'diaspron' or 'diaper' from the name given to it in Constantinople, but after the twelfth century when Damascus became famous for its weaving of silk, the name "damask" was given to all patterned silks, including the Chinese."

It is recorded that the Emperor Ming-ti of the Wei Dynasty presented five rolls of brocades with dragons woven on a crimson ground to the empress of Japan, who sent an embassy to the Chinese Court in 238. Throughout this era of the growth of Buddhism silk was used for religious banners and vestments.

Due to their perishability and lack of means of preservation, very few T'ang textiles survive in private collections. I know of none in the United States, other than those in my collection. Some, discovered in Tun Huang and elsewhere by Sir Aurel Stein and others, are in museums and some of similar character have been found in burials in Russia. The fruit of long search has resulted in the inclusion of five textile fragments in my collection, dating from just before to just after the beginning of T'ang. The largest of these pieces is unquestionably a fragment from the sash said to have been presented to Princess Kashiwade, wife of the Regent, Prince Shōtoko. A larger part, very probably removed from the Hōryuji Temple at Nara, is now preserved in the Tokyo National Museum. Some of those illus-

[86] *Sir Aurel Stein, "Ancient Chinese Figured Silks."* Burlington Magazine, *XXXVII, No. CCV III,* (July 1920), p. 5

[87] *Burling, op. cit., pp. 309–10; Yamada,* Decorative Arts of Japan *(Tokyo: Kodansha International Ltd., 1964), p. 208*

trated are from the treasures of the Shōsō-in at Nara. The Shōsō-in collection is by far the largest in the world and has received utmost care under the aegis of the Imperial household since its arrival from China in the eighth century. A new museum is being constructed at Nara, where, for the first time, the general public is expected to be given a less restricted view.

T'ang textiles, as we have noted, including some which show Persian and other designs for Chinese products were in great demand throughout the Mohammedan world. Fine fragments of T'ang figured silk, plain silk, embroideries, tapestries, brocades, and gauzes were excavated from various sites in Chinese Turkestan. The figured textiles include conventional floral patterns, vines, tendrils, animals, birds, and dragons. In some cases the pattern is set in circular rosettes. Similar designs appear on the T'ang examples of silks and embroideries which can be seen in the Imperial Treasury in Nara.

During the T'ang Dynasty, the textile arts reached their fullest development; the textile material was more abundant, and many important artists made designs for textiles, embroideries, and tapestries.[88]

The fiber most used for textile making in T'ang was silk, both the long filaments reeled from the cocoon of the domestic silkworm, and the short broken fibers from the cocoon of the wild silkworm which needed to be spun into thread. There were also a number of vegetable fibers from which both plain and fancy linens could be made, including ramie, kudzu, hemp, banana, and bamboo. Wool was used mostly for felt in the Far East, woolen textiles being more characteristic of the Iranian sphere of culture.

The wools of Turkestan, both eastern and western, were famous in medieval times. Woolens were familiar enough in T'ang (they are frequently mentioned in poetry), but, except for rugs and carpets, they seem not to have been imported. Indeed, there was a sort of native industry in wool which may have sufficed for the limited purposes for which the Chinese required them.

"The native T'ang woolens were almost as curious as the Tibetan: a 'woolen' fabric was made of rabbit hair at Hsuan-chou near the mouth of the Yangtze, and woolen goods of camel hair were manufactured in Kansu (Hui-chou) and the Ordos (Feng-chou)."[89]

By this time the Chinese fleets were not infrequently seen in the Persian Gulf, and the effects of trafficking with Western Asia began to show themselves. The Arab chronicler, Mas'udi, writing towards the end of this period, speaks of the unsurpassed skill of the Chinese artist. ... The affinity is obvious in many of the

[88] *Burling, op. cit., p. 310*
[89] *Schafer, op. cit., p. 198*

stuffs of T'ang times. Motives of decoration are sometimes shared with Persia and its neighbors, and it is not always the West which is the borrower. The intercourse between India and China was emphasized by the Chinese acceptance of Buddhism. Testimony to this association is borne by an embroidered silk hanging of the T'ang period in the British Museum, representing a standing figure of Buddha attended by disciples and Bodhisattvas. ... A conspicuous illustration of Chinese relations with Persia is the woven silk banner formerly in the Hōryu-ji monastery at Nara and now in the Tokyo Museum. The pattern is disposed in large circles, each containing four men on winged horses aiming arrows at lions. It is a typical Sassanian hunting-scene with the king as the hero, but the craftsman has recast it in a mould of his own. The banner is said to have been used by Prince Shōtoku (A.D. 572–623) at the conquest of Shiragi in Korea and deposited in the monastery by the Emperor Keka (A.D. 884–887).[90] Undecorated fragments from two silk banners, one yellow and one orange, are in the author's collection, (as is the fragment of a scarf reportedly presented to Prince Shōtoku's wife, as heretofore noted).

In a Sung book over fifty brocade patterns of the T'ang Dynasty which were still in use were recorded. ... There were striped and diapered designs of more simple character, groups of symbols, and combinations of Chinese written characters. The damasks and transparent gauzes were woven in similar patterns.[91]

"In 726, the king of Bukhara sent envoys to T'ang asking help against Arab raiders. These emissaries brought with them a number of valuable gifts, such as saffron and 'stone honey' and also a 'Roman embroidered carpet.' The king's wife, the 'Qatun,' sent the Chinese empress two large rugs and one 'embroidered carpet.' ... Among the 'embroidered dance mats' of Persia which arrived at the T'ang capital in 750, some were characterized as 'great hair' and 'long hair,' terms which must refer to rugs with unusually deep and thick piles. ... in T'ang times, ... felt was widely used for curtains, draperies, tents, mats, saddle covers, boots, and all sorts of coverings. Somehow it was regarded as more characteristic of the nomadic peoples, like butter, and T'ang descriptions of nomadic life invariably emphasize its presence."[92]

"But felt boots were made in Ch'ang-an itself; scarlet felt for Chinese use was brought in from the garrison at Kucha, and white felt was a regular product of inner Kansu and the Chinese Ordos.[93]

"If 'linen' is used in its broadest sense, meaning a fabric woven from threads

[90] *Kendrick, op. cit., pp. 39–41*
[91] *Burling, op. cit., p. 310*
[92] *Schafer, op. cit., pp. 198–200*
[93] *Ibid., p. 200*

spun of vegetable fibers, the Chinese had many excellent linens of their own, especially those of hemp, ramie, and kudzu."[94]

"T'ang, and other Far Eastern countries as well, made bombycines or tussahs of thread spun from the silk remnants left when the wild tussah moth cuts its way out of the cocoon."[95]

"Cotton was well enough known from mid-T'ang times, it seems, but more as a popular novelty than as an old familiar thing. . . . The cotton of Qoco in Serindia was especially well known in T'ang: it was grown, spun, and woven into cloth by the natives of that city and then imported. Administratively, this was Chinese territory, and its conquest must have stimulated the creation of a Chinese cotton industry. But the cottons of Indochina and the Isles enjoyed much greater repute in T'ang. . . . cotton was imported from many places in the South: cotton thread from Nan-chao; 'flowered' and other cotton fabrics from Champa; and fine cottons from Ceylon."[96]

Textile designs supplied the basis for the decorations of many other art forms, and it was estimated that two-thirds of the decorations used on Ming porcelains—such as the foliated panels and medallions on brocaded grounds surrounded by bands of diaper, or the borders of waves around the base of vases—were derived from ancient textile designs, while the other third were based on the patterns used on old bronzes. Designs in a herringbone pattern were also employed.

"If the silk weavers clung to the old traditions when it came to selecting designs, they were equally bound to the past in their looms, which have remained unchanged except for their increase in size. Throughout the centuries the silk has been woven on the same upright loom worked by two artisans. The weaver is seated below, while his assistant, perched on top of the frame, works the treadles and helps to change the threads. There is a Chinese saying in regard to silk weaving that: 'The warp symbolizes the immutable forces of the world, and the weft the transient affairs of man.' "[97]

Textiles in the Shōsō-in

The textile fabrics preserved in the Shōsō-in at Nara, near Osaka (where one may admire the oldest wooden building in Japan) have been preserved with extreme care since the eighth century. They are wondrous indeed in color, variety,

[94] *Ibid., p. 201*
[95] *Ibid., p. 201*
[96] *Ibid., pp. 204–5*
[97] *Burling, op. cit., pp. 310–11*

and elaborate and varied techniques. There are several hundred thousand of them, from large ritual banners to tiny fragments, in addition to ten odd boxfuls still unsorted or described.

They may be roughly classified as follows:

1. Items listed in the *kenmotsu-cho* (dedicatory record) of the 21st day of the 6th month, A.D. 756.

2. Dance and music costumes used at the consecration ceremony of the Great Buddha at the Tōdai-ji Temple on the 9th day of the 4th month, A.D. 752.

3. Hundreds of large and small ritual banners used at the memorial service at the Tōdai-ji on the 2nd day of the 5th month, A.D. 757, for the first anniversary of the death of the Emperor Shōmu.

4. Pieces of clothing for people who worked at the offices for hand-copying the Buddhist scriptures and for the construction of the Tōdai-ji.

Design motifs on these textiles are mostly animal motifs, plant motifs and geometric patterns, often in skillful combinations. They include motifs which show the influence of Persian and Assyrian arts.

In the magnificently produced two-volume publication by Asahi Shimbun Publishing Company,[98] 218 color plates are shown. While the publication does not distinguish between textiles of T'ang China and Japanese textiles inspired by the gifts from China's ruler, it is certain that a very large number of these textiles were actually made in China. Indeed, many of the fabrics are in the shape of covers for musical instruments and crafted articles which themselves were a part of the generous gifts from China.

Plates I and II of Volume II, for example, repeat the Sassanian backward looking warrior in the midst of wild beasts so often seen on T'ang silver mirrors and cups and on T'ang ceramic ewers. The rhinoceros on Plate IV and the Mandarin ducks on Plate IX are certainly not Japanese!

An eighth century rug (Plate 120) is one of the oldest rugs existing today. Gordon B. Leitch describes it as one of the finest examples of its kind. It is made by a process of felting rather than knot-tying. Its size is approximately 8'5" by 4'3" on a ground of grayish white with a brown border.

Two other eighth century rugs in the Shōsō-in (Plate 121) use lotus flower and leaf motifs; one, with a gray background has a brown border and indigo and brown figures; the second uses indigo and brown patterns upon a white ground.[99]

[98] Textiles in the Shōsō-in *(Tokyo: Asahi Shimbun Publishing Company, 1963)*
[99] *Gordon B. Leitch, Chinese Rugs, (New York: Dodd, Mead & Company 1928), pp. 6-7*

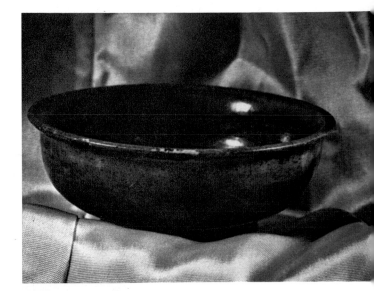

51. (A) SMALL GREEN GLAZED BOWL
Height: 1 5/8 inches
Diameter: 4 inches
(B) ELEPHANT AND BOWL
Height: 6 1/2 inches
Width: 4 inches

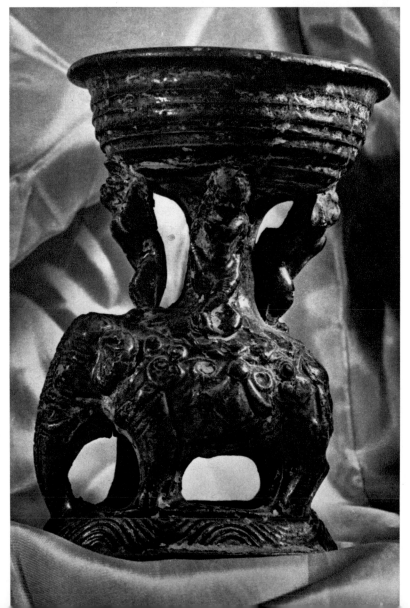

52. RARE PILLOW OF BUFF WARE WITH LIGHT BROWN GLAZE
FIVE DYNASTIES

53. GREEN AND YELLOW-GLAZED POTTERY PILLOW
Length: 13 1/2 inches

54. TERRA-COTTA ELEPHANT-HEAD TRIPOD INCENSE BURNER
Height: 8 1/4 inches

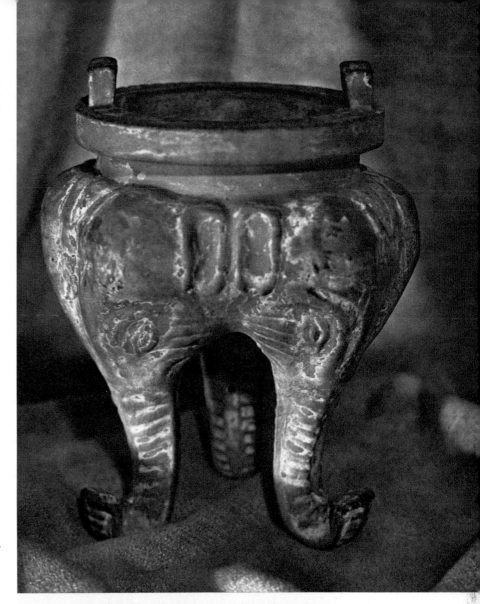

55. CHANG SHA BOWL
Height: 1 5/8 inches
YOU CHOU VASE
Height: 2 1/2 inches

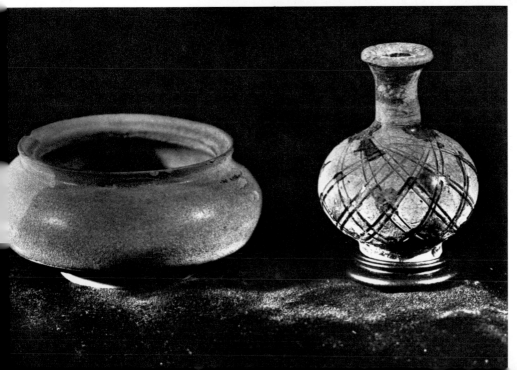

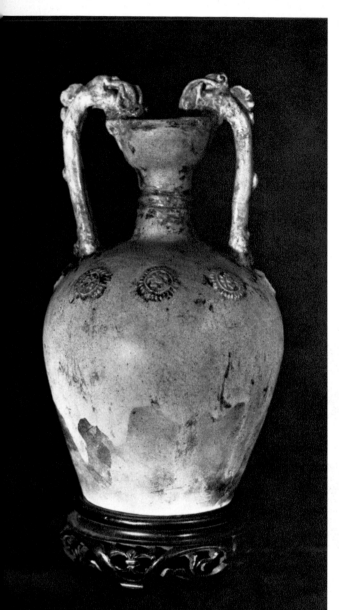

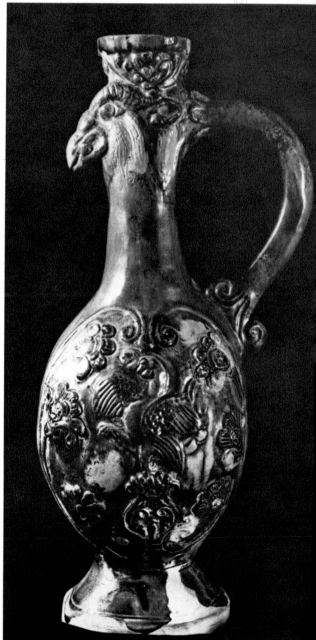

56. YELLOW-GLAZED POTTERY AMPHORA
Height: 8 3/4 inches

57. BIRD-HEADED EWER
Height: 11 1/2 inches

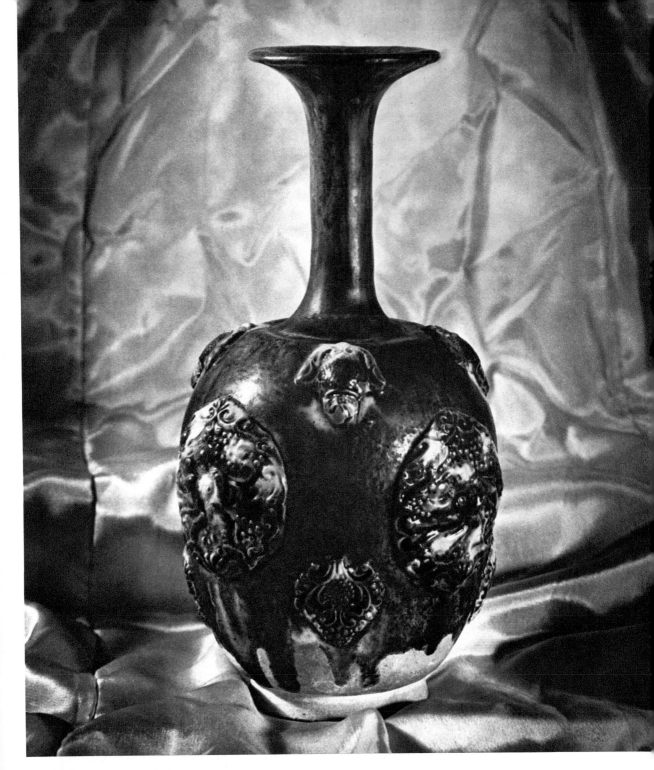

58. TALL NECKED VASE
Height: 9 1/2 inches

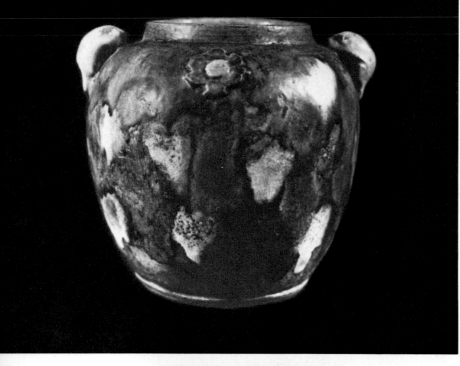

59. GRAIN JAR
Height: 5 inches

60. GLAZED JUG
Height: 6 1/2 inches

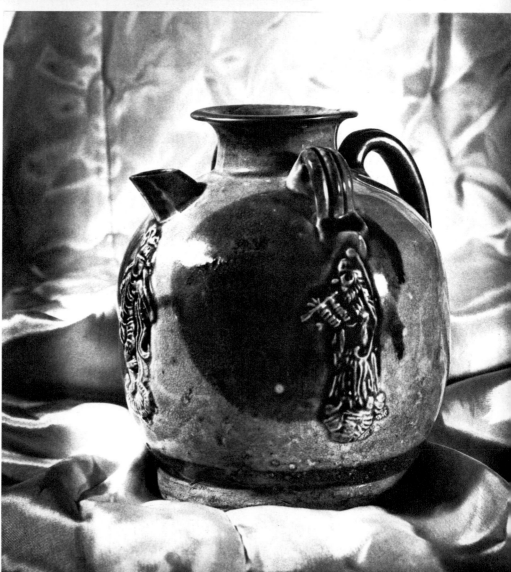

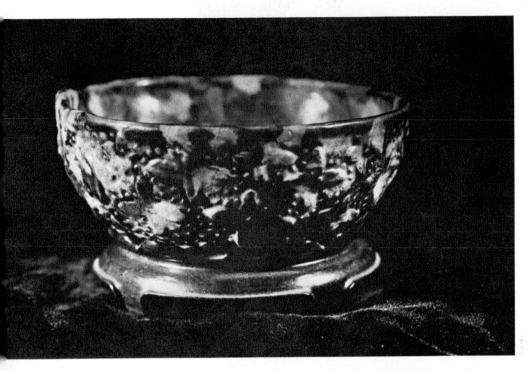

**61. THREE-COLOR
SPLASH-GLAZED
BOWL**
Diameter: 4 3/4 inches

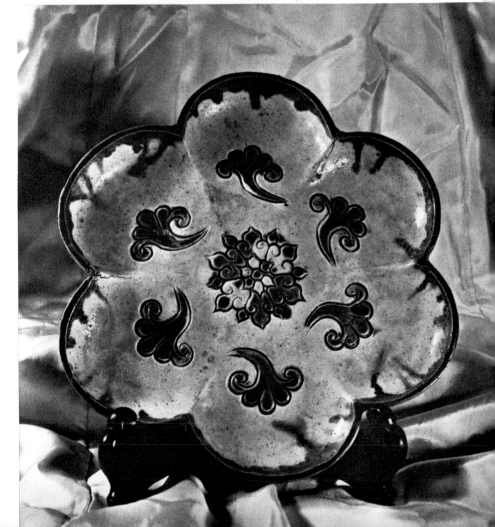

**62. DECORATED
SIX-LOBED DISH**
Width: 8 5/8 inches

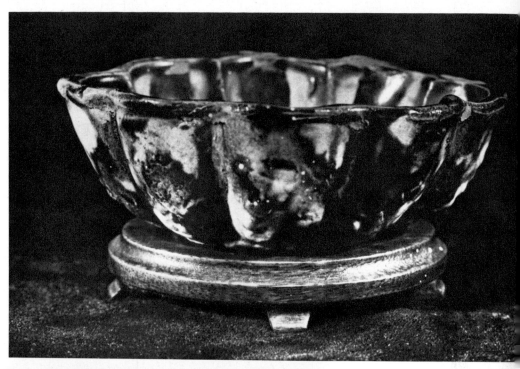

63. EIGHT-LOBED DISH
Height: 2 1/16 inches (with stand)

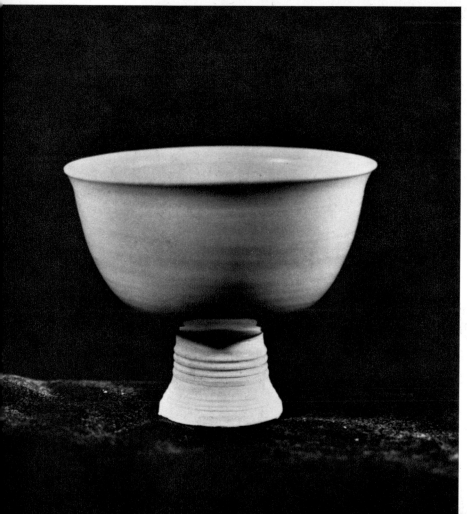

64. WHITE STEM CUP
Height: 2 7/8 inches

65. YELLOW-GLAZED TERRA-COTTA MODEL OF A HOUSE
Length: 5 1/4 inches

66. TOMB FIGURE OF A PIG
Length: 5 inches

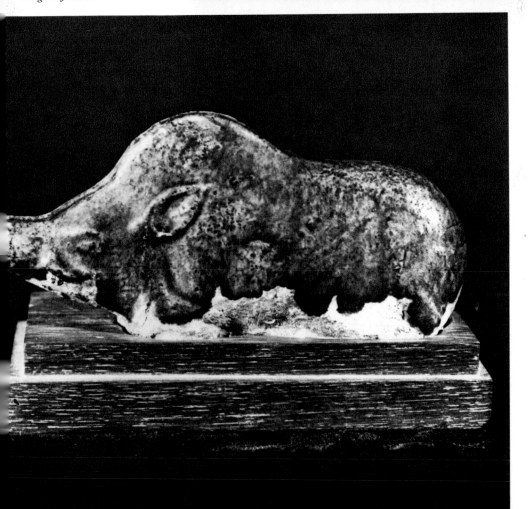

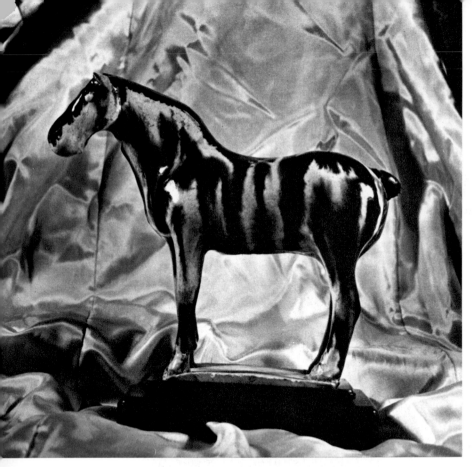

67. HORSE
Height: 9 inches with stand
Length: 8 1/4 inches

68. HORSE
Height: 5 inches
Length: 6 1/2 inches

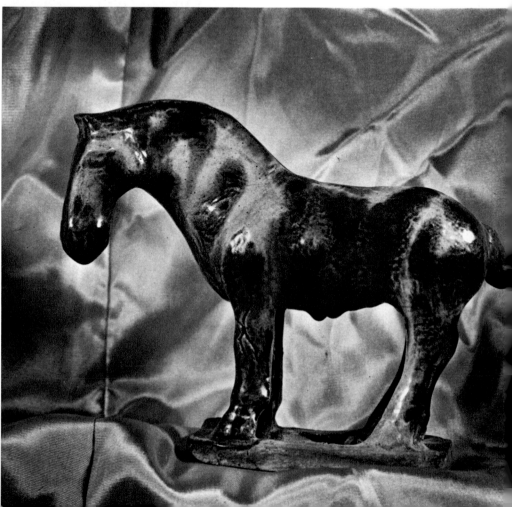

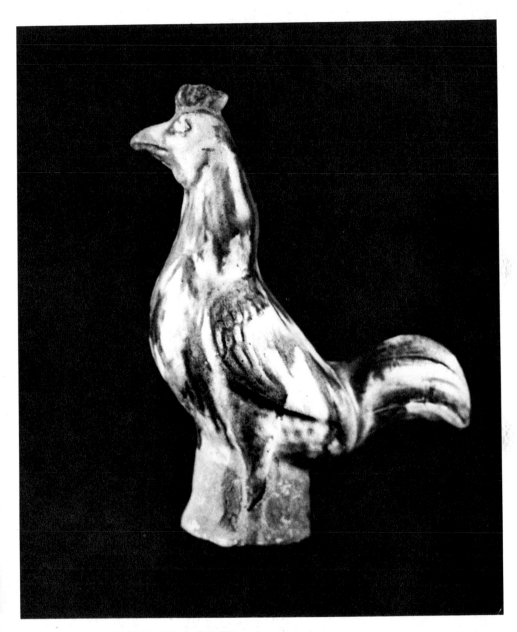

69. TOMB FIGURE OF A COCK
Height: 6 3/4 inches

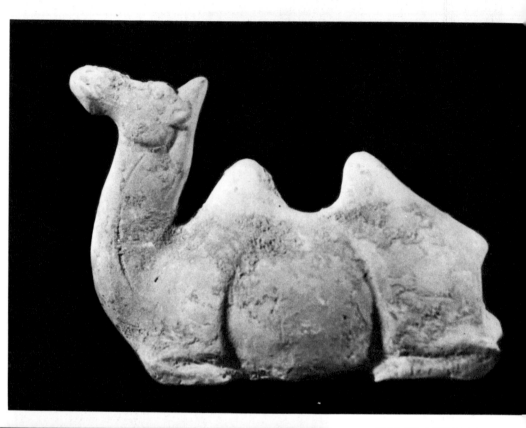

70. TOMB FIGURES
OF CAMELS
(A) Height: 4 1/2 inches
Width: 5 1/2 inches
(B) Height: 5 1/8 inches
Width: 5 7/8 inches

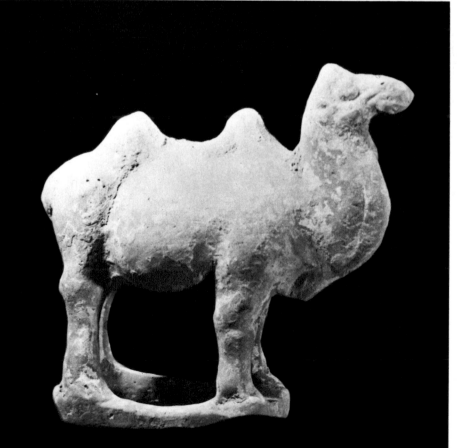

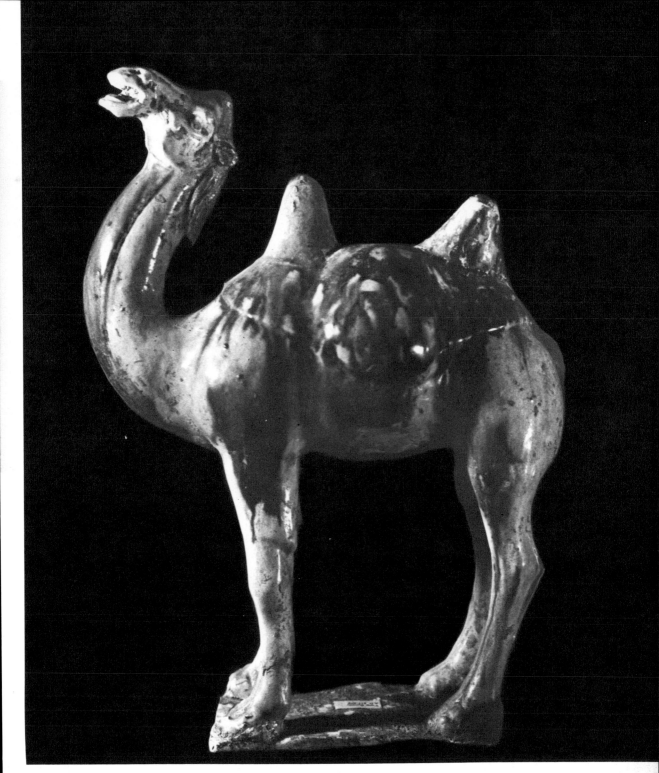

71. CAMEL
Height: 15 3/4 inches. Length: 12 inches

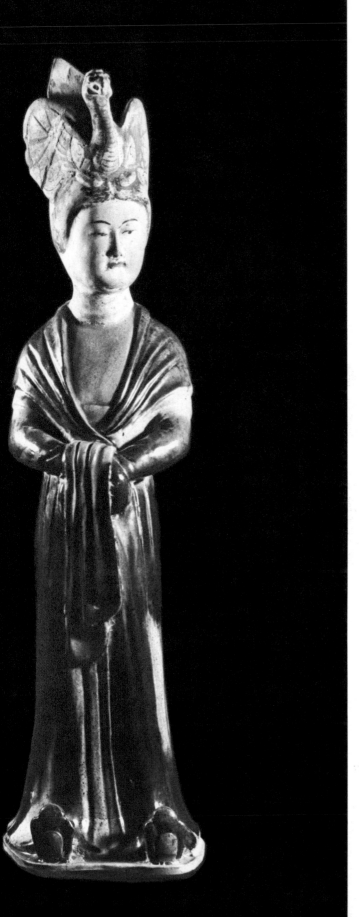

72. TALL COURT
LADY
Height: 16 inches

73. TOMB GUARDIAN
Height: 36 inches

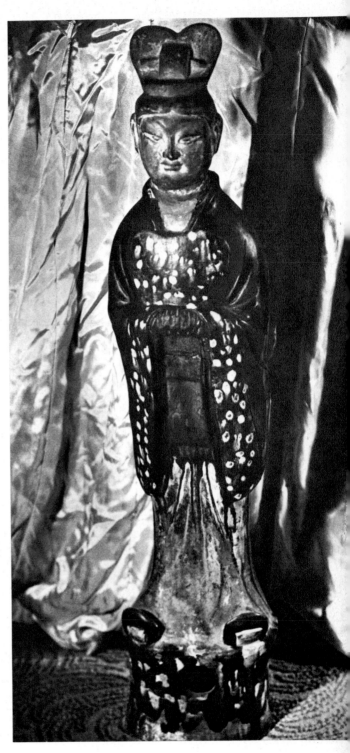

74. COURT LADY
Height: 16 inches
SUI DYNASTY (A.D. 489–617)

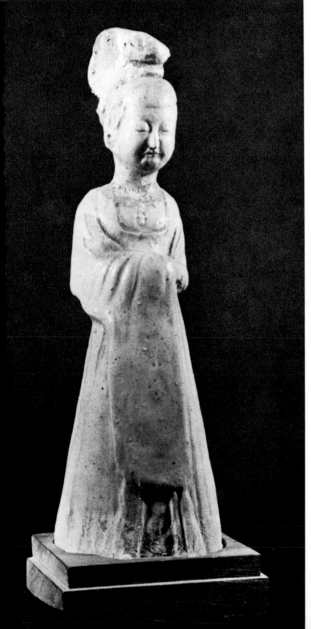

75. SPIRIT OF THE EARTH
Height: 14 inches

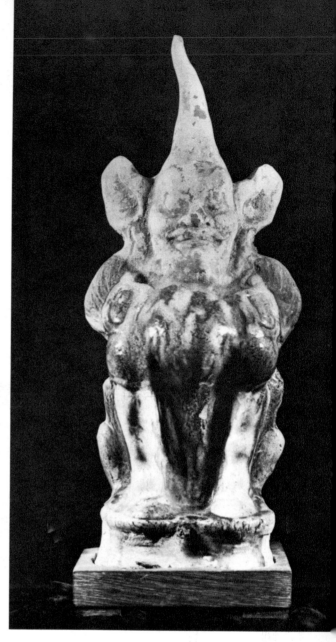

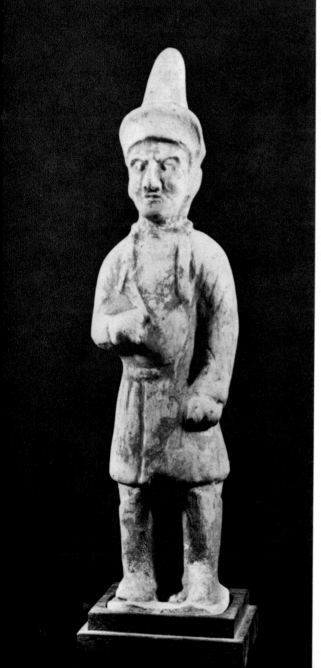

76. SEMITIC MERCHANT
Height: 11 inches

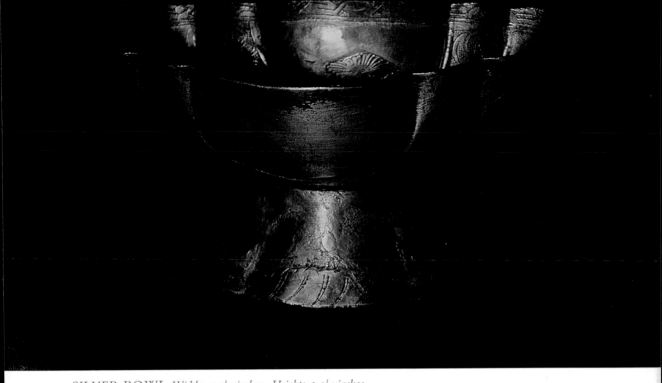

77. SILVER BOWL *Width: 4 3/4 inches. Height: 2 1/4 inches*

78. PAIR OF WHITE DISHES *Diameter: 4 1/2 inches*

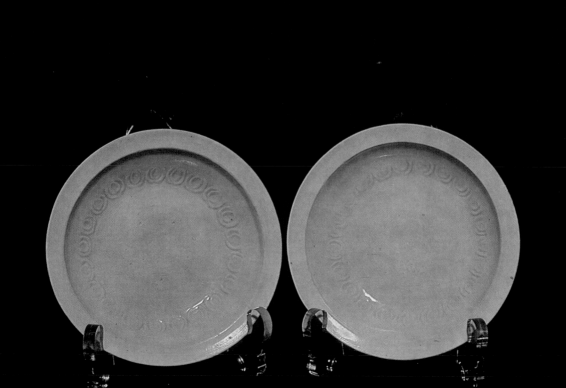

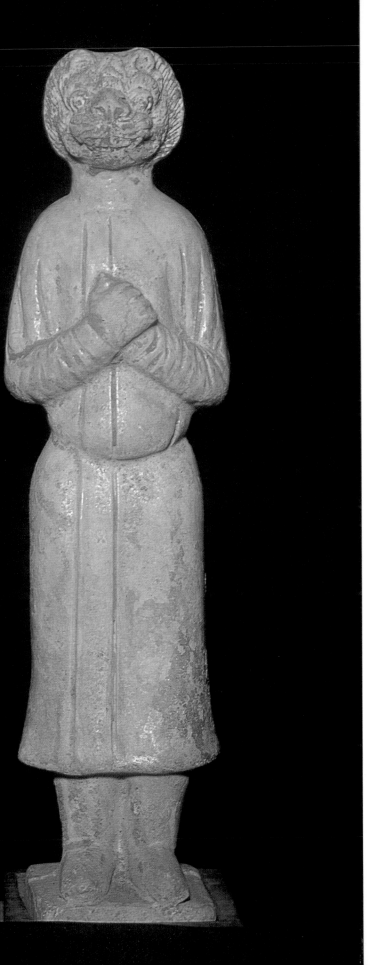

79. ZODIACAL
FIGURE
Height: 9 1/2 inches

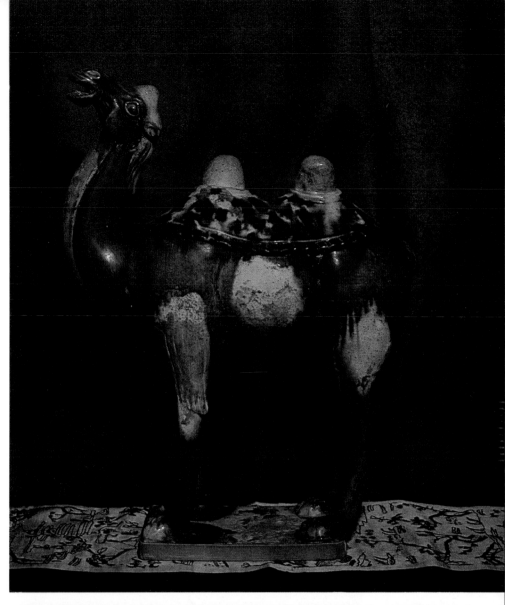

80. BACTRIAN
CAMEL
Height: 16 1/2 inches
Length: 13 1/2 inches

81. MINIATURE
WINE CUPS
AND JARS
Diameter: 1 1/2 inches
Height: 1-2 inches

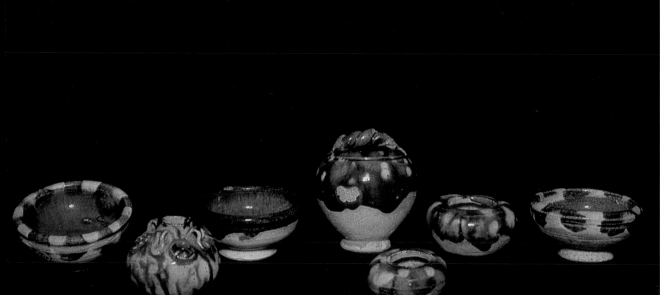

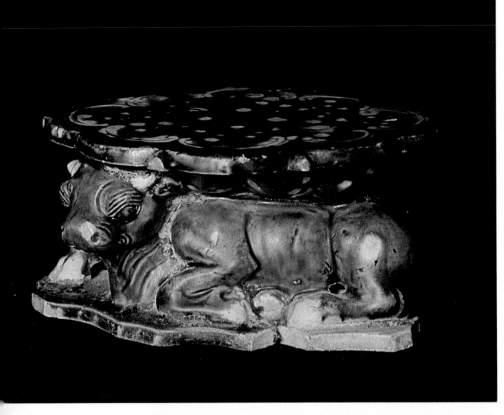

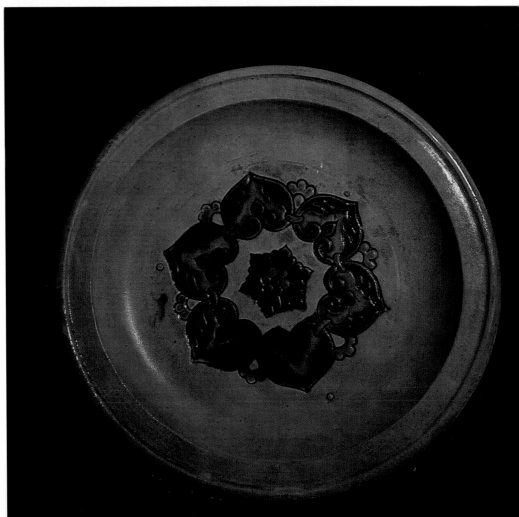

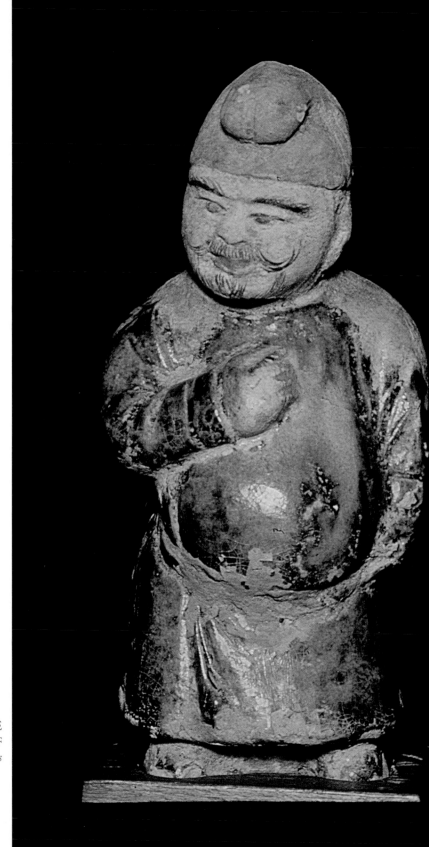

84. TOMB FIGURE
OF A DWARF
Height: 4 1/2 inches

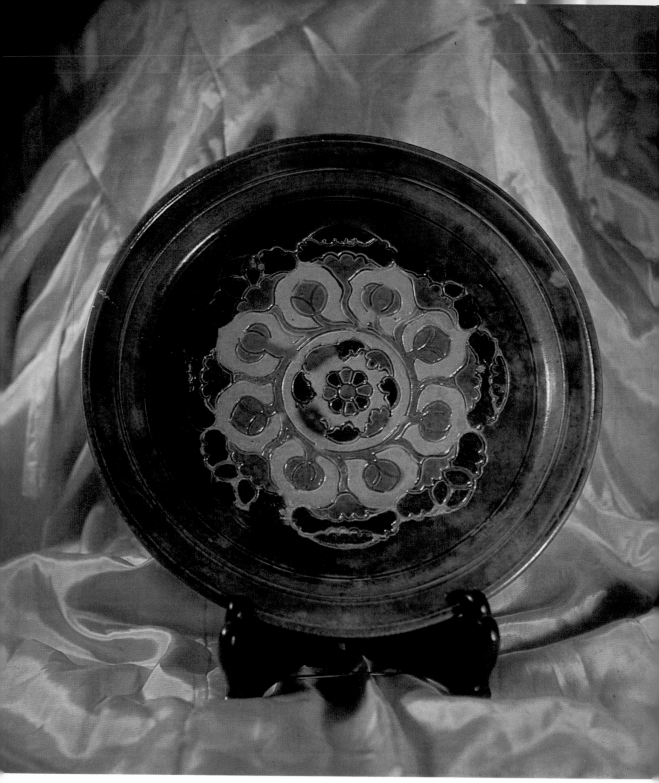

85. LARGE PLATE IN FOUR-COLOR GLAZE

Diameter: 11 15/16 inches

86. MARBLEIZED BOWL
Height: 2 3/8 inches
Diameter: 5 1/4 inches

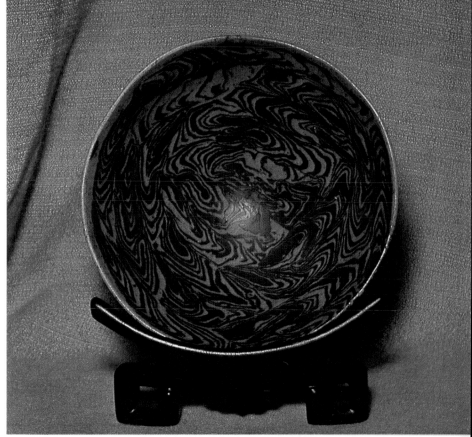

87. TOMB FIGURES OF DOGS
Width of one: 3-1/2 inches
Height of one: 4 inches

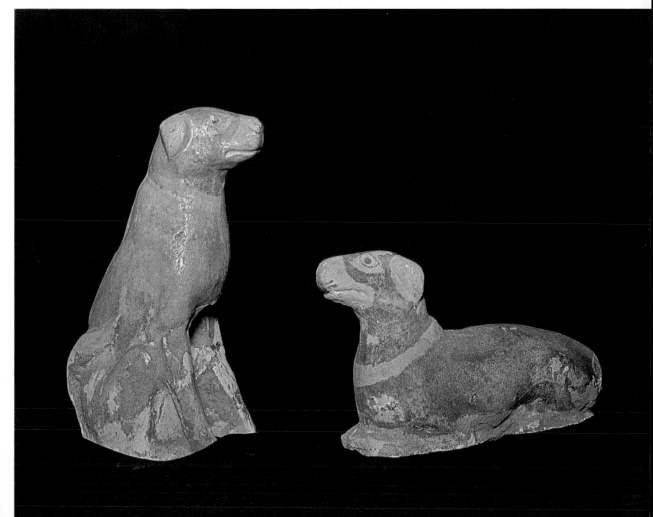

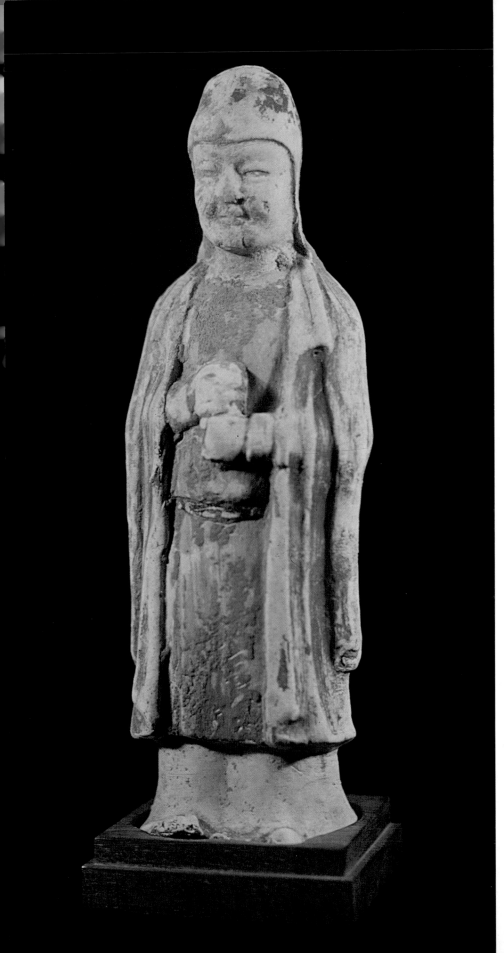

88. TOMB FIGURE
OF A CHRISTIAN
Height: 10 inches

89. HEAD OF A LADY
Height: 2 3/4 inches

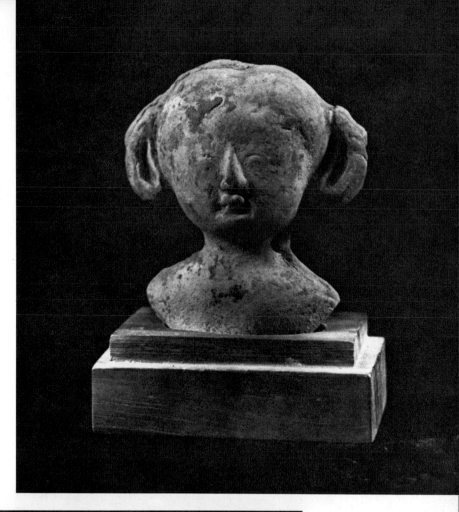

90. KNEELING WOMAN
Height: 2 1/4 inches
WOMAN WITH CHILD
Height: 4 inches

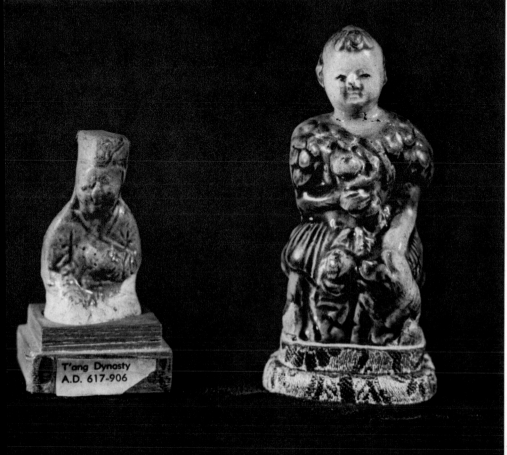

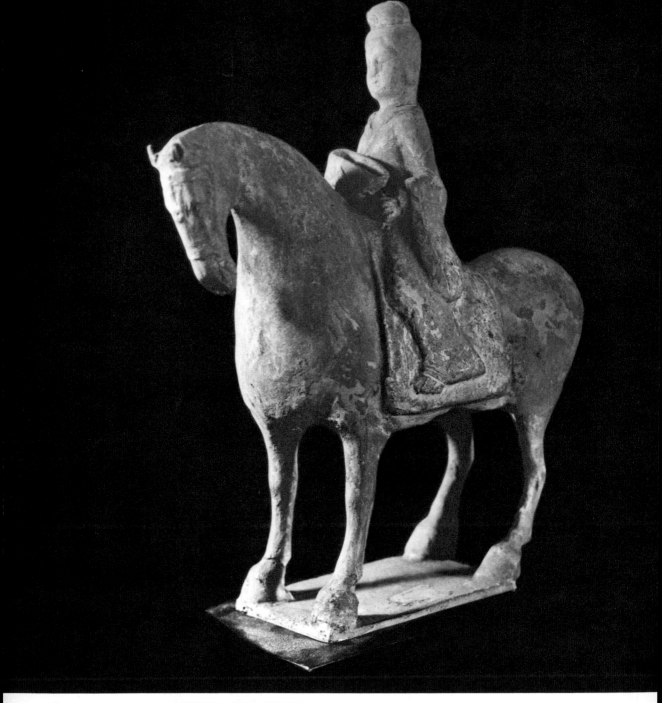

91. HORSE AND RIDER

Height: 10 1/4 inches. Length: 8 inches. WEI DYNASTY

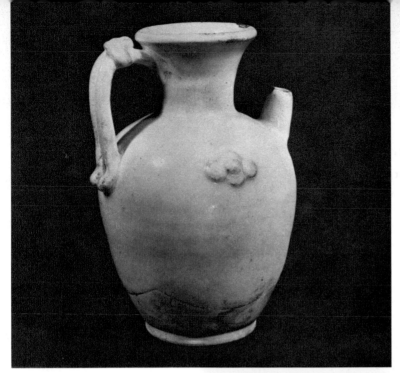

92. WHITE GLAZED EWER
Height: 5 3/8 inches

**93. SPLASH–GLAZED
TERRA-COTTA STATUETTE
OF A LOKAPALA**
Height: 16 1/2 inches

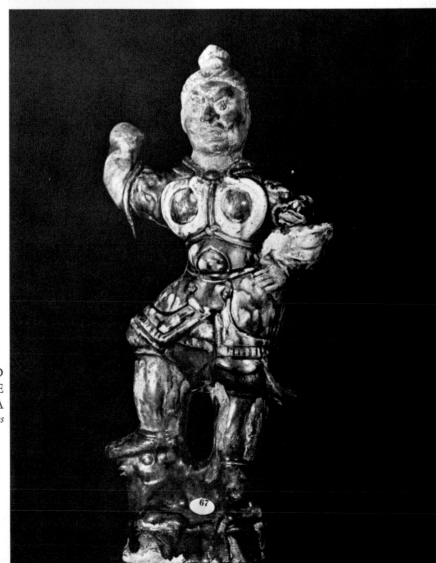

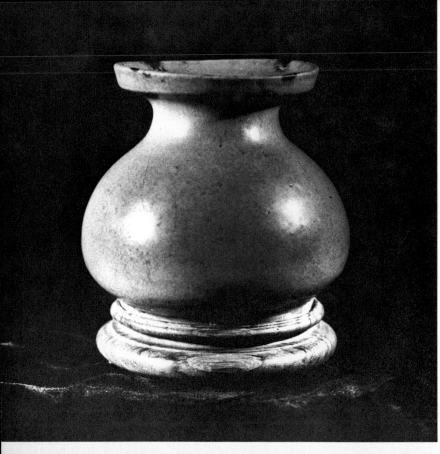

94. YUEH VASE
Height: 5 1/2 inches

95. TERRA COTTA HORSE
Height: 21 inches

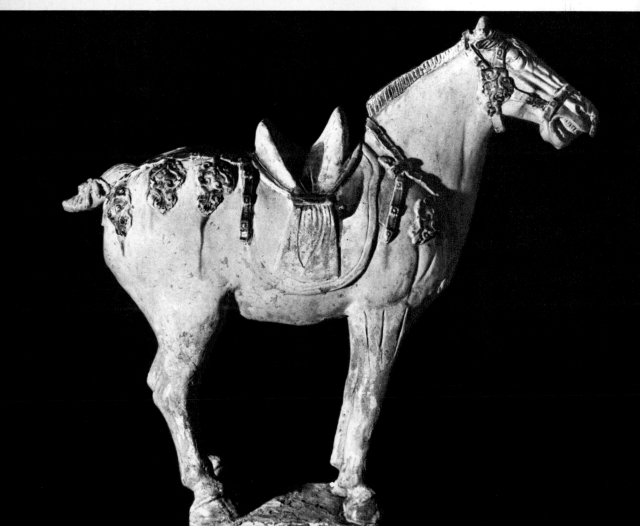

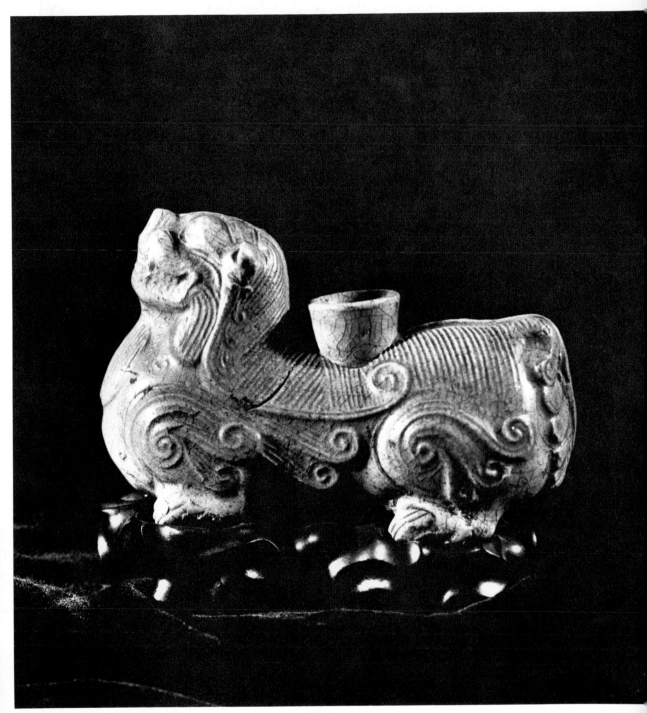

96. YUEH WARE VESSEL

Length: 5 inches. SIX DYNASTIES

97. SMALL GREEN
BOWL WITH COVER
Height: 2 1/2 inches

98. MINIATURE
JARS
Diameter: 1 2 inches
Height: 1 1/4-2 inches

99. MINIATURE JAR
Height: 2 inches

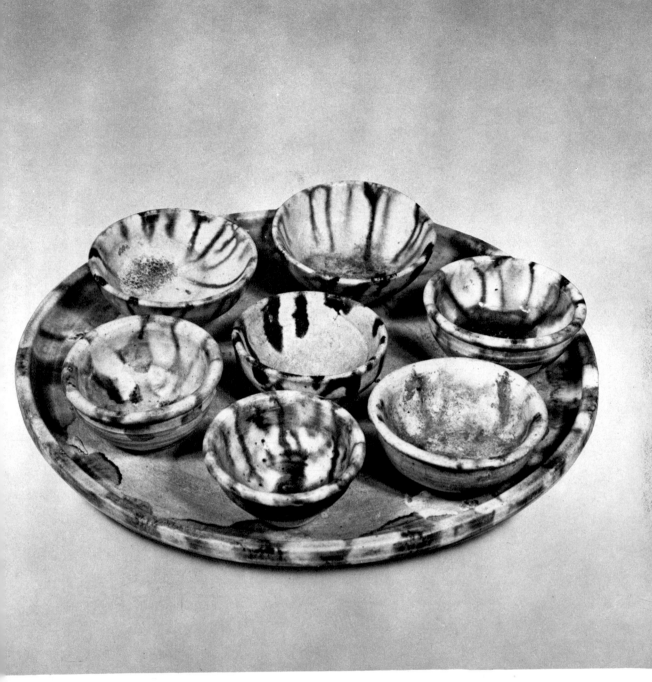

100. WINE CUPS AND TRAY

Diameter of cups: 2 inches
Height of cups: 1 1/2 inches
Diameter of tray: 8 5/8 inches
Height of tray: 1 1/4 inches

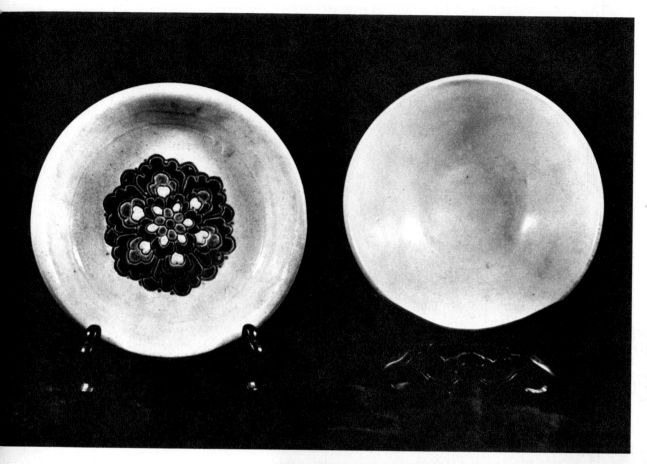

101. DISHES
A. Diameter: 5 1/2 inches
B. Diameter: 5 3/8 inches

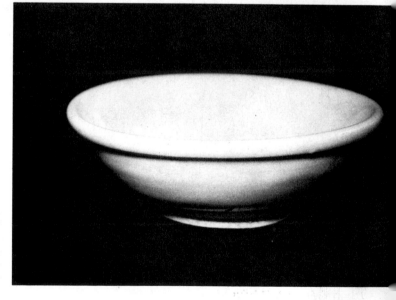

102. WHITE
GLAZED
BOWL
Diameter: 16 inches
Height: 2 3/4 inches

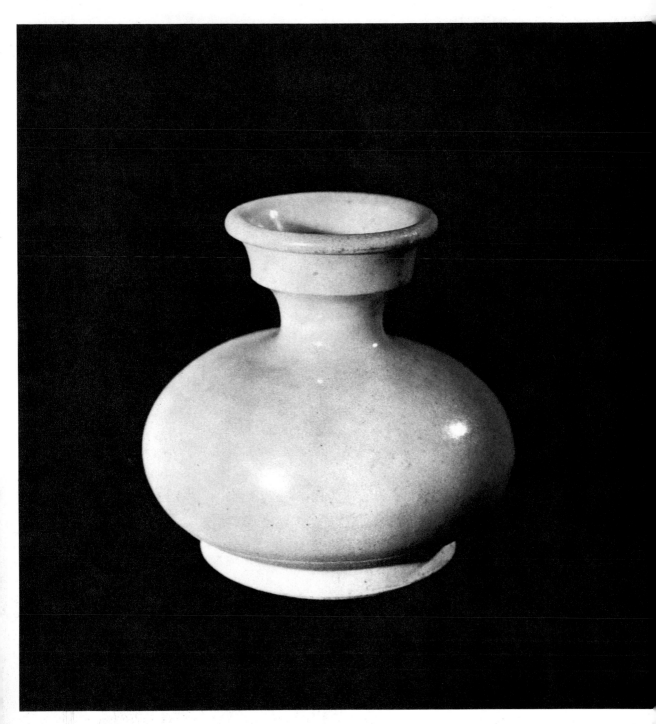

103. SMALL WHITE JAR
Height: 5 1/2 inches

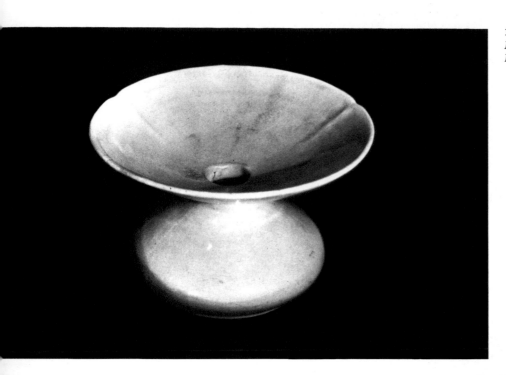

104. SPITTOON
Height: 4 inches
Diameter: 18 1/4 inches

105. SMALL JAR
WITH COVER
Height: 7 1/4 inches

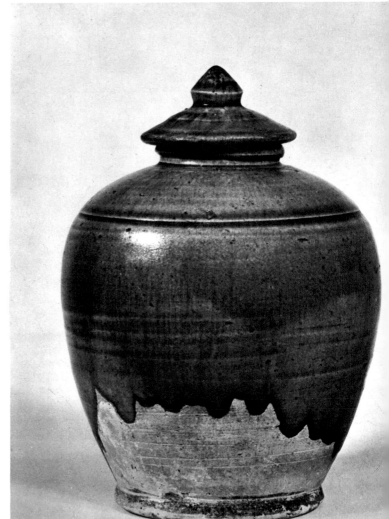

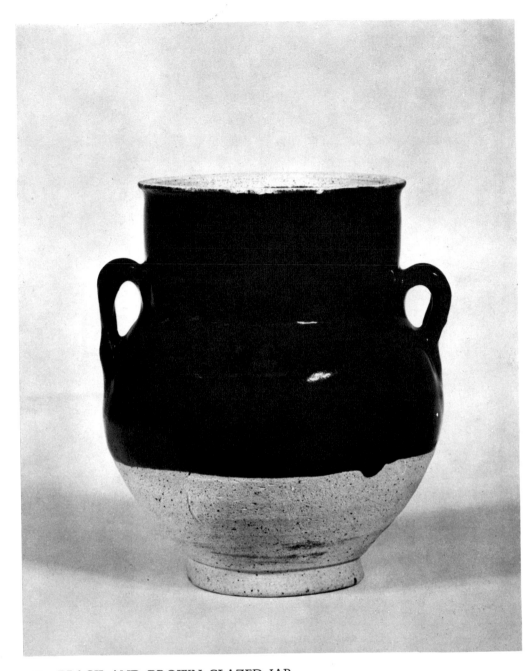

106. BLACK AND BROWN GLAZED JAR
Height: 6 inches

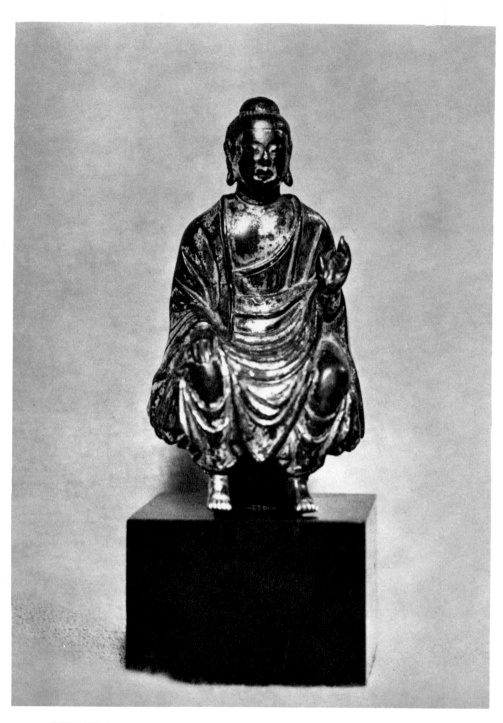

107. GILT BRONZE BUDDHA
Height: 3 5/8 inches
SIX DYNASTIES OR EARLY T'ANG

108. GILT BRONZE STATUETTE
Height: 2 1/4 inches

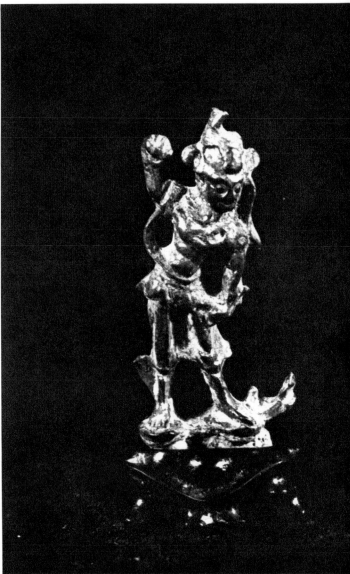

109. PAIR OF GILT BRONZE ORNAMENTS
Length of duck: 3 1/2 inches
Length of cloud form: 4 1/4 inches

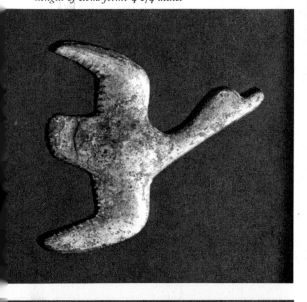

110. GOLD AND BRONZE CUP
Height: 1 1/2 inches
WEI DYNASTY

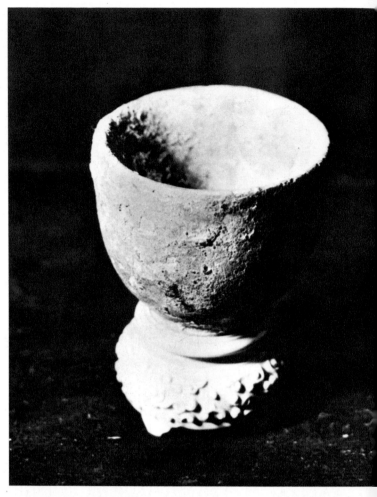

111. THREE LION DOGS
Height: 1 1/2 inches
Width stand: 2 inches

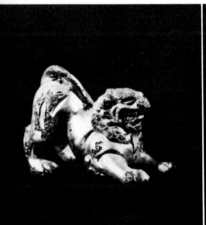 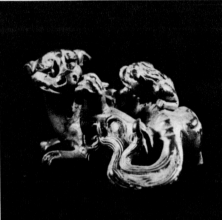 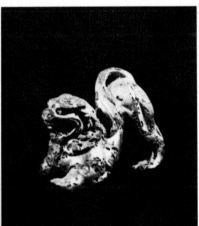

112. GILDED CUP
Height: 2 inches
T'ANG DYNASTY

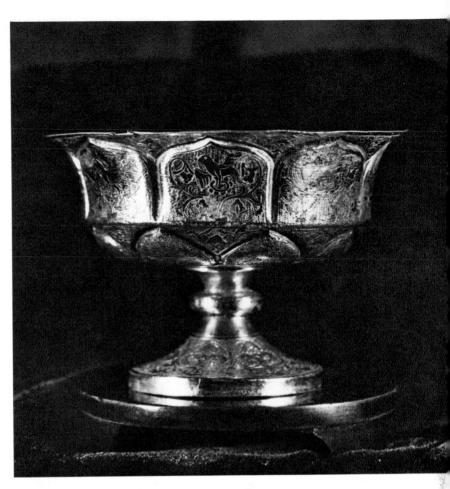

113. GILT BRONZE CUP
Length: 3 1/4 inches

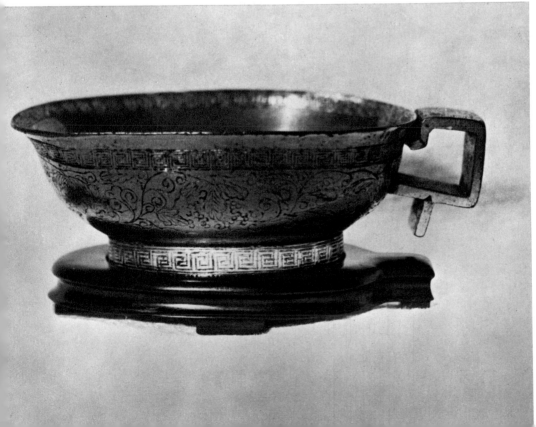

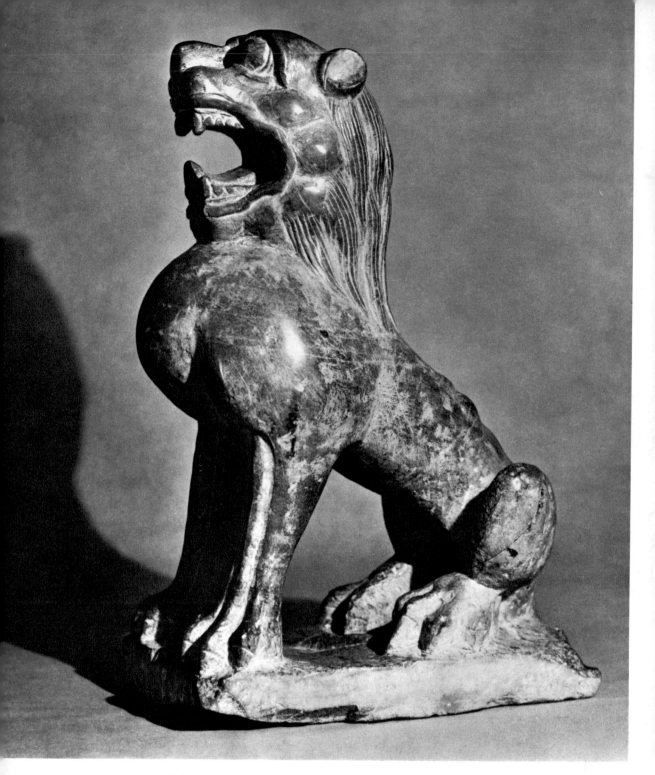

114. STONE LION

Length: 9 inches. Width: 6 inches. Height: 14 1/2 inchas.

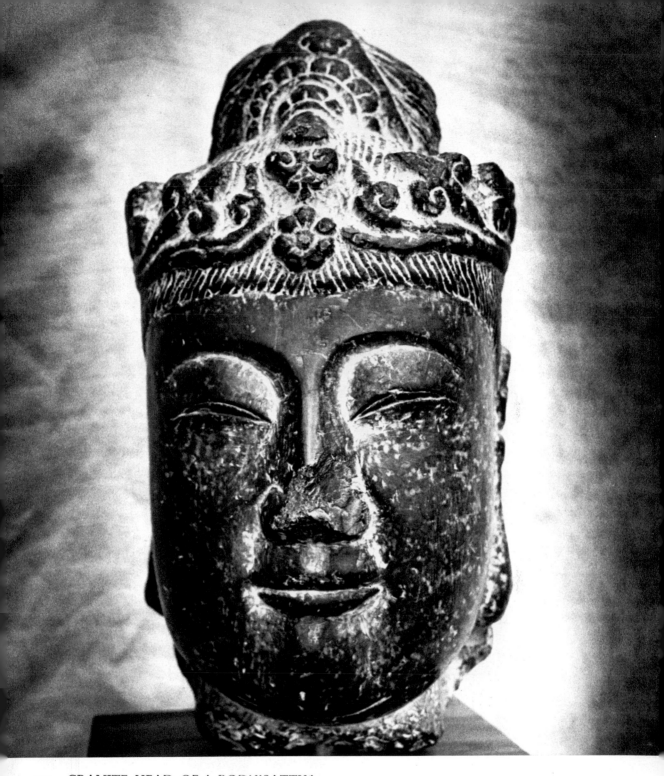

115. GRANITE HEAD OF A BODHISATTVA
Height: 13 1/2 inches

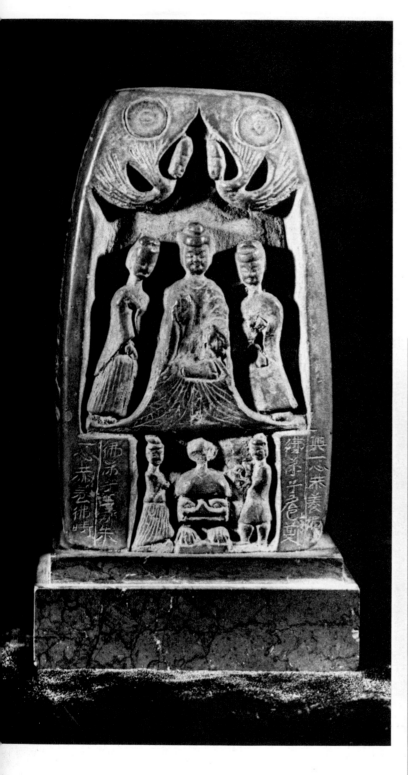

116. BUDDHIST ALTAR TABLET
Height: 4 5/8 inches
WEI DYNASTY

117. STONE STATUETTE
Height: 16 inches
SIX DYNASTIES (A.D. 265-618)

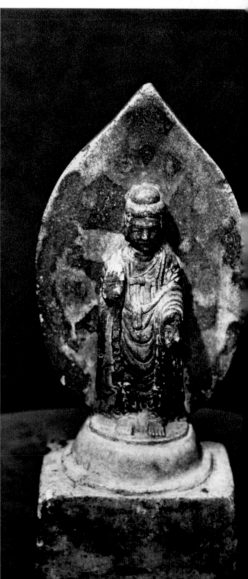

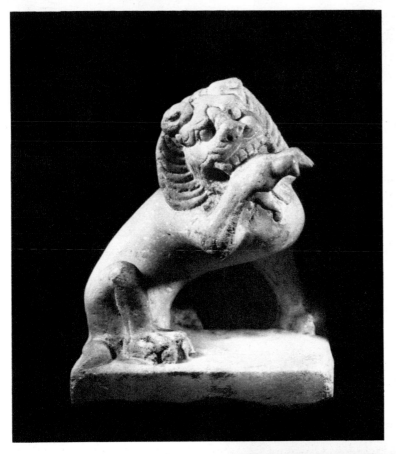

118. PAIR MARBLE LIONS
Height: 8 1/2 inches
Width: 6 1/2 inches
EARLY T'ANG DYNASTY

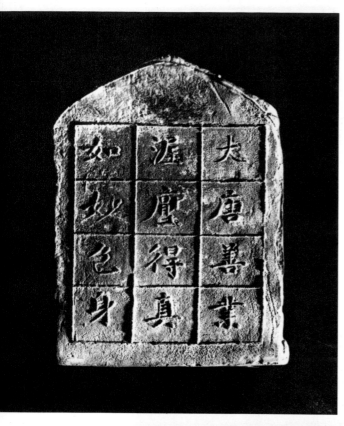

大唐善業
漏盡得真
如如色身

119. MINIATURE GRAY POTTERY
VOTIVE STELA (FRONT) (BACK)
Height: 4 5/8 inches

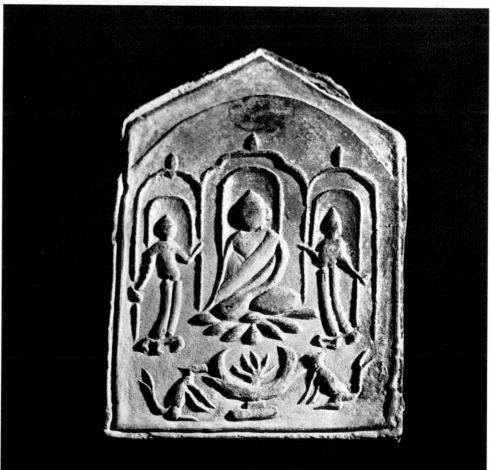

120. EIGHTH CENTURY RUG
Courtesy of the Shōsō-in, Nara, Japan

121. PRE-MING WEAVINGS
Courtesy of the Shōsō-in, Nara, Japan

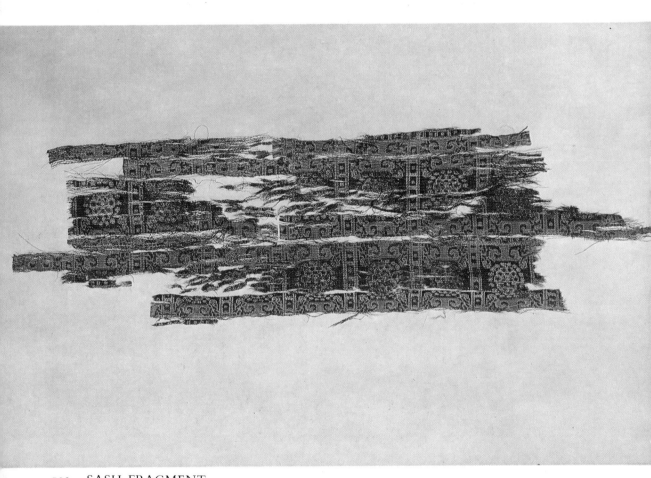

122. SASH FRAGMENT
Length: 12 1/2 inches
Width: 3 1/2 inches

123. PIECES OF EARLY TEXTILES

Various dimensions: From 1 inch × 1 inch to 4 1/2 inches × 2 1/2 inches

T'ANG OR SUI DYNASTY

Chronological Chart

Shang-Yin	*circa* 1765–1028 B.C.
Latter half of Yin	1300–1028 B.C.
Early Chou	*circa* 1027–900 B.C.
Middle Chou	*circa* 900–*circa* 600 B.C.
Late Chou centuries	600–256 B.C.
Huai style period	*circa* 600–*circa* 222 B.C.
Interregnum	255–222 B.C.
Ch'in	221–206 B.C.
Han	206 B.C.–A.D. 220
The Six Dynasties	220–589
Wei.	385–557
Northern Wei . . . 385–535	
Eastern Wei 535–550	
Western Wei . . . 550–557	
Sui	581–618
T'ang	618–906
The Five Dynasties	907–960
Liao (Mongol)	907–1125

Sung 960–1279
Yuan 1279–1368
Ming 1368–1644
Ch'ing 1644–1912

Notes on the Plates

FRONTISPIECE:
RARE
BLUE-GLAZED
POTTERY
TRIPOD

Fashioned from buff ware, made in the form of a tripod, type Li, having a bulbous cauldron shaped body, with contracted neck and wide flanged lip rim with a broad mouth; two rudimentary rectangular handles rise above the neck. The tripod rests upon three slightly outward spread feet. The body is decorated with an over all leafy-like pattern embossed in low relief. Below the handles are large rudimentary monster masks with rings done in relief. The sides bear two diametrically opposed reclining figures done in high relief holding staffs and flanked by cloud scrolls. Invested on the exterior with a blue glaze. The three feet and interior are unglazed. Enhancd by a minute crackle and silvery iridescence.

1. LARGE GOLD
AND SILVER
MIRROR

On lobed bronze backing. Silver foil with gilded figures and landscaping of gods on clouds or under trees. The figures of gold burnished on the silver background. The entire scene is closely filled with abundant plants, trees and cloud forms. Around the outer circle are birds in flight. Clouds circle the inner section around a raised gold lobe (for insertion of silken cord to carry the mirror); on the lobe are incised plants and butterflies.

[147]

The bronze back bears marks of textile impressions, probably from burial.

This may be regarded as one of the earliest examples of Chinese landscape "painting" since few landscapes paintings of this period still exist.

Exhibited at Virginia Museum, Richmond. A landscape painted in ink on hemp cloth, similar to this mirror, is in the Shōsō-in at Nara, Japan. *Treasures of the Shōsō-in*, Tokyo National Museum (1959). See also illustration 89, an eight-lobed mirror of bronze. Design of landscape in gold and silver on the back. The hills, cloud scrolls, figures and other decorations are strikingly similar to the design on this mirror.

2. SILVER AND GOLD MIRROR

A large silver sheet, gold decorated, with a gold decorated central knob. Applied to an eight-lobed bronze mirror back. Taoist "immortals," some with musical instruments are seated among various kinds of trees and bushes. Mountains are seen in the distance. Numerous clouds and cloud scrolls are shown, as well as bird and butterflies in flight.

Most unusual, both as to size and because of the skillfully executed "landscape."

This landscape is similar to that found on two surviving textiles of the period, described in *Treasures of the Shōsō-in*, Tokyo National Museum (1959).

3. SILVER STEM CUP

Stem cup, in beaten silver. It is bowl-shaped, with everted lip and a short stem which merges with an everted foot. The stem is soldered to the cup. The pattern of the cup itself is in two parts, divided by a silver rim, which also marks a change in the outer slope of the cup from gradual to a marked incurving.

The upper half is decorated with six birds amid floral sprays and varied plant forms. The lower half is lavish with scroll and palmetto designs, as is the decoration around the foot. The pattern is chased on a ground of regular ring matting.

Exhibited at Philadelphia Museum of Art and at Los Angeles Art Museum.

Somewhat similar cups are in the MFEA, Stockholm; the Kempe Collection; the Metropolitan Museum of New

York; The Freer Gallery, Washington; and the Hakkaku Art Museum, Kobe. Ref: Yamanaka, *To-so Seika,* Vol. II, Plate XXVII; Hakkaku-cho, Vol. I, Plate XLVI.

4. PAIR OF
 SILVER BOWLS

A pair of silver wedding bowls. Inside of silver, rimmed with continuous heart-shaped scrolls, gilded. In the bottom of each, a large golden carp with a lozenge on its forehead, inside which appears an X.

Outside are an upper rim below the everted lip, bearing six gold flowers, each with two large and two small leaves. Below the center rim along an incurvate surface are six lotus plants in gold, each with a pair of leaves.

Along the foot rim are also six plant forms. The foot rim is gilded.

The bowls are quite heavy and show some discoloration from burial.

Found at Hsi-an-fu, HONAN, SUNG DYNASTY

5. "WHITE BRONZE"
 MIRROR

This "silver bronze" mirror, eight-lobed, contains scrollings and plant forms along the outer rim. Within a circular reserve, a pair of confronting birds, their mouths holding ribbons, are perched above leaves and tendrils. At the top is a bird in flight, in its mouth a pair of twigs or ribbons.
Kriger (1963—CHH)
Ex-Ladejinrsky Collection
Cite: *Chinese Art,* Burling, p. 229; *Chinese Art,* Ashton & Gray, Plate 52 a, p. 146; *Chinese Art,* Batsford, plate 65 a.

6. SILVER MIRROR

Hexagonal, small silver mirror with central figure of frog surrounded by animals, birds in flight, and plant designs within a hexagonal border. All on ring matted ground. The mirror side and edges coruscated. All figures raised above surface.

7. GOLD AND
 SILVER MIRROR

Handsomely gold decorated mirror on silver foil within an outer circle of pointed "teeth" is a middle circle of twelve raised compartments containing animals representing zodiacal signs, with backgrounds of cloud forms within the large circle are a mythological phoenix, a winged dragon and the tortoise held by a coiled snake. Interspersed are scrolls, waves, and cloudpatterns. All decorations are in high relief. The small central circle encloses a raised knob.

The burnished mirror back is partly corroded.
In possession of one family for over 55 years.
See: *Chinese Art,* Jenyns and Watson (1963), Pl. 17.

8. SILVER STEM CUP

Silver cup on an expanded stem foot, curved side with everted lip, decorated on the exterior with scrolling vines, foliage and various birds, gilt on silver ground. On small stand.

This same cup illustrated in Chinesische Kunst, Berlin Exhibit. (1929), Illustration 436, Ex- Mrs. Christine R. Holmes Collection; see also illustration 437.

Similar cup in Victoria & Albert Museum, Plate IXb, *Chinese Art,* Mackenzie (1961).

9. SILVER BOWL

Silver six-lobed bowl on high foot ring. Foliated lip ring. Decorated with center medallion of lotus spray. Incised border on lip rim, slightly gilded. (Similar to eight-lobed bowl in Hoyt Collection, Boston Museum of Fine Arts)

10. SMALL CIRCULAR BOX

With straight sides and slightly convex cover and base. In beaten silver. The cover and box are decorated with radial floral sprays and palmettos. In the center, two birds confront a six-petalled flower. The pattern is chased on a ground of regular ring matting. The sides are plain.

"As a rule they are regarded as cosmetic boxes for ladies ...containing rouge or some other kind of cosmetic." T'ang Gold and Silver, Bo Gyllensvärd, MFEA, page 45. Also Chinesische Kunst, Berlin Exh. (1929) Illus. 440.

Similar boxes are in the M. Månsson and Kempe Collection, Sweden.

11. THREE SILVER COSMETIC BOXES

(A) Small silver box, the top and bottom decorated with birds, scrolls and vines on ring matted background. On the sides scrolls and flowering plants. (Also illustrated elsewhere in fitted box.) See *Kempe Collection,* Gyllensvard, 40 a, 41a, p. 97.
Width: 1-1/4 inches.

(B) Silver rectangular box with lobes at four corners, on the lid a design of a pair of grouse, on ring matted background. Peony designs on sides of top and bottom.

Base is plain. See *Kempe,* Gyll., 40 b, 41b, p. 97.
Width: 1-1/4 inches.

(C) Small silver box in shape of a clam shell, hinged at base. The design is of strawberry vines and buds with two small confronting birds on ring matted background. *Kempe,* Gyll., 125 a, b, p. 194; 124 a, b, p. 193.
Width: 1-3/8 inches.

12. GOLD CUP AND PLATE

The gold cup has exquisitely incised design of a lotus flower at the bottom and also on the extended flat surface beyond the rim. The cup has the typical T'ang circular handle, slenderly wrought.

The gold plate also bears similar incised design of a lotus flower. The rim is incised with coin design.

The cup and plate are extremely rare, although several later types are known, of Sung attribution. A somewhat similar cup of silver in the Kempe Collection (No. 136, Chinese Gold and Silver in the Carl Kempe Collection; Bo Gyllensvärd.) of the Sung Dynasty is said to have come from LO-YANG in HONAN. A similar cup to the Kempe item but of iron, was found by Sir Aurel Stein at KHARA-KHOJA, attributed to Northern Sung. This type of cup is known in Sung-style ceramic. Another cup of gold, similar to the Kempe silver cup is in the Victoria and Albert Museum. See also Sung gold cup and plate (Nos. 53A and 53B) of later date, in the Kempe Collection, found in LO-T'OKOU, SHENSI.

13. SILVER LADLE, GOLD DECORATED

A long curved silver ladle, with bird form at tip of handle; the bowl is seven foliated. The ladle is decorated in gold on silver on the front with scrolls, plant forms and volutes. The outer side of the bowl engraved on a stippled ground with gold on silver. Lotus and peony, plants and leaves.
Kempe Collection, Gyllensvärd, 163.
Chinesische Kunst, Berlin Exhibition (1929), Illustrated 425.

14. SILVER LADLE

Long curved silver ladle with bird form at end of handle. The bowl and handle are otherwise undecorated. Partly coruscated.

15. SILVER LADLE

Large silver ladle, plain except for repeated design of small double circles on handle. Deep scoop-shaped bowl curves to a point at the pouring end. Tip of ladle is covered by heavy patina.

16. GOLD AND LACQUER TEAPOT

A superb example of T'ang craftsmanship in the use of variant materials to produce a harmonious effect.

This teapot (no similar one is known to exist) applied perhaps by niello technique, on the black lacquer surface over a base of copper.

The decoration, enclosed, in two large double banded 'reserves', consists of standing and flying birds, flowers and lotus plants. Outside the 'reserves' are other flowering plants. The bottom is concave. The top is connected to the bowl by a hinge in the back and a circle (for locking between enclosing loops) in front. It bears a gold phoenix (symbol of the Empress) amid rushes and flower forms. The handle swings on two loops. The spout is affixed by an interesting metal medallion of triangular shape. The bowl, top and curved spout show numerous incrustations of greenish-blue.

An interesting feature is noted in the appearance beneath the gold design of an earlier design in copper by a different artist. Note bird(s) at bottom of photograph.
Found at Hsi-an-fu (Chang-AN) by Mr. J. T. Tai in 1939.
Exhibited at St. Louis Museum
Exhibited at Indianapolis Museum
Exhibited at Museum of the State of Virginia

17. SILVER BUDDHIST INCENSE CUP

An unusual cup, in two parts, the top of which fits into a circular slot in the bottom section. The upper section is plain inside. The outer surface is covered with two layers of incised floral designs, separated by a raised double ring design, which also appears on the lip and at the bottom of the lower floral design. The stem is surrounded by two larger fluted rings, within which is a plain, curved band.

The lower section of hammered or raised work in what appears to be long petals is of less artistic workmanship, suggesting a later date, except that the base is decorated with the same double ringwork of the upper section.

In the center of the bowl of the cup is a small hole, pre-

sumably to contain a single stick of incense, as used in Buddhist worship. Somewhat similar Annamese cups exist. I have seen them in exhibitions, New Delhi, India.

A curious piece; the two parts may not have been made at the same time.

18. SILVER CUP	Silver stem cup. Excellent quality, with incised design of conventionalized flowers and scrolls covering entire outer surface.

Chinese Art, Jenyns & Watson (1963) Plate 56; see similar design in Sedgwick Collection, plate 46b, p. 134. *Chinese Art,* Ashton & Gray.

19. SILVER GILT OVAL BOX	Oval, four-lobed silver box, gilded, over a ring-matted background appear a regular pattern of knots or rosettes. On one side appear, in relief work, two furry animals, (perhaps tapirs) snarling and facing away from each other. On the other half of the box, in high relief (3/4 round) are two embracing figures in erotic pose.

On the sides of the box is a diaper design of modified palmettos on the background of ring matting.

Erotica of this period is rarely met with.

Found at Hsi-au-fu (Chang-an) by Mr. J. T. Tai in 1939.

20. SILVER "TURKS-HEAD" COVER	Silver cover fitting over sea shell, on small stand. Cover in pattern of bird and floral design on ground of regular ring matting.

21. SILVER STEM CUP	Engraved silver stem cup. Bell-shaped, on low flaring foot with ring-knobbed stem, engraved on a stippled ground with lotus and peony scrollings amid which appear birds of typical T'ang style with spread wings.

Exhibited at Burlington Exhibition, London, 1935–1936. (See Catalogue)

Exhibited at China House, New York. January, 1948. #E 5474 Loo (KHH) See also Berlin, 1929 (Chinesische Kunst), No. 438.

22. RARE SASSANIAN TYPE TAZZA CUP

On high stemmed foot, oval-shaped, of hammered silver, chased and gilt. Four lobed sides terminating into points at its greatest width are gently rounded and merge into the oval-conical high foot which rests upon a quatrefoil base with straight side rim. The exterior only is embellished with a rich ornamentation of scrolling tendrils with a bird in flight on each lobe. The foot is ornamented with crested waves. The entire decor is nearly chased and delineated in gilt against a closely seeded ground.

23. HEXAFOIL BOX AND COVER

A striking gold-decorated silver box. Divided in two equal halves; the straight foliated sides are ornamented with formalized scrolling foliage bearing tendrils. The top and bottom halves are divided into six convex lobes radiating from a central, slightly depressed floral rosette. The lobes on both top and bottom are ornamented with an intertwined leaf bearing scrolls enclosing alternatingly a flower, then a bird, with wings raised or spread as in flight. The entire decor is neatly engraved against a ring-matted punched ground and delineated in gilt. The interior is unornamented oxidized silver bearing adhesions.

Similar box of same size on loan from H. E. Dr. R. Flaes, in the Museum of Asiatic Art, Amsterdam (4-1/2 inches across,) p. 130, Speiser, Werner, *The Art of China* (New York, 1960); also Illus. 443, Berlin Exh. (1929), Chinesische Kunst; *Chinese Art,* Jenyns and Watson (1963) Pl. 58.

24. SILVER STATUETTE OF A DOG

Seated figure of a mastiff with upraised head, wearing a collar with sash. Shows traces of earth encrustations. Extremely rare. No similar figure known to me. Has stand.

25. SILVER MIRROR

A uniquely resplendent mirror with traces of gold decoration. Within an outer rim are twelve raised compartments containing zodiacal figures of animals, birds and snakes. The center is enclosed by a sawtooth banding and abounds in fierce activity. Four striding animals, paired in confronting positions are surrounded by flowers, vines and birds in flight. The central knob has two holds to contain a silken cord to carry the mirror. These mirrors were also intended to be mounted on raised stands. The burnished

mirror back is partly corroded.
Exhibited at Los Angeles Museum.

26. SILVER PLATE

On the inside outer edge of the plate there is a border showing the Hui Wen (everlasting scroll design).

Just below this border is a border showing the conventional flower scroll design. At the bottom of the plate, there are two borders—one showing incised (?), or repoussé design, of Frog, Turtle and Fish, each holding a weapon. And narrow border with the conventional flower scroll. On black lacquer stand.

The designs—all after the Han pottery.

27. PAIR SILVER STATUETTES OF OFFICIALS

Well-molded hollow silver statuettes of officials with smiling countenances, their hands clasped before them in the long sleeves of their robes. With stands. These figures are commonly known in pottery, although quite rare in silver. Four of these figures (including the Kempe figure) were found in a burial ground near Lo-Yang, Honan. (Illustrated in Oriental Art, Vol. X, No. 1 (Spring, 1964)

Similar silver tomb figure of a woman of the same period, *Kempe,* Gyllensvärd, 130 a, b, p. 201. Similar figures are in the British Museum and the Victoria & Albert Museum. Ref. Hobson, A T'ang silver figure (British Museum Quarterly, 1926); L. Reidemeister, Über einige typische Chinesische Falschungen (Ostasiatische Zeitschrift, 1929); U. Percival Yetts, Chinese Tomb Figures in Silver (Ostasiatische Zeitscrift, 1929); Sekai Toji Zenshu (Tokyo, 1956), Plate 9. Note that Plate 8 is similar to woman in Kempe collection.

28. GOLD MIRROR

Gold mirror, mounted on plain bronze mirror frame.

Outlined with six flower petals. There are three borders. The outer border, shows design in relief of six animals, six birds, and six bunches of grapes. The second border shows design in relief of grapes and six animals. The center border with design in relief of grapes, three animals and three birds.

This mirror illustrated in Chinesische Kunst, Berlin Exhibit. (1929), Illustration 1163.

29. JADE ANIMALS

Yellow jade sheep with two young lambs. With brown veinings. The feet are carved on the under side. With stand.

30. ANIMALISTIC JADE FIGURE

This figure of mixed brown and white jade is of a strangely contorted animal with its head appearing from within an animal coil. Striated or "combed" marks appear upon the eyebrows and back of the head as sort of a mane. Incised design of curves and commas appears on the body and circles from which spines or hairs project are seen on the coil.

It is difficult to attribute this jade firmly to any period, but it is somewhat similar to a very forceful jade "dragon" attributed to T'ang in the Desmond Gure Collection, Illustration 82, p. 179, *Chinese Art,* Goldschmidt & Moreau (1960). "Professor Salmony considered this article to be a masterpiece of jade sculpture." *Chinese Ceramics, Bronzes, and Jades,* Plate 157 b (note similarity of "comb marks").

31. SUNG JADE

Softly polished lustrous white jade with darker shades along outer edges. This exquisite Buddhist figure (possibly an apsara) is represented as in flight. Her hands hold what appears to be a lotus blossom. The garments and surrounding scrolls are exquisitely done. This figure is typical of many jades carved during the Sung period. An unusually fine piece.

32. JADE PLAQUE

Mutton fat jade female figure, in T'ang style attire within a circle. On the back are four sets of double holes. This plaque in size, type of figure, and measurement of holes conforms to a set of plaques and certain remains of belts found in T'ang tombs, as described in *Transactions of the Oriental Ceramic Society* (London) 1953–54, 23–25, Plates 1a, 1b. These jades, commonly known as *hsi-yü,* were imported from Sinkiang. The plaques were originally attached to a leather belt; through two slanting holes, silver cords were passed to fasten the plaques to the belt. The decoration is carved in low relief.

A leather belt with square and oval plaques is illustrated in *Treasures of the Shōsō-in,* Tokyo National Museum Catalogue (1959).

A glass plaque of the same type was illustrated in the *Venice Catalogue of Chinese Art,* 1954, figure 250, in the National Palace Museum of the Republic of China at Taichung, the large portrait of Emperor Tai Tsung of the T'ang Dynasty (A.D. 627–649) shows him wearing a belt of red leather or red silk with similar jade plaques. See text for further discussion.

33. JADE SWORD ORNAMENTS

(A) One of yellow and green jade, carved with conventional Tao T'ieh type decoration. Slightly corroded.
(B) The second ornament is of yellow-amber color, with dragons carved in high relief.

34. JADE ORNAMENTS

Clear yellow jade girdle hook, decorated with convenitonalized cowrie shell. Slightly corroded.

Beige-brown disc with concave outer edge and raised central section, central circular knob pierced with two holes. Back smoothly polished.

35. YELLOW JADE CIRCULAR DISK

Yellow jade circular disk with brown markings showing cowrie shell motif. The central hole is approximately 2 1/2 inches in diameter.

36. SMALL JADE ANIMALS

These charming and somewhat humorous jade animals consist of a horse, a ram and a tiger. The tiger is incised with short curving lines to indicate fur. One rear leg of the tiger and of the ram is foreshortened, giving the effect of perspective. The curving right front leg of the horse achieves the same effect.

These animals may have been used as inlays in lacquered wooden objects or in the lacquered surface of a bronze mirror.

A jade horse, much larger, Illustration 232 in the Venice Exhibition Catalogue, *Arte Cinese, 1954,* is attributed to "Yüan" (?)" The only reason given is a comparison with a woodcut from the Ku Yu T'u p'u (A.D. 1341), as reproduced in Laufer's *Jade.* This may justify the "(?)", but not the attribution.

37. GLASS BRACELET

A lovely translucent bracelet of pale green glass, the ends comprising the heads of dragons, their mouths open, confronting the pearl of immortality.

The surface is partly covered with calcined matter resulting from burial.

Repaired behind the neck of each dragon.

A very similar bracelet was illustrated in the Venice Exhibition "Arte Cinese," 1954.

Gyllensvärd has seen recently discovered glass bracelets in China, and thinks they may be Sung Dynasty.

39. SILVER GILT AND JADE EARRING

White jade carved in the form of a fish, with incised lines to indicate fans and gills, the jade fish is partly covered by silver gilt decoration suggesting the head and eye of a fish, along with wavy lines suggesting water. Once one of a pair. On lucite stand.

Exhibited at University Museum, Philadelphia, and at Cleveland Art Museum, 1963.

40. GOLD AND SILVER HAIRPIN

Gold filigree setting including pearl, on plain silver stem. On lucite stand.

Gold floriform setting in beaten and filigree work on gilded silver stem. On lucite stand.

41. SILVER HAIRPINS

Pair of hairpins in beaten silver, the heads of which are of gilded silver. These wide heads are embellished with a rich openwork representation of floral scrolls extending from the mouth of a dragon. In the scroll work of the pins are two confronted mandarin ducks in flight. The long pins are of flat bifurcated silver.

Similar pairs in Röhsska Konstlöjdmuseet, Gothenburg, and Kempe Collection, Ekolsund, Sweden.

"Chinese Gold and Silver" Kempe Collection, Gyllensvärd (1953), p. 197.

42. GOLD FILIGREE BEADS

Pair of gold filigree beads, 14-sided, with delicate work in each panel, corners surmounted by small gold knobs. L. Wannieck (1954)—CH Paris

43. SMALL CROWN ORNAMENTS

Four small ducks in gilt silver filigree work. The bodies are made from plaited threads simulating feathers. The wings are principally of plain silver. The underside is a plain sheet. At the tail is a small rosette surmounted by a

metallic "pearl". There is also a small "pearl" of metal in the mouth. The body is gilt. The plain surfaces of the wings have been grooved and probably were once filled with kingfisher feathers. The head of one bird is missing. These birds were very likely part of a royal lady's crown.

Kempe Collection, Gyllensvärd, 48, p. 105; see also: Chinesische Kunst, Berlin Exhibit. (1929), illustrations 448, 449.

44.	(A)	SILVER SCISSORS	Blades decorated with incised scrolls, floral designs and palmettos. Tension operated ring handle in plain silver. (See *Kempe Collection,* Gyllensvärd, 106, 107, p. 164.)
	(B)	SILVER HAIRPINS	A pair of undecorated "utility" silver hairpins, of a well-known shape, frequently encountered. Has stand of red velvet over wood. Lucite base. (See *Kempe Collection,* Gyllensvärd, 51a, p. 106.)
	(C)	SILVER AND GOLD HAIRPIN	Long, the pins of silver, the head topped with beaten gold in raised design. (See *Kempe Collection,* Gyllensvärd, 88, p. 140.)
	(D)	SILVER HAIRPINS	Plain silver pins, topped by silver birds, supporting a series of silver loops forming setting for a jewel (missing).
45.		GOLD EARRING	Gold earring in the shape of a bat—the emblem of good luck—with original pearl inset. Similar pieces are in the Kempe Collection. A gold wire loop at the back is intended to hold the earring in place by fitting closely back of the ear. The earring is on a small lucite stand.
46.		SILVER HAIRPIN	An exquisite silver hairpin for a young girl. Depending from a flat silver pin (on the back of which are two un-deciphered characters) are two delicate silver springs, to each of which is attached a small beautifully carved white jade bird. Hanging from the beak of each bird are small silver chains to which are attached two small enamelled silver bird-shaped pendants and a small enamelled silver oval pendant at the end. On the back of each bird is a silver rosette, which may once have been enamelled. Much of the original "kingfisher blue" enamel still remains on the pendants. On lucite stand.

47. HAIR PINS

A set of silver-gilt filigree hair pins, comprising eight of various designs, all reputedly excavated from the same tomb. Three pins have colored glass bead tops. Five pins bear unusual and finely wrought dragon heads, two of which have lovely open work handles of silver gilt.

48. (A) SILVER HAIRPIN

Lady's silver hairpin, two dragons facing outward, surmounted by blooming peonies in repoussé. The pair of flat pins are plain.

(B) SILVER TWEEZERS

Said to be used to pull up lamp wicks, as the scissors were used to trim wicks. (Another theory: tweezers were used to pluck eyebrows.) Of silver and bronze, containing tiny ear cleaning cup on handle end. Tweezers were sometimes connected to scissors by a short chain.

(C) SILVER SCISSORS

Pair of scissors in beaten silver. The handle is shaped as a spring in the form of a figure 8. Undecorated, except for narrow line along border. With fitted case. See description of two pairs of decorated silver scissors in "Gold and Silver in the Kempe Collection" (1953) at page 164.
See: Chinesische Kunst, Berlin Exhibition (1929), Illustration 424.

49. MOTHER-OF-PEARL COMB

Comb top in carved mother of pearl. Decorated on a background of leaves and plants with two birds apparently attacking an unidentifiable animal. A circular rosette appears on each side of the birds.

50. MOTHER-OF-PEARL BOX

A box of clamshell shape in carved mother-of-pearl. The top decorated with a curly-haired dog on a bed of flowering plants. The bottom bears four raised cloud forms on a background of etched plants and parallel lines.

51. (A) GREEN GLAZED BOWL

Shallow pottery bowl covered almost to the foot rim with a dark green glaze. The lively tone is due to copper oxide in the glaze.

(B) ELEPHANT AND BOWL

Standing elephant on base marked with wavelike design. The elephant bears a stemmed bowl supported by two human figures with crossed legs and two bearlike figures. The outside of the bowl is marked by a series of parallel

ridges or bands. The glaze is fairly uniform dark green. The inside of the bowl being partly glazed and partly clay.

52. **RARE BUFF WARE PILLOW**

Five Dynasties (A.D. 907–960) pillow of buff ware with light brown glaze, in rectangular form with model of temple inside. Two temple eaves project from either side towards a round arch opening, and under them stand guardian lions, front and back. The ends have *t'ao t'ieh* masks with open jaws. These designs are all pierced.

53. **GREEN AND YELLOW GLAZED POTTERY PILLOW**

Oblong, with one incurvate side incised and decorated in green, yellow and *rouge de fer* with a long-tailed songbird perched in branches of leaves and berries, flanked by small panels of flowers.

54. **TRIPOD INCENSE BURNER**

Wide-mouthed vessel, the projecting lip with two angular loop handles, the body formed of three conjoined elephant heads, the trunks forming the tripod supports.

55. **(A) CHANG SHA BOWL**

Miniature bowl with light, rather flaky brown glaze. Lower part of bowl and foot show red brown clay, unglazed. Chang Sha.

(B) YOU CHOU VASE

Miniature vase with graffito linear decoration under incomplete light brown glaze. Has stand; in fitted box. You Chou Yao, Honan Province.

56. **YELLOW-GLAZED POTTERY AMPHORA**

Ovoglobular vessel with ring-molded neck and two high animal-headed loop handles joining the shoulder, which has three relief-molded medallions on either side; with pale yellow glaze. Has stand.
See: Sekai Toji Zenshu (Tokyo 1956), Plate 3.

57. **BIRD-HEADED EWER**

Pear-shaped body with large looped handle. This bird-headed ewer is in four-color splashed glaze of blue, green, brown and straw color. On each side of the body is an oval medallion. In one oval is a phoenix standing on a lyre, surrounded by flowers. On the other side is a mounted archer facing backward on a horse in full gallop, surrounded by flowers and plant forms. Both medallions are in relief. The mounted horseman reveals undoubted Sassanian influence. The clay is buff. This ewer is illustrated in Cox, *Pottery and Porcelain,* Vol. I, Plate 33.

See: *Chinese Ceramics,* Los Angeles Museum, 1952, Illustration 67; *Art of the T'ang Potter,* Prodan, Plate 114; Sekai Toji Zenshu (Tokyo 1956), Plate 57.

58. TALL NECKED VASE	Vase with tall neck, three-color glazes, plus blue glaze, applied medallions. As usual, glazes do not run entirely to bottom of vase. See Sekai Toji Zenshu (Tokyo, 1956), Plates 60–62; Body of vase similar to bowl in W. H. Nelson Gallery, Kansas City.
59. GRAIN JAR	A jar splash-glazed freely in green, blue, brown and straw colors, the glaze stopping almost at the foot over brownish clay. Near the top, front and back, are brown rosettes with a straw colored disk in the center. The handles engaging little straw colored mice, presumably seeking to get at the grain within the jar. Rather crude design, doubtless of provincial origin.
60. GLAZED JUG	This jug, glazed in two shades of brown has an ovoid body, short spout and one large and two small triple-stranded loop handles. The large handle and the lip have been repaired (probably in Japan). The glaze stops just short of the foot. There are three medallions, one of a dancer and two of musicians. The dark brown glaze was applied roughly in circles in an attempt to cover the figures in relief, but this was not wholly accomplished. The lighter glaze is olive-brown. The clay is gray, burned reddish.
61. THREE-COLOR SPLASH-GLAZED BOWL	Small bowl, the interior mottled with white, green and yellow splashes, the exterior decorated with an intricate floral design in low relief on the dotted background signifying a plentiful harvest. See: Chinesische Kunst, Berlin Exh. (1929), Illustration 405; Chinese Ceramics, Bronzes and Jades, Sullivan, Plates 18c, 18d; Sekai Toji Zenshu (Tokyo, 1965), Figure 105.
62. DECORATED SIX-LOBED DISH	A plate on three small spiral legs. Straw color, with green rim. Design in green, deep blue and dark amber. Back in mottled, iridescent, amber tones.

This plate, from the Cox Collection, is illustrated in Cox, *Pottery and Porcelain,* Vol. I, as Figure 260, p. 119.

63. EIGHT-LOBED DISH

An eight-lobed dish, in blue, brown and white glaze, molded. The interior of the dish is glazed in alternating bands of blue, white and brown.

64. WHITE STEM CUP

A white pottery cup with transparent white glaze. Skill-fully potted. A forerunner of the celebrated Ming stem cups. The forerunner of white porcelain.

Sekai Toji Zenshu (Tokyo, 1956), Plate 19. Chinese Ceramics, Los Angeles Museum 1952, Illustration 98.

See White T'ang cup, Seattle Art Museum, Cox, *Pottery & Porcelain,* Vol. I, 104.

65. YELLOW-GLAZED TERRA-COTTA MODEL OF A HOUSE

Small roofless four-walled house with open entrance and window; glazed nasturtium yellow, centering a blue-glazed flange 'ramp' or 'catapult' at centre.

66. TOMB FIGURE OF A PIG

Small figure, glazed yellowish brown, and of the con-ventional type.

67. SMALL HORSE

Small standing horse on a cut-out rectangular unglazed base, coated with straw-colored glaze heavily splashed with blue glaze. The mane and front of face are in a dark brown glaze.

68. SMALL HORSE

Small pottery horse on a square, unglazed base, coated with a creamy glaze with large blue splashes. This is known to be one of a pair, shown in New York City about 1947. These small horses are much more rare than the larger ones. The glaze and color are exceptional.

69. TOMB FIGURE OF A COCK

Recently excavated at Lo Yang in the province of Honan, the glaze of this figure is quite interesting. Instead of the usual "straw-color" (a transparent glaze with a faint tinge of yellow) we here find the same transparent glaze with a

faint tinge of green; the comb and beak have been glazed with the usual brown color, which has run downwards with a rather pleasing effect of the coloring of the feathers. On the tail a small accidental bright green spot caused by a small particle of more concentrated copper, shows plainly in the soft lead glaze.

70. TOMB FIGURES OF CAMELS

Small well modelled figures in unglazed reddish clay. See: *Chinesische Kunst,* Berlin Exh. (1929), Illustration 274.

71. CAMEL

A Bactrian camel in brown, green and yellow glaze. In collected pose, head upraised. Similar figures: Naprstek Museum, Prague, *Chinese Art,* Hajek, Plate 117.

72. TALL COURT LADY

A tall extremely elegant court lady. A long scarf hides her hands, the bell-shaped dress reveals shoes with up-turned toes. Coiffure elaborate. Feminine fashion of this period is amazingly varied and elegant, both in cut of clothes and fantasy of hair styles. Cold pigments used on unglazed head. See: M. Michel Calmann Collection, Illustration 133, p. 308.

73. TOMB GUARDIAN

Dignitary. Civil official, probably Uighur Turkic Type. Body glazed white, green, yellow and brown. Head unglazed. See: *Art of the T'ang Potter,* Prodan, Plate 65; Cox, *Pottery and Porcelain,* Vol. I, Plate 30(b).

74. COURT LADY

With high headdress and necklace with pendant of beads in the form of a cross, the lady wears a long pleated dress (the pleats emphasized by red pigment applied on the buff clay and mostly covered by yellow and nasturtium-green glaze). Her hands are concealed within a long hanging scarf, also wrapped around her shoulders. There is pigment at the lips, neck and arms.

[164]

75. SPIRIT OF
THE EARTH

This tomb figure, which is glazed in the typical T'ang green, white, and yellow splash-glaze, represents the SPIRIT OF THE EARTH, whose duty it was not only to protect the corpse against malignant spirits, but also to prevent any sort of violation of the grave.

See Cox, *Pottery and Porcelain,* Vol. I, p. 31(a).

76. SEMITIC
MERCHANT

Unglazed, with considerable areas of red pigment. The clothing is of Sassanian or Persian inspiration and the hat is of felt, which could be folded flat.

Westerners Among the Figurines of the T'ang Dynasty, Mahler (Ismeo) page 10, plate 2c, d. White, W. C., *Chinese Jews,* Toronto 1942, Part I, page 10. *The Art of the T'ang Potter,* Plates 79, 83.

See: *Chinese Ceramics, Bronzes and Jades,* Sullivan, Plate 13a; Sekai Toji Zenshu (1956) Tokyo, Plate 103.

77. SILVER
BOWL

Silver-gilt bowl resting on a flaring foliated base, ornamented with petal-like design. The outside of the oblong ovoid cup is plain, the inside being incised with florals, fishes and a fret lip rim band. Coated with gilt.

This bowl was shown in C. T. Loo's Exhibition of Chinese Arts (1942) as illustrated, 183.

Kempe Collection, Gyllensvärd, 119a, 119b, p. 184. A similar but twelve-lobed dish in gilt bronze is shown as Illustration 59, p. 128, *Chinese Art,* Lion-Goldschmidt and Moreau-Gobard (1960). An eight-lobed bowl has been in the Shōsō-in, Nara since the eighth century. See also eight-lobed silver bowl in Victoria & Albert Museum, plate IXa, *Chinese Art,* Mackenzie (1961).

78. PAIR OF WHITE
DISHES

Two flat saucer-shaped dishes with conventionalized floral design in regular circles around bottom of bowls. White ware and creamy white glaze. Hsing yao from Hsing Chou, Hopei Province. Extremely rare. Both in fine condition.

79. ZODIACAL
FIGURE

Tall human figure, with well-modelled head of a lion. The glaze is partly iridescent and of an unusual light green color. Standing in calm pose, a creature of great dignity. This

[165]

figure is from the outer Zodiacal circle of twenty-eight animals. The inner circle has but four figures: dragon, phoenix, tiger, turtle. The tiger was indigenous to China, but the lion was known only in zoos and as gifts from foreigners to Chinese officials or communities. In excellent condition.

80. BACTRIAN CAMEL

A standing camel with arched neck and open mouth, two humped. In four-color glaze of blue, green, straw-color and brown. The blue and green glazes are concentrated in the saddle cloth, a very effective artistic device. This fine terra cotta tomb figure is in superb condition. The expression is excellent and the modelling shows considerable skill.

The Art of the T'ang Potter, Prodan, page 28, plate 12. See camel in tomb retinue, illustration 478, C. T. Loo's Exhibition of Chinese Arts (1942).

81. MINIATURE CUPS AND JARS

Three pottery miniature wine cups, two small globose bowls and two small jars, one with twisted rope handle and one with two small loop handles decorated with appliqués below the neck. All are coated in three color glazes: blue, yellow and creamy white, the blue glaze quite prominent in most.

82. ARTIST'S WRIST REST

In brown, green and yellow glaze. The lower part is a seated bull, the top eight-lobed, the pattern consisting of a six-petalled leaf central design and an outer border of eight semi-circles with rounded ends. This unique object was used to support the wrist of painter or scholar, while holding a long brush (usually of camel's hair or the hair of other animals, e.g. rabbits).

83. LARGE DISH

Decorated in green and yellow glazes, the background a cream color glaze, continuing over the rim for about two inches on the back. Remainder of the back unglazed, showing a buff-colored clay. The central rosette is green with yellow circles, the central circle in green; surrounded by linked heart-shaped floral designs in green and yellow. Connecting the outer rims of the design are three lobed floral motifs in yellow.

Supported on three legs resembling animal feet.

| 84. | TOMB FIGURE OF A DWARF | This small dark-green glazed figure of a Near Eastern dwarf court jester with Tartar cap, is remarkable for the state of preservation of the features of the face and the black upturned mustache, painted with pigment colors, and still in original condition. Rarv. |

84. TOMB FIGURE
OF A DWARF

This small dark-green glazed figure of a Near Eastern dwarf court jester with Tartar cap, is remarkable for the state of preservation of the features of the face and the black upturned mustache, painted with pigment colors, and still in original condition. Rarv.

85. LARGE PLATE
IN FOUR-COLOR
GLAZE

A large plate, on three legs, the outer edges and border of deep green glaze. The central medallion, covering most of the plate is of plant forms with green stems and blue blossoms, rising from a central circle of brown which also supports smaller buds of brown on a white background. Within the brown circle is a circle of blue and green leaves. Within this circle, in turn, are alternating small buds of green and blue surrounding a central disc of brown glaze. The back of the plate bears a brown glaze, which runs part way toward the center, leaving exposed a rather large area of pinkish gray clay. The dish is supported on three feet.

A similar plate is in the Freer Gallery, Washington, D.C. See also: *Chinese Ceramics*, Los Angeles Museum 1952, Illustration 70; Seaki Toji Zenshu (Tokyo, 1956), Plates 80, 81. Also Plate 128, p. 298 colored glaze (similar to mine except for bird in center). Clearly akin to Sassanian silverware. Supported by three feet, a characteristic more suitable to metalwork than to ceramics. Octagonal motif of stylized lotus flowers. Glaze divided by incised lines to keep the colors separate. The blue of the reverse flows freely over a cream ground." Collection of M. Michel Calmann, Boisrond.

86. MARBLEIZED
BOWL

Chao Tso small bowl, of dark brown and off-white color clays, marbleized under a transparent glaze. Perfect.
See *Chinese Ceramics, Bronzes and Jades*, Sullivan, Plate 22b; three marbleized bowls in M. Michel Calmann Collection, Illustration 132, p. 306, Lion-Goldschmidt and Moreau-Gobard (1960).

Marbled decoration is one of the most delicate of T'ang skills. It consists in mixing dark and light clays so that the more or less regular veined decoration is in the body itself. Bowl was then covered with colorless or yellow glaze.

87. TOMB
FIGURES
OF DOGS

Very unusual both in modelling and in coloring. These dogs bear no resemblance to the usual tomb dogs of chow or greyhound type, nor to the more rarely seen huge mastiff-type watch dogs, but seem rather to represent hunt-

ing dogs, or possibly shepherd dogs (Note collar and bell around neck).

Painted in green and orange-red pigment lightly stippled and brushed over with transparent glaze, these dogs are remarkably different, hence of unusual interest.

See somewhat similar pair exhibited C. T. Loo, Paris (1962). See *Chinese Art,* Burling, 183.

88	TOMB FIGURE OF A MAN	This tomb figure, practically identical in appearance with the one in the Metropolitan Museum of Art which is illustrated in C. Hentze's "Chinese Tomb Figures" plate 67-A, represents a foreigner, probably a Manichean (Christian) Missionary. The polychrome pigment decoration of this figure is in excellent condition because it is a recent excavation. Otherwise pigment—that is, unfired—colors remain only as a trace in the deep folds of garments and other protected surfaces, as they rub off very easily.
89.	HEAD OF A LADY	Unglazed head of unglazed clay, with headdress of large side loops. Appears to be the individualized "portrait" of a young girl.
90.	(A) KNEELING WOMAN	A crudely fashioned female figure in bright green glaze stopping at the waist, over whitish clay. She wears a rounded hat, in the center of which is what appears to be a bird design. On stand.
	(B) WOMAN WITH CHILD	Appealing small figure of a mother nursing her child, her left hand resting on the head of a chow dog. She is seated on a bench or rock. Her hair comes forward in a central curl or knot. She wears a feathered or leaf-covered cape, with a tasselled end. Her dress is pleated and held with a ropelike belt tied in a frontal bow. The face is glazed in pale greenish white, the eyes indicated by brown glaze. The baby, the woman's hair and dress are in bright green glaze. Her arms and part of the dog's head in colored glaze, her legs, seat and most of the dog in brown glaze, which ends near the bottom of the figure, revealing a buff-colored clay. A most intriguing piece. Has brocaded stand.
91.	HORSE AND RIDER	In reddish pigment applied over gray clay, the horse in in collected pose, the lady seated on a saddle blanket in contemporary attire with headdress in topknot, carrying some sort of musical instrument or grain container. See Cox, *Pottery and Porcelain,* Vol. I, 91.

92. WHITE GLAZED EWER

Rare small white glazed Ewer, fashioned from well lavigated porcellanous ware, having a pear-shaped body resting on a low circular unglazed foot with a flat base. From the round shoulders a trumpet-shaped neck emerges with a rounded lip. A loop handle of strap form is knotted at the apex. It has a small cylindrical tapering upright spout. On two sides, diametrically opposed, are floral ornaments composed of five rounded petals in high relief. Invested with a smooth creamy white glaze, partially crazed and irridescent. The glaze stops in irregular volutes near the foot. The interior of the neck is glazed. Slight abrasions at lip and body. T'ANG (Circa: 8th century A.D.)

93. SPLASH-GLAZED TERRA-COTTA STATUETTE OF A LOKAPALA

Grotesque figure with upraised right arm, wearing a green, nasturtium yellow and brown splash glazed armored tunic with dragon-mask epaulettes; standing on a reclining bull; the head unglazed. Has stand. (N.Y. Educ. Inst.) See: Cox, *Pottery and Porcelain,* Vol. I, Plate 31 b; Sekai Toji Zenshu (Tokyo 1956), Plates 116, 117.

94. YUEH VASE

Small vase with seagreen glaze characteristic of the ware; with rare iron brown spots. In perfect condition. Yueh Yao. See: *Chinese Ceramics,* Los Angeles Museum, 1952, Illustration 48.

95. TERRA COTTA HORSE

A large standing horse of terra cotta, a part of the tomb furnishings of a dignitary of the late seventh or eighth century. This horse is quite similar to one buried in the tomb of General Yang, A.D. 693. Coated with an overall glaze (except the saddle) in green, straw yellow and brown, the horse wears handsome harness of Sassanian style from which rosettes or ornaments depend in front of and behind the saddle and above the forehead. The horse's mane is stylized and coated with a deeper yellow glaze. The saddle is unglazed, and partly decorated with red pigment. These horses were placed in tombs in pairs, usually with a pair of camels and numerous other figures of personages, including athletes, dancers, musicians, "mourning women" on horseback, women polo players. Also included were numerous animals, especially dogs and pigs. It was felt that the departed personage should be accompanied into his

new life by persons and animals familiar to him during his earthly existence. The practice largely disappeared with the end of the T'ang Dynasty.

Cf. Westerners Among the Figurines of the T'ang Dynasty, Istituto Italiano per il medio ed. Estremo Oriente (IsMeo), Plate XVIII b; Sekai Toji Zenshu, Vol. 9 (1956), Plate 124; Cox, Pottery and Porcelain, Plate 29, p. 113. The art of the T'ang Potter, Plate 54.

96. YUEH WARE VESSEL

A well-modelled chimaera, or lion, in light brown glaze, with wings (in Babylonian style) extending from fore and rear legs. Described as an artists water vessel or as a "lion candlestick." Probably made at Chiu-yen.

This piece was exhibited as illustrated 487, C. T. Loo's Exhibition of Chinese Arts (1942). See Chinese Ceramics Exhibition, Los Angeles Museum, 1952, Illustration 101; *Art of the T'ang Potter,* Prodan, Plate 17; *Chinese Celadon Wares,* Gompertz, Plate 7 b, Lord Cunliffe Collection.

97. SMALL GREEN BOWL WITH COVER

This little bowl with smooth, occasionally dappled apple green glaze, has its original cover, which is especially unusual in the small pieces, although always rare.

The glaze stops short of the base, exposing its white clay surface. The base which stands on three small feet, is unglazed.

A mostly graceful object of unusual color.

98. MINIATURE JARS

Pottery miniature jars on flat foot rims, partly coated in san t'sai three-color glazes.

99. MINIATURE JAR

A miniature jar of ovoid form with four strap handles. Buff pottery with splashed white, green, blue, and yellow glazes.

100. WINE CUPS AND TRAY

A pottery set of seven wine cups on small flat foot base, curved sides, rolled liprim; coated in and out with T'san T'sai (three colors) glazes, green, yellow and creamy glaze running short at the foot.

A pottery small round tray on flat foot base, flat form with everted lip-rim. Partly coated in T'san T'sai glazes, matching the wine cups. Center of tray and under base unglazed.

101. DISHES

(A) Whitish clay, covered by pale slip straw-colored, almost white. The central medallion in well-defined usual threecolor glazes plus glaze.

(B) Whitish clay, covered with unctuous white glaze almost to broad shallow foot rim. One of the earliest examples of T'ang white ware. Hsing Yao.

See: *Chinese Ceramics,* Los Angeles Museum 1952, Illustrations 95, 97; Sekai Toji Zenshu (Tokyo, 1956), Plates 30–33.

102. WHITE GLAZED BOWL

A white glazed porcellaneous bowl, with typical broad Hsiang Yao type foot.

A number of these bowls are illustrated in Vol. 9 *Sekai Toji Zenshu* (Catalogue of world's ceramics), Zauho Press, Tokyo, 1956.

A similar bowl, illustration 60, *Kinesisk Kunst,* Copenhagen Exhibition, 1959, is compared to the finds at Samarra, a city destroyed in the latter part of the ninth century.

103. SMALL WHITE JAR

A pleasingly shaped small ovoid jar, with contracted neck and flanged, everted cup-shaped mouth. This jar has a low foot and flat base of hard, white ware with finely crackled creamy-white glaze.

See Figure 14, Vol. 9, *Sekai Toji Zenshu* (Catalogue of world's ceramics), Zauho Press Tokyo, 1956.

A similar jar, with cover, is illustrated at Plate 26a in the Barlow Collection, *Chinese Ceramics, Bronzes and Jades,* by Michael Sullivan, Faber and Faber, London, 1963. A tomb figure of a young girl holding a similar jar with cover appears as Color Plate A and on the dust jacket of the same volume.

Sullivan notes (page 36): "The earliest datable example I have come across is in Yueh celadon, excavated from a Chin Dynasty tomb dated 345 (A.D.) at Nanking, illustrated in *Kaogu* 1959, p. 6, Plate 5."

104. "SPITTOON"

An old Chinese porcellanous Leys Jar, entirely covered in a cream glaze.

See Pl. 43, Spittoon, celadon glaze. The color of the celadon glaze was still faintly yellowish. Introduction by Seiichi Mizuno, p. 3, height, 20.5 cm.; diameter, 15.6 cm., Yüeh ware—T'ang Dynasty—A. D. 750–900

SEKAI TOJI ZENSHU, vol. 9 (Sui and T'ang Dynasties), the ZAUHO Press and The Kawade Shobo (1956) Tokyo.

See "Arte Cinese", catalog, Venice, Exposition 1954, Illustration No. 368 (Referred to as "white porcelain vase"); Arts of the T'ang Dynasty, O.C.S. Exhibition, London, 1955, Illustration Number 212, Coll. Dr. Carl Kempe (referred to as "Flower holder"); Michael Sullivan, Chinese ceramics, Bronzes and Jades, Barlow Coll., Faber and Faber, Ltd. London, 1963, Illustration No. 29a (referred to as "Spittoon or Slop Bowl"); same known also in Yüeh, Honan, Hunan and Liao Green Glazed Ware, as well as in glass. (Shōsō-In Treasury, Nara) and in silver (excavated from Yüan grave), the shape probably of Near Eastern Origin, Ibid, p. 39.

See also, for another 'spittoon' with somewhat higher and deeper lip, pl. 23, *The Art of the T'ang Potter,* Mario Prodon, The Viking Press, New York, New York, 1961. (Published in 1960 in London by Thames and Hudson, Ltd.). Described as: "Low vase (perhaps a spittoon) 10 cm. high. Shing-Yao porcelain with a cream colored glaze. Royal Ontario Museum, Toronto.

In my opinion, there is strong ground for an alternative supposition as to the use of this vessel. The quality of the ware suggests that this may have been a flower bowl to hold a single, or perhaps several, blooms.

Moreover, as to the common usage suggested, the small size of the central opening presupposes that the Chinese were more accurate in employing this sort of vessel than were their western counterparts!

105. SMALL JAR
 WITH COVER

A pottery ovoid jar, (with own lid) on a flat base, with small short neck and grooved shoulder, the cover with a high finial or knop, both coated with an amber colored glaze dropping on the vase (some cups show partial glaze erosion and iridescence), in heavy tears around the foot.

A similar glaze treatment is pictured as Plate 17a, a jar with cover in the Barlow Collection, *Chinese Ceramics, Bronzes and Jades,* Michael Sullivan, Faber and Faber, London, 1963.

See especially discussion of these jars at P. 113 (Illustration 98), *Art of China and Japan,* Peter Swann, Thames and Hudson, London, 1963.

106. BLACK AND BROWN GLAZED JAR

A pottery jar on high foot rim, ovoid body, tall broad neck, ornamented with loop handles, partly coated in brilliant black glaze with brownish splashes.

The glaze on this excellent Honan jar ends about one-third from its base. The unglazed portion and base are of pinkish clay.

A somewhat similar Honan jar with the same style of glaze application (but in brownish-black) is illustrated on Plate 176 at P. 385, *Chinese Art*, Lion-Goldschmidt and Moreau-Gobard, Universe Books, N.Y.C., 1965.

107. GILT BRONZE BUDDHA

A gilt-bronze Maitreya Buddha, seated with legs pendant on a double lotus throne. The robe falls in parallel folds over the front of the body.

A similar gilt bronze Buddha is illustrated in the *Los Angeles Exhibition, "T'ang", 1957.*

108. GILT BRONZE STATUETTE

A small, handsomely wrought figure of a Lokapala, or tomb guardian.
See Chinesische Kunst, Berlin Exhibition (1929), Illustration 303.

109. PAIR OF GILT BRONZE ORNAMENTS

A pair of rare gilt bronze appliques, one in the form of a stylized cloud form, suggesting Persian origin, and the other a rather stylized duck in flight. Both objects are partly covered by a bluish-green patination.

Interestingly, both these motifs are to be found, somewhat modified, in modern Korean art forms.

110. GOLD AND BRONZE CUP

This cup is part bronze and part gold. It is a most interesting mortuary piece. The Malachite patina incrustations are beginning to show. This ceremonial cup, a sacred vessel for wines in religious ceremonies, is a signed Wei piece.

111. THREE LION DOGS

A pair of gilt bronze lion dogs of the T'ang period. The dogs are crouching, with open mouths and bared teeth. There are encrustations from burial.

The lion dog in the center has two puppies playing beside her.

112. GILDED CUP

Gilded bronze foliated chalice on wide expanding foot, repoussé lotus petals form the bowl of the vessel and the lip rim is everted. The all-over exterior decoration is formed by delicate patterns of flowers and scroll motives brought out by a background of punch-work.

Illustrated, Burlington Exhibition, London, 1935–1936; Los Angeles T'ang Exhibition, 195–.

Exhibited in *Exhibition of Ancient Chinese Bronzes and Chinese Jewelry,* Toledo Museum of Art, Toledo, Ohio, February to March, 1941, Catalogue #84.

See almost exactly similar cup, *Kempe Coll.,* Gyll. 108a, p. 167; also 11a, 11b, p. 168.

113. GILT BRONZE CUP

Oval cup, gilded, with incised decorations of flowers, plants, fruits and tendrils, on footed base. Inside and outside rim and outer base in key fret design, probably added later as is the rather crude handle, on the back of which is a flower surrounded by the key fret design.

114. STONE LION

Brown stone carving of a lion sejant rearing back on his haunches and snarling. The forelegs are fluted, a characteristic of the period and the body is slender. A very impressive, strong animal.

This lion (which so much resembles the British armorial lion!) may be of the early T'ang Dynasty. See catalogue, Oriental Ceramic Society, Loan Exhibition, *"The Arts of the T'ang Dynasty."* 1955. Illustrations 328 and 329. See also: *"The Arts of the T'ang Dynasty,"* Catalogue, Los Angeles Museum, 1957. Illustrations 41, 42 and 43.

NORTHERN WEI (A.D. 386–532)

115. GRANITE HEAD OF A BODHISATTVA

Rounded features, heavy-lidded eyes cast downwards, long lobed ears of wisdom, the hair dressed in a high topknot with a tiara of flowers and leafage. A serence face, sophisticated carving, the decorations on the head well executed. Some ancient damage to nose. Has stand.

116. BUDDHIST ALTAR TABLET (DATED)

Small stone stela ovalized shape, decorated on the front with a Buddha accompanied by two Bodhisattwas and two flying apsaras. Small figures of the donors at bottom. Inscribed on the sides and dated A.D. 542 10th Moon, 11th day, carved in a very fine granite and mounted on pink marble stand.

[174]

117.	**STONE STATUETTE**

Of mottled, brownish stone, a standing Buddhistic figure, its hands in the gesture of benediction. The figure, leaf-shaped mandorla, and base are carved from a single stone. The barefooted figure stands on a circular base, atop a larger square pedestal.

118.	**PAIR MARBLE LIONS**

Vigorously sculptured. The powerful heads, muscular bodies, the legs rest upon exaggerated claws. One lion is biting its forelegs, the other scratching its ear. The faces and manes are conventionally rendered in Buddhist fashion. Although lions are not native to China, they are common to its art. Pairs of lions were used to flank the Buddha's throne.

The Art of the Chinese Sculptor, Munsterberg, Plate opposite page 20; *Chinese Art,* Ashton & Gray, Illustrations 41a, 41b, page 124; *Introduction to Chinese Art,* Silcock, Plate XIX; Sekai Toji Zenshu (Tokyo 1956) Figures 11, 12, page 211. Note similar treatment of manes and ears as in pair here illustrated.

119.	**MINIATURE GRAY POTTERY VOTIVE STELA**

Gabled tablet, relief molded with a central figure of Buddha and two acolytes in an arcaded niche, beneath them foxes flanking a brazier; reverse with twelve characters. Has stand.

John A. Pope, Director of the Freer Gallery, states on this stela (May 11, 1964): "The twelve characters translate:

"Obtaining the Truth by means of the Karma of the Great T'ang and by means of this clay votive tile is as (positive a thing as) the wonderful Body of Bliss."

One or two brief explanations may clarify this a little. "Truth" refers to the essential and ultimate truth that is the essence of Buddhism. "Karma" refers, of course, to earthly deeds; in this case, the earthly political and military activities of the T'ang dynasty which determine its greatness. "Body of Bliss" is the second of the so-called "Three Bodies of the Buddha." These are: (1) the Body of the Law, which is the essential teaching of the Buddha, the spiritual content of the faith; (2) the Body of Bliss, which is the body of the Buddha himself, invisible to the high-level saints of the sect; and (3) the Body of Transformation, which is the body in which the Buddha can manifest himself to mankind in any way that happens to suit his immediate purpose...

We have two similar stele, both carrying the same text, in our collections here."

120 EIGHTH
CENTURY
RUG

"This is one of the oldest rugs existing to-day. It is probably as fine an example as any of those Chinese antique pieces in possession of the Japanese Imperial Household. Its known history dates back to the 8th century. It is made by a process of felting, rather than knot tieing.

In size it is approximately 8' 5" by 4' 3". The ground is now a grayish white, and the border is a brown, as in most of the old pieces. The figures are in shades of brown and indigo, the latter predominating. In the center are two phoenix birds in *yin yang* form, while surrounding these are various rocks, supporting a plant which is not clearly defined as to type. Interspersed are butterflies and clouds. In the corners the clouds are depicted in *ju-i* form, which establishes the Chinese origin of the design."
Gordon B. Leitch, *Chinese Rugs,* (New York: Dodd, Mead & Company, 1928) Not in Scott collection.

121 PRE-MING
WEAVINGS

"*(Upper)* One of the few pre-Ming rugs in existence to-day, a part of the collection in the Japanese Imperial Household. In colors it resembles the others with, brown border, and indigo and brown figures upon a gray background. The figures are conventionalized lotus flowers and rock plants.

(Lower) An 8th century felted rug, from the collection of the Japanese Imperial Household. The design consists entirely of lotus flowers and leaves, highly conventionalized. Colors are indigo and brown upon a white ground."
Leitch, supra., opp. p. 7

122 PIECES OF
EARLY
TEXTILES

Exhibited between glass in mulberry wood frames. Of the six fragments in the top frame, two (lower left and lower right) are from just before, or just after, the beginning of T'ang. The Japanese date these distinctively Chinese pieces, in accord with their own corresponding dynastic periods.

Curator Nishimura of the Nara Museum describes the yellow textile piece, with marks of hand-sewn thread "the bottom of a flag, Asiginu."

The smaller yellow-green piece at lower left is also des-

cribed as the "fragment of a flag, circle pattern of green Aya."

The upper left strip is a "ko kechi" of red color bearing roughly circular designs of white with red (dyed?) centers, remindful of certain Han Dynasty designs, but dated to the Heian Period, A. D. 784—897. This work could be either Chinese or Japanese.

The upper right fabric is of unknown origin. A part of the same beige fragment with self-pattern is preserved in the Hakutsura Museum, Kobe. Japanese. Probably based on Chinese designs in the Shōsō-in, Nara.

The provenance of the black violet center fragments is unknown.

The small lower center fragment of pale brown-yellow, described only as "*nishiki,* white diamond shape," is also of unknown origin.

The bottom frame illustrates four textile pieces, two of which (left and right) are from just before or just after the beginning of T'ang and are likewise referred to the Asuka Period, although these two are Chinese textiles.

The illustration on the left is described as "Ashigunu of red color." It is presently of a faded orange color to which a slender strip of darker orange is woven at the top. Referred to as the "bottom of a flag", it is more likely from the top of a flag or banner, unless the fragment is reversed in the glass frame.

The illustration at right is of a lovely fragment of yellow silk from the side of the piece. The pattern is "herringbone" and the condition is good. Described as "Yamagata mon of yellow Aya."

The two center fragments are each of brilliant half-orange, half-green silk. The color probably results from the use of tie-and-dye technique. Japanese. Described as "Maki-shibori, used for a costume of the Bugaku dance."

123. SASH
 FRAGMENT

Exhibited between sheets of glass.

The descriptions and attributions are validated in Japanese by Hyobu Nishimura, a former Curator of the Nara National museum, in his handwriting.

This single fragment is in red, green, and yellow. Once, quite possibly, one of the treasures of the Hōryū-ji Temple, another part of this exact brocade is preserved in the Tokyo National Museum and illustrated as color plate 84, p. 208,

[177]

Decorative Arts of Japan, Tomoyuki Yamanobe, Kodansha International Ltd., Tokyo, 1964.

Both the Tokyo fragment and the piece here illustrated, are part of a sash which belonged to Princess Kashiwade, the consort of Prince Shōtoku, then Imperial Regent for the Empress Suiko.

Known as Shu-Chiang brocade, it was produced in Shu-Chiang Province (now Szechwan) just before or just after the beginning of T'ang. The Japanese date it to their Asuka Period (A.D. 593—628). This same dating applies to four of the fragments illustrated on the other two frames. The province became famous during the third century A.D. for the rich red color in its textiles; the description of this piece is a reference to this famous color.

A result of compound weaving, several pieces of similar weave are preserved in the Shōsō-In, presumably a part of the Treasures sent from China to Japan.

This piece is made by a technique called *tate nishiki* (Nishimura calls it *Shokko nishiki*), whereby the pattern is woven with a multi-colored warp. This type of compound weaving was used in the Han Dynasty and is believed to be the oldest method of compound weaving. Subsequently, probably during the seventh or (more likely) the early eighth century, the technique of *yoko nishiki* brocade weaving, with patterns rendered by colored threads in the woof, was introduced to Japan.

China exerted great influence, directly and via Korea, upon the art of weaving in Japan.

This fragment (when with the Tokyo fragment) was a part of the Princess' sash. It is one of the oldest of these Chinese woven pieces extant. Yamanobe suggests that this very sash "might easily have been used as a model by Japanese artisans of the Nara Period."

Both pieces of this sash must have been stored, with other objects related to the Regency of Prince Shōtoku (A.D. 592 —628) at the Hōryū-ji Temple in Nara. At the beginning of the Meiji Period, most of the treasures connected with the Prince were presented to the Imperial Household and are today housed in the Tokyo National Museum.

Glossary

à jour: (or *ajouré*) pierced; showing light through; said of carving, metalwork, drawn work, etc., where the background is pierced or removed or where it is translucent.

apsaras: From Hindu mythology. One of the celestial water nymphs or dancers of Indra's heaven.

bodhisattva: One who has entered on the path of Buddhahood and will, generally in a future incarnation, become a Buddha. In art, bodhisattvas are often represented as youthful or, sometimes, as feminine figures.

boss: A protuberant ornament on any work, either patterned or carved, and of different material from that of the work or of the same.

casting: A metallurgical process, whereby molten metal, in "pure" or alloyed form is poured into a pre-carved mold, often of clay. When cool, the clay mold

is broken away, leaving the object with the design previously worked into the mold, in reverse.

celadon: A porcelain ware from China, grassy green to sea green in color.

chasing: Act or art of ornamenting material by means of chasing tools, as a hammer and chisel; also the design or work so produced. The process of finishing up the surface of casting by polishing and removing small imperfections.

Ch'i-lin: From Chinese mythology. The unicorn, king of all animals, whose appearance usually is a happy portent. "Ch'i" is the male and "Lin" is the female.

dress hooks: (or garment hooks) For the same purposes as our buttons and other fasteners. Some have a knob beneath, for insertion into a buttonhole, and a hook (often a narrow dragon's head)

at one end for insertion into a loop or another buttonhole. Some have simply two knobs beneath; and some are in two parts linked together like many of our buckles.

feng-huang: From Chinese mythology. A bird of rich plumage and clever form and movement. Fabled to appear in times of peace and prosperity, and often represented in art, sometimes in pheasant-like form.

glaze: In T'ang pottery usually a thin liquid lead baked on as an underglaze. On this glaze was often applied colored glazes of green, yellow or amber, brown and blue, according to the metallic oxides used. These also were subjected to controlled temperatures. Sometimes light and dark clays were used and covered with the colorless or pale yellow lead glaze, to produce marbled effects.

granulé: Grainy; Not smooth, grainy. Raised bead technique in metalwork.

intarsia: A kind of decoration in woodwork, much employed in Italy in the 15th century and later, in which scrolls, arabesques, architectural scenes, fruits, flowers, etc., were produced by inlaying wood in a background of wood; art or process of making such work.

Kaolin: Named for high hill, the place where it was found. A very pure white clay ordinarily in the form of an impalpable powder, used to form the paste of porcelain; china clay; porcelain clay. It is a hydrous silicate of aluminum, $H_4Al_2Si_2O_9$, and is derived from the decomposition of aluminous minerals, especially feldspar. It is used as an absorbent; as a base or filler for pigments; to some extent as a pigment by itself; in the manufacture of paper,

etc., the name is now applied to all porcelain clays enduring the fire without discoloration.

Lokapala: In Hindu and Buddhist religion, a world guardian; one of the regents of the quarters.

Ming Ch'i: Chinese name for tomb or funerary figures usually of ceramic ware. These were used to accompany the dead in the place of burial.

p'ing-t'o: Chinese for "flat cut-out." See "à jour."

pu yao: Hair ornament with silver or gold stems, from which hang ornaments of silver, gold, jade, precious stones, enamelled objects or inlays of kingfisher feathers.

raising: The process whereby a flat sheet of metal, e.g. gold or silver, is gradually worked up into a standing form, such as a bowl.

repoussé: Formed in relief, as a pattern on thin metal beaten up from the reverse side; also, shaped or ornamented with patterns so made.

ring matting: A pattern of small dots or rings, raised by use of a small stamping die or tool, forming the background for more elaborate decorations.

san-t'sai: A three-color design over the colorless or pale yellow "slip" glazes of green, brown and yellow or amber. The term *san-t'sai* does not include the rarer blue glaze, also found in T'ang multi-colored ceramics. Sometimes the designs were painted.

slip: Potter's clay in a liquid state, used in the casting process and for the decoration of ceramic ware, or as a cement for handles and other applied parts.

spathe: The large sheathing bract or pair of bracts enclosing an inflorescence on the same axis. The true spathe is found

only in plants whose inflorescence is a sapdix; it then assumes various forms, and is often highly colored, as in the calla.

tectonic: Of or pertaining to construction; the science or art by which implements, vessels, buildings, etc. are made both in relation to their use and artistic design.

TLV pattern: A mirror design, particularly of the Han Dynasty, which features predominantly a design resembling the letters "T," "L," and "V". Sometimes one of the three letters does not appear.

volute: A spiral or scroll-like conformation; also, an object or part of spiral or scroll-like form.

"white bronze": Bronze of a very light color because of the large proportion of tin in its composition.

Yü: Chinese for "jade."

yüeh ware: A type of porcelain similar to celadon, with an olive green glaze and an underglaze decoration—often of leaves and flowers—finely incised in the paste. Made at Yü-Yao Hsien, near Shao-hsing Fu (formerly Yüeh-Chou) in northern Chekiang. Sometimes called "secret color" glaze, because at one time it was reserved for royal use.

zoomorphism: The representation of God, or gods, in the form, or with the attributes, of the lower animals.

Bibliography

Ashton, Sir Leigh, and Basil Gray: *Chinese Art*. Beechhurst Press, New York, 1953

Bachhofer, Ludwig, *A Short History of Chinese Art*. Batsford, London, 1947

Beurdeley, Michel: *The Chinese Collector through the Centuries*. Tuttle, Tokyo, 1967

Broomhall, Marshall: *Islam in China, A neglected problem*. Morgan and Scott. London, 1910

Burling, Judith, and Arthur Hart: *Chinese Art*. Studio Publications, in association with Crowell, New York, 1953

Cammann, Schuyler: *The Lion and Grape Patterns on Chinese Bronze Mirrors*. Artibus Asiae, v. 16, 1953

Carter, Dagny (Olsen): *Four Thousand Years of China's Art*. Ronald Press Co., New York, 1948

Cheng, Te-k'un: *The Royal Tomb of Wang Chien*. Sinologica, v. 2, 1949–50

————: *The Royal Tomb of Wang Chien*. Harvard Journal of Asiatic Studies, v. 8, 1944–1945

————: *T'ang and Ming Jades. In* Oriental Ceramic Society. Transactions. v. 28, 1953–1954

Chi, Yen-lang: *Red China Discovers an Ancient Capital*. Art News, v. 61, May 1962

Chu, Chang-chao: *China Unearths Its Greatest Wall Paintings*. Art News. v. 62, September 1963

Cox, Warren Earle: *The Book of Pottery and Porcelain*. L. Lee and Shepard Co., New York, distributed by Crown, 1944

Ecke, Gustav: *A Throning Sakyamuni of the Early T'ang Period*. Oriental Art. n.s., v. 5, Winter 1959

Fenollosa, Ernest Francisco: *Epochs of Chinese & Japanese Art, An Outline History of East Asiatic Design*. 2nd. W. Heinemann, London; Frederick A. Stokes Co., New York, 1921

Freer Gallery of Art, Washington, D.C. *Annotated Outlines of the History of Chinese Arts.* rec. ed. Washington, D.C.: 1962. 1 v. (loose-leaf). Cover title: *Outline for the Study of Far Eastern Arts: China*

Grousset, Rene: *Chinese Art & Culture.* Translated from the French by Haakon Chevalier. Orion Press, New York, 1959

Gump, Richard: *Jade, Stone of Heaven.* Doubleday, Garden City, New York, 1962

Gure, Desmond: *Some Unusual Early Jades and Their Dating.* In Oriental Ceramic Society. Transactions. v. 33, 1960–62

Gyllensvärd, Bo: *T'ang Gold and Silver.* In Museum of Far Eastern Antiquities. Bulletin No. 29 (2), 1957

———: *Chinese Gold & Silver in the Carl Kempe Collection,* Nordisk Rotogravyr, Stockholm, 1953

Hajek, Lubor: *Chinese Art.* Spring Books, London, 1958

Kendrick, A. F., "Textiles": In *Chinese Art.* Batsford, London, 1935

Beurdeley ,Michel: *Chinese Portrature.* Tuttle, Tokyo, 1967

Lanfer, Berthold: *Chinese Pottery of the Han Dynasty.* Tuttle, Tokyo, 1962

Leitch, Gordon B: *Chinese Rugs.* Dodd, Mead, New York, 1928

Los Angeles County Museum, Los Angeles: *The Art of the T'ang Dynasty,* A Loan Exhibition organized by the Los Angeles County Museum from collections in America, the Orient, and Europe. January 8–February 17, 1957, Los Angeles, 1957

MacKenzie, Finlay: *Chinese Art.* Spring Books, London, 1961

Mahler, Jane (Gaston): *The Westerners Among the Figurines of the T'ang Dynasty of China.* Istituto italiano per il Medio ed Estremo Oriente, 1959. (Istituto italiano per il Medio ed Estremo Oriente. Serie orientale Roma, v. 20)

Munsterberg, Hugo: *The Landscape Painting of Chinaaud Japan* Tuttle, Tokyo, 1955

———: *Art of the Chinese Sculptor.* Tuttle, Tokyo, 1962

Nott, Charles: *Chinese Jade throughout the* Tuttle, Tokyo, 1962

Oriental Ceramic Society, London: *Catalogue of an exhibition of the arts of the T'ang Dynasty.* February 25, 1955 to March 30, 1955 at the Arts Council Gallery. Chas. F. Ince & Sons Ltd., London, 1955

Pan, Ku: *The History of the Former Han Dynasty.* A critical translation, with annotations, by Homer H. Dubs, with the collaboration of Jen T'ai and P'an Lo-chi. Waverly Press, Baltimore, 1938–55

Penkala, Maria: *Ages. Far Eastern Beramics.* Tuttle, Tokyo, 1963

Perry, Lila S.: *Chinese Snuff Bottles.* Tuttle, Tokyo, 1960

Pelliot, Paul: *Les Grottes de Touenhouana; peintures et sculptures buddhiques des époques des Wei, des T'ang et des Sung.* Librairie P. Geuthner, Paris, 1914–24

Prodan, Mario: *The Art of the T'ang Potter.* Viking Press, New York, 1961

———: *Chinese Art, an introduction.* Pantheon, New York, 1958

Rackham, Bernard: "Ceramics." In Chinese Art. Batsford, London, 1935

Reischauer, Edwin O. and John K. Fairbank: *East Asia: The Great Tradition.* Houghton Mifflin, Boston, 1960 (A History of East Asian Civilization, v. 1)

Schafer, Edward Hetzel: *The Golden Peaches of Samarkand: A Study of T'ang Exotics*. University of California Press, Berkeley, 1963

Sekai Toji Zenshu (catalogue of the world's ceramics). Edited by Okuda Seiichi and others. Kawade Shobo, Tokyo, 1955–58. *China: Sui and T'ang Dynasties*

Silcock, Arnold: *Introduction to Chinese Art and History*. Rev. ed. Oxford University Press, New York, 1948

Sirén, Osvald: *Chinese Paintings: Leading Masters and Principles*. Ronald Press, New York, 1956–58

————: *Sculpture*. In Fry, Roger Eliot. Chinese Art. Batsford, London, 1935

————: *Two Chinese Buddhist Stele*. Archives of the Chinese Art Society of America, v. 13, 1959

Speiser, Werner: *The Art of China: Spirit and Society*. Translated by George Lawrence. Crown Publishers, New York, 1961

Stein, Sir Aurel, "Ancient Chinese Figured Silks Excavated By Sir Aurel Stein." *The Burlington Magazine*, V. XXXVII, Number CCVIII, pp. 3–10

Sullivan, Michael: *Excavation of the Royal Tomb of Wang Chien*. In Oriental Ceramic Society. Transactions. v. 23, 1948

————: *An Introduction to Chinese Art*. University of California Press, Berkeley, 1961

Swann, Peter C.: *Art of China, Korea and Japan*. Praeger, New York, 1963

Toledo Museum of Art: *Exhibition of East Asiatic Glass*. October 3–31, 1948. Toledo, 1948

Venice: *International Exhibition of Chinese Art, 1954*. Mostra d'arte cinese. Catalogo/Catalogue. Carlo Ferrari, Venezia, 1954

Watson, William: *Ancient Chinese Bronzes*. Tuttle, Tokyo, 1962

Willetts, William. *Chinese Art*. Penguin Books, Harmondsworth, Middlesex: 1958

Yamada, *Decorative Arts of Japan*. Kodansha International Ltd., Tokyo, 1964

Index